Pre-Raphaelite Portraits

Andrea Rose

 The Oxford Illustrated Press

Acknowledgements

I would like to thank all those who have generously given permission to reproduce their works here, and in particular to thank the following for their help:

Michael Brandon-Jones John Leathart
Ian Charlton Jeremy Mass
Mrs Diana Cuthbert Jane Marshall
Deborah Cherry Natalie McCance
Mrs Imogen Dennis Andrew Pollock
Diana Eccles Richard Ormond
Sara Ellis Harold Rossetti
William Feaver Jeremy Sandelson
Mrs S. Fierz Florence Shanks
Julian Hartnoll Mrs Virginia Surtees
Trevor Jones Merlin Waterson

I specially want to thank my editor, Alison Freegard, for her constant support and encouragement.

I am grateful to the following for their permission to reproduce extracts:

The Beinecke Rare Book and Manuscript Library for extracts from Ruskin's letters.

Longman for an extract from *The Letters of William Morris to his Family and Friends* ed. Philip Henderson.

Oxford University Press for two excerpts from *Dante Gabriel Rossetti and Jane Morris: Their Correspondence* ed. John Bryson with Janet Camp Troxell (1976).

University of British Columbia for an extract from a letter from Edward Burne-Jones to Dante Gabriel Rossetti which is held in the Special Collections Division.

This book has been produced in close consultation with the Ashmolean and Birmingham City Museum and Art Gallery whose help is gratefully acknowledged.

For my Mother

Printed in Great Britain by
Haynes Publishing Group, Sparkford, Yeovil, Somerset, England

Distributed in the USA by Haynes Publications Inc, 861 Lawrence Drive, Newbury Park, California 91320, USA

Oxford Illustrated Press, Sparkford, Yeovil, Somerset BA22 7JJ

Hardback ISBN 0 902280 74 0
Paperback ISBN 0 902280 82 1

Contents

3

Introduction

Pre-Raphaelite Portraits
'Beauty is truth, truth beauty'

Theda Bara lures the camera. It is 1915. She is the star of a film that will launch her on a short, but sensational Hollywood career as The Vamp, or, as she was otherwise known, as 'The Burne-Jones woman'. The image was to influence a host of aspiring screen stars, from Louise Brook to the young Garbo. The film, *A Fool There Was*, was adapted from Porter Emmerson Browne's play; its title was taken from Rudyard Kipling's ballad, *The Vampire*:

> A fool there was and he made his prayer
> (Even as you and I!)
> To a rag and a bone and a hank of hair
> (We called her the woman who did not care)
> But the fool he called her his lady fair —
> (Even as you and I!)

When Philip Burne-Jones, son of Edward Burne-Jones, exhibited his painting 'The Vampire' at the Grosvenor Gallery in 1897, Kipling's poem was printed below it. Kipling and the young Burne-Jones were related not only by marriage (they were first cousins) but by a fellow feeling for women. In 'The Vampire', a male victim lies prone on the silken couch, while Mrs Patrick Campbell, as Siren, flexes her body over him, her lips parted in anticipation, her chin thrust back in triumph and disdain. Only fangs are missing to make this image totally absurd. But for the turn-of-the-century audience, for both cinema and gallery-going public alike, these images of women were serious. They were Modern. They welcomed the demise of the nineteenth century, where, as Eleanor Acland put it in *Goodbye for the Present*, 'nice Ladies no more thought of showing their legs than did nice chairs'. As century ceded to century, a change of face denoted a change of heart.

For the major part of the nineteenth century, the body politic was under attack on various fronts. Newman first sent out a blast against the established church with the Oxford Movement. John Bright salvoed in the direction of the monarchy when he suggested in front of a rally of British reformers in 1866 that the Queen abdicate in favour of a republic (with himself as President). Social reforms were ricocheted by Morris, Ruskin, John Stuart Mill and the educationalists. Darwin laid siege to the crusty concepts of science and geology

'Theda Bara'
The Kobal Collection

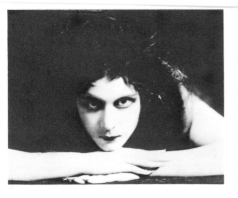

4

with his evolutionary theories. Political structures were battered and reconstituted with the respective rise and decline of the Socialists and Whigs. In the visual field the loudest agitators were the Pre-Raphaelites. They set fire to time-honoured ideas of what art was and what an artist should be. From the ashes of their assault however, rose a bird of a rather different feather from any that they might have envisaged. For the head of the body the Pre-Raphaelites fashioned a new face — intense, iconic, wasting with an unnamed passion. Rossetti was the first to model these features on his female portraits. Burne-Jones and other later nineteenth-century followers of the Pre-Raphaelite school refined them until they transmogrified onto the silver screen, all celluloid sex and artful ardour. Theda Bara was nobody's idea of 'The Angel in the House'.

The Burne-Jones Woman came slowly into focus. Various blurred images of her were transmitted across Europe throughout the second half of the nineteenth century as traditional notions of femininity were challenged. The first small buds of feminism which appeared around the 1850s smelled suspiciously of the stock that would also breed Baudelaire's *Fleurs du Mal*. Artists at home and abroad began to fear the growing strength of women. In France, Gustave Moreau suggested that 'the intrusion of women into Art would be an irremediable disaster'. Small wonder that he didn't risk marriage, as did neither Delacroix, Corot nor Degas. Baudelaire, Gautier and Flaubert felt a similar distaste for women, only their reaction was more ambiguous. They gazed, fascinated but repelled, at women of a curious frigidity, cold but sensual, erotic but invulnerable — Flaubert's Salammbo, Nerval's Aurelia — dream women that one would rather not wake to find lying in one's bed the next morning. In England, Swinburne and Walter Pater extemporised along the same lines, but with added horror. Their attitudes are piped with a fear of female malevolence, and characteristically they attempt to control this fear by boiling down the variety of individual experience into the image of a single symbolic figure. The formula of the *femme fatale* is typical of this narrow, reductive view, and nowhere captured with such chilly precision as in Pater's famous description of the Mona Lisa.

> The presence that thus rose so strangely beside the waters, is expressive of what in the ways of a thousand years men had come to desire. Hers is the head upon which all "the ends of the world are come", and the eyelids are a little weary . . . All the thoughts and experience of the world have etched and moulded there . . . She is older than the rocks among which she sits; like the vampire she has been dead many times, and learned the secrets of the grave . . .
>
> 'Leonardo da Vinci'
> *The Studies in the History*
> *of the Renaisance, 1869*

In her memoirs, Lady Dilke (former wife of Mark Pattison) said the trouble with Pater was that he treated the Renaissance as 'an air-plant, independent of the ordinary sources of nourishment . . . a sentimental revolution having no relation to the actual conditions of the world'. He certainly regarded art (and women as a symbol of art) as a flower that would not be so vulgar as to have its roots in the soil. For Pater, art was a cut flower, beautifully arranged in a choice vase. All relationship to common or garden life was to be cleaned off — the dirt washed away, the roots hidden. He seemed only to be able to see beauty when it was divorced from natural surroundings. How different from Ruskin, who only sixteen years earlier had thrilled his readers with his belief that:

> Imperfection is in some sort essential to all that we know of life. It is the sign of life in a mortal body . . . Nothing that lives is, or can be, rigidly perfect; part of it is decaying, part nascent. The foxglove blossom — a third part bud, a third part past, a third part in full bloom — is a type of the life of this world. And in

all things that live there are certain irregularities and deficiencies which are not only signs of life but sources of beauty.

The Stones of Venice, 1853

For the generation of artists growing to maturity in the 1860s however, Ruskin was a fading light and Pater the rising star. Pater's hothouse aesthetic looked genuinely fertile to Rossetti, Burne-Jones, Swinburne, Wilde and Walter Crane. What it produced though was a new but flashy bloom, effective rather than subtle, life as a short burst rather than as a sustained effort. The female portraits that Rossetti started to paint at the end of the 1850s, and which were subsequently copied by many a latter-day Pre-Raphaelite, are typical of this growth: 'Female heads with floral adjuncts,' William Michael Rossetti called them. Their obvious beauty is without depth: they are like one third part of Ruskin's foxglove blossom, the nascent and decaying parts eliminated, and only the full-blown head on show.

This stasis Pater chose as an ideal: 'To burn always with this hard, gemlike flame,' he wrote, 'to maintain this ecstasy, is success in life.' Nowadays, few would elect to burn with this gemlike flame as a permanent mode of living. Those that do are probably rather young. But the artists of the mid nineteenth century were young — young that is in their belief that they were revolutionaries, and that with no very great weight of tradition or prejudice behind them, but with plenty of vehemence, they could stun the bourgeoisie out of complacency and make the world a more beautiful, and hence a better, place to live in. But revolutions are easier to start than to maintain. By the late 1860s the Pre-Raphaelites had been toiling away for twenty years. As young men they had jeered at the stale academic conventions of their peers and attempted to raise a new artistic tricolour — Truth, Honesty, Sincerity. As more disappointed men, they had, by the 1860s, largely turned away from active social revolution to a more introspective, socially disengaged form of work. Their leader was Dante Gabriel Rossetti, and it is through the progress of his own disappointment that the emerging face of Pre-Raphaelitism took its shape.

Pater and Swinburne both came to know Rossetti in the 1860s. Although his major volume of poems was not published until 1870, he had already achieved an esoteric fame. *The Blessed Damozel*, written when he was only eighteen, was eagerly circulated in manuscript and had been published twice: once in *The Germ*, the Pre-Raphaelite literary magazine, and once in *The Oxford and Cambridge Magazine* (1856), a magazine set up in emulation of *The Germ* by William Morris and Edward Burne-Jones when they were both undergraduates at Exeter College.

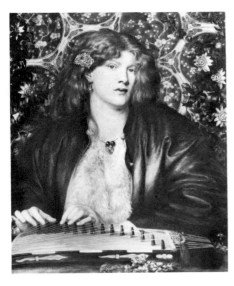

'The Blue Bower' by Dante Gabriel Rossetti Barber Institute of Fine Arts, University of Birmingham

The sensual qualities of the poem are pronounced. Rossetti is already seen putting flesh on the supposedly ethereal bones of the spirit. A deceased woman looks from her balcony in heaven and yearns for her lover on earth. Her bosom warms the gold bar that she leans against. Her hair is thick and yellow. She thrills to the thought that her lover's body will one day be beside hers in heaven. By the time Rossetti began to place such women on canvas, towards the end of the 1850s, these sensory details already bear the hallmark of a style. The full, pouting lips, the heavy-hooded eyes, the unbound and luxuriant hair, the statuesque figures expanding without benefit of corset or much else besides under the exotic and loosely-fitting gowns — these are familiar to anyone with only the vaguest knowledge of who and what the Pre-Raphaelites were. Portraits of Rossetti's favourite models, of Alexa Wilding as 'La Ghirlandata', of Jane Morris as 'The Water Willow', of Fanny Cornforth in 'The Blue Bower', became the prototype for a group of Rossetti-worshippers: Spencer Stanhope, Fairfax Murray, J. M. Strudwick, T. M. Rooke, Marie Stillman, Rosa Corder and Evelyn de Morgan. Burne-Jones and Beardsley, as well as European Symbolists such as Fernand

Khnopff and Arnold Böcklin, also drew on these images for their stock-in-trade of viragos and *femmes fatales*. But these portraits are Rossetti at his worst. They are the Rossetti of such verse as *Sybilla Palmifera,* one of the sonnets from *The House of Life* sequence, in which he affirms his religion of beauty:

> This is that Lady Beauty, in whose praise
> Thy voice and hand shake still — long known to thee
> By flying hair and fluttering hem — the beat
> Following her daily of thy heart and feet,
> How passionately and irretrievably,
> In what fond flight, how many ways and days!

It is all vague and gestural. A cloak of beauty is thrown over the spiritual emptiness. For the main note of these sonnets, as well as the later portraits, is that of spiritual sickness. The ardours and opiates of love, the hectic and languid attitudes of the lover, the emotional overtones, the incidental accents of style, the beautiful ornament — these are just seductive substitutes for a vigorous central feeling. Rossetti used spiritual sickness as an excuse for suggesting spiritual superiority; the inevitable result is monotony and boredom. Behind the sophisticated surfaces of 'The Blue Bower' lies romantic idealisation, with its corollary of selfishness. In front of them lies disappointment, with various shades of guilt, remorse and futility.

Rossetti was at his best illustrating the Moxon edition of Tennyson. His literary mind could build bridges over the gaps that separated romance from reality in the medieval world. His essentially romantic imagination could conceive of the Ideal Woman as both a Virgin and a Holy Mother. What he found more difficult to deal with was his Ideal Woman presenting herself to him bodily, in the shape of Elizabeth Siddal. Before meeting her in 1849, Rossetti had written a prose-tale, *Hand and Soul,* about a fictitious painter living in thirteenth-century Tuscany. The painter, Chiaro dell'Erma, is in despair because neither his art nor his faith suggest any reason for living. One day he has a vision. His own soul, in the form of a young and beautiful woman, appears before him and tells him not to worry about abstract moralities but to create only what comes from his own imagination, the mirror of his soul. As he listens to her, Chiaro realises that 'the first thoughts he had ever known were given to him as at first from her eyes, and he knew her hair to be the golden veil through which he beheld his dreams'.

Elizabeth Siddal, with her bright, coppery hair, her dim-golden eyes, and her slender, elegant figure, appeared to Rossetti (alias Chiaro) as the mirror of his dreams. Not only the mirror, but also the mould, into which he could pour his fluid thoughts and hold them hard. Like most moulds however, she became worn with use. She corresponded to a youthful conception which Rossetti outgrew as his character widened and deepened. Also, being idealistic, he was not very clear-sighted about her. Bessie Parkes, later to become well-known as a feminist, was friendly with Lizzie and Rossetti in the 1850s, and one of the few people to have recorded unsentimentally what she thought of Lizzie:

> 'She was not of his rank in life, and I did not think her in the least like 'a countess'; but she had an unworldly simplicity, and purity of aspect which Rossetti had recorded in his pencil drawings of her face. Millais has also given this look in his 'Ophelia', for which she was the model. The expression of Beatrice was not hers, and when I look at the famous Beatrice in the National Gallery, I feel puzzled by the manner in which the artist took the head and features of a remarkably retiring English girl, with whom I was perfectly familiar, and transfused them with an expression in which I could recognise nothing of the moral nature of Miss Siddal. She had the look of one who read her Bible and said her prayers every night, which she probably did.'

Rossetti was obsessed with Elizabeth Siddal as an ideal, and his drawings of her read as a romance, each portrait a stanza within a larger and denser essay on the poesie of love. It was, as Ford Madox Brown remarked:

> 'monomania with him . . . Miss Siddal, looking thinner and more deathlike and more beautiful and more ragged than ever . . . Gabriel drawing wonderful and lovely Guggums [Rossetti's pet name for Elizabeth Siddal] one after another, each with a fresh charm, each one stamped with immortality . . .'

If one wants to see what she really looked like, the best account is her own. The pale eyelashes, the pursed lips, and the slightly soured expression of her self-portrait, show that she could see herself more realistically than Rossetti; it must have made it all the harder for her to maintain the posture of the Ideal Woman.

The passage from romantic enchantment to intimacy never occurred. After an engagement of ten years, Rossetti married his model, but the relationship was dead. Lizzie's ill-health proved an additional strain, and it is no surprise to find Rossetti turning towards the relaxed charms and easy virtue of Fanny Cornforth (sportingly referred to as his 'housekeeper'). By the time Rossetti had involved himself with Fanny, Barbara Leigh Smith (later Mme Bodichon) had just published *Women and Work* (1857). Barbara was a close friend of both Rossetti and Lizzie, and had been particularly helpful to them in 1854, when Lizzie's health broke down (she found them cheap lodgings near her farm at Scalands, Hastings). Barbara was pragmatic and tough-minded, 'a young lady blessed with large rations of tin, fat, enthusiasm and golden hair, who thinks nothing of climbing a mountain in breeches, or wading through a stream in none', as Rossetti described her to Allingham. Barbara saw well enough that physical delicacy was not a prerequisite of femininity:

> 'WORK — not drudgery, but WORK — is the great beautifier. Activity of the brain, heart and limb, gives health and beauty, and makes women fit to be the mothers of children. A listless, idle, empty-brained, empty-hearted, ugly woman has no right to bear children.
>
> To think a woman is more feminine because she is frivolous, ignorant, weak, and sickly, is absurd; the larger-natured a woman is, the more decidedly feminine she will be; the stronger she is, the more strongly feminine. You do not call a lioness unfeminine, though she is different in size and strength from the domestic cat, or mouse'.

The exaggerated esteem for refinement and sensibility in women was, ironically, largely the legacy of the Industrial Revolution. Women had, of course, always held a subordinate position in society. But at least before industrialisation they had been mistresses of household crafts and been important in their own domains. As 'industry' increased, the cottage industries declined. Families moved into the cities and country wives became factory hands. With the growth of material prosperity it became a social imperative that middle-class wives should not work. In fact the further removed they were from the sphere of toil and labour of any kind, the more sensitive and ladylike they were considered. Tenniel's cartoon for *Punch*, 'The Haunted Lady' (4 July 1863), shows not just the vanity, but the cruelty of such attitudes. A young seamstress, no doubt having worked for twenty-six hours without a break (as was the actual case of Mary Ann Walkley, whose death under similar circumstances prompted the cartoon) dies of exhaustion as her Ladyship admires herself in the new ballgown. 'We would not have disappointed your Ladyship, at any sacrifice,' exclaims Madame La Modiste, 'and the robe is finished *à merveille*'.

But then, what were women to do? The dependency of the average middle-class Victorian wife was at least respectable. For those who could not find an eligible partner in a society where women greatly outnumbered men, life was insulting. 'What dignity can there be', asked Josephine Butler in *Women's Work*

'The Haunted Lady or ''The Ghost'' in the Looking-glass' Madame La Modiste: 'We would not have disappointed your Ladyship at any sacrifice, and the robe is finished *à merveille*.'
Punch cartoon by John Tenniel, published 4 July 1863

and Women's Culture, 'in the attitude of women in general, and towards men in particular, when marriage is held (and often necessarily so, being the sole means of maintenance) to be the one end of a woman's life, when it is degraded to the level of a feminine profession, when those who are soliciting a place in this profession resemble those flaccid Brazilian creepers which cannot exist without support, and which sprawl out their limp tendrils in every direction to find something — no matter what — to hang upon?'

Several voices railed against the closed option of marriage. Florence Nightingale, whose own example led to a new conception of the place in society of the trained and educated woman, was a relative of Barbara Leigh Smith. She had also offered to help Elizabeth Siddal to a place in a Harley Street sanatorium in 1854, an offer which was refused. 'Why have women passion, intellect, moral activity,' she demanded to know, 'these three — and a place in Society where not one of these can be exercised?' From across the Atlantic Mrs Judith Sargent Murray asked whether it were reasonable 'that a candidate for immortality, for the joys of heaven, an intelligent being, should at present be so degraded as to be allowed no other ideas than those which are suggested by the mechanism of a pudding or the sewing of the seams of a garment?' Rossetti was not the man to answer these questions. But as he gradually began to make the adjustment from idealism to maturity, his women naturally begin to appear more sturdy, less 'feminine', less likely to succumb to the selfish invalidism which to many women of the period must have seemed the only way they could make a stand for individuality. Annie Miller, Ruth Herbert, Ellen Smith, Ada Vernon and Fanny Cornforth, Rossetti's models of the 1860s and 70s, all have rude health. Physically it was plain to see that they were simply not the sort to fill the role of doll-wife or virginal heroine demanded by the likes of Dickens' Dora Copperfield, Agnes Whitfield or Esther Summerson. But emotionally, and intellectually, they were just as empty. Rossetti sought them out because their beauty lay on the surface, like full-blown roses, with as little as possible to awaken in him the want of something deeper and more urgently felt. So he concentrated on their form, not their content. For what else could these blowzy laundrymaids and bar-wenches give him, other than a slap-up evening at Astley's or a jolly giggle in Cremorne Gardens? For something fuller, he had to wait for Jane Morris.

By all accounts, Mrs Morris was striking. Some oddness, some irreducible arcaness hung about her features. 'When she came into a room,' reflected Bernard Shaw, 'in her strangely beautiful garments, looking at least eight feet high, the effect was as if she had walked out of an Egyptian tomb at Luxor.' Her beauty had a solemnity alien to the conventions of grace and lightness set by the French, as Graham Robertson recalled in *Time Was:*

'She required appropriate setting and was perhaps at her wonderful best in her own house, standing in one of the tall windows against the grey river or lying on a low couch with beyond her the dim splendours of a great cabinet painted by Burne-Jones with the legend of little Saint Hugh of Lincoln. There she seemed to melt from one picture to another, all by Rossetti and all incredibly beautiful. I can well understand that her type was too grand, too sombre to every eye. When she travelled in France, our light-hearted and often beauty-blind neighbours found her appearance frankly amusing and would giggle audibly when she passed by, to the astonishment and rage of Morris, who was with difficulty restrained from throwing down his gage in the cause of his Ladye.'

In Mrs Morris the strong physique of Rossetti's other models coincided with a sympathetic and responsive mind — responsive, that is, to Rossetti. To her husband she was not. When William Morris describes the amorous adventures of Hammond in *News from Nowhere* he is really talking about his own misplaced

idealism, of a 'calf-love, mistaken for a heroism that shall be life-long, yet early waning into disappointment'. For Rossetti though, Mrs Morris closed the gap between emptiness and sensual desire. Again he found a mould into which to pour his feelings. But Mrs Morris was married, and so much of the yearning with which the Pre-Raphaelites have become identified is moulded by this particular emotional see-saw. In Rossetti's portraits of her, Janey fades into a veiled, impenetrable world of her own. The sharpness of passion becomes blunted as the years go on. Mrs Morris stares out at Rossetti as if from the end of a see-saw permanently weighted to the ground. He will never let her rise, even to the half-way point, where she might balance things in her favour. And Rossetti, forever high up on the see-saw, directs his gaze with morbid attachment down onto his beloved below, forever out of reach. Echoes of *The Blessed Damozel,* of the lover in a loveless heaven, ring hauntingly true.

Rossetti's best portraits, where he is looking as closely at his ideal as idealism will allow, are really only the result of a transient phase of style. Unlike the two other major painters of the group, Millais and Holman Hunt, he was not really interested in naturalism. When the group came together in 1848, naturalistic accuracy, together with an attempt to introduce the qualities of early Italian painting into visual art, were its main aims. It was appropriate to the dawning age of science, to an age which placed its faith in facts. 'Fact, fact, fact,' cries the Superintendent of the Government School of Design (a character based on Henry Cole) in *Hard Times,* ticking off little Sissy Jupe for wanting to decorate a room with a highly illusionistic floral carpet. Solid, unadorned fact was the cry of the enlightened, the sort of fact that would call a fork a fork, and not present it embellished with such tricky designs as those found on Lambert and Rawlings' cutlery entries in the Great Exhibition of 1851. 'Novel and fanciful . . .' the catalogue called them, 'emblematic respectively of fish, flesh and fowl, three out of the four elements . . . of which the humblest repast and the most *recherché* combinations of the *cuisine* consist. They will bear and repay inspection — between the courses'. No doubt they did, but they must also have been virtually unusable. Every department of life was affected by this call for hard-boiled realism. The first issue of *The Ecclesiologist** (1841) insisted that '. . . in God's House everything should be real'. What was meant by real was the display of solid virtues: of honest workmanship, of attention to detail, of particularity and plainness. To be real meant to be moral. Butterfield and Street applied such precepts in their religious buildings, putting a plain but honest face before the good manners and nice taste of their predecessors: a sort of honest ugliness of expression. Like well-bred girls, good buildings should wear no face-paint.

The way the Pre-Raphaelites answered the cry for realism in art was to paint with as much care and as much accuracy as they had at their command. Natural backgrounds were painted with botanical precision (Millais' 'Ophelia'), interiors with avid attention to all the furnishings (Hunt's 'The Awakening Conscience'). Contemporary subjects were looked at with cold-eyed objectivity: prostitution (Rossetti's 'Found'), labour (Wallis' 'Stonebreaker'), religious historicism (Millais' 'Christ in the House of his Parents'), industry (Scott's 'Iron and Coal'), and emigration (Ford Madox Brown's 'Last of England'). Madox Brown recorded how in order to paint the portraits of himself and his wife in 'The Last of England' he had gone to uncomfortable lengths to get the exact effects of the coastal atmosphere: 'To insure the peculiar look of *light all round* which objects have on a dull day at sea, it was painted for the most part in the open air on dull days, and, when the flesh was being painted, on cold days'. As a separate branch of painting, portraiture did not particularly interest the Pre-Raphaelites. When they came to paint portraits, however, they applied the same ground rules as in all other areas of their work: absolute fidelity and naturalness. The result, some critics found, was an inexcusable plainness (the honest ugliness of expression). A

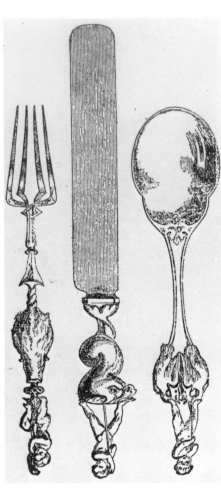

'Knife, fork and spoon, by Lambert and Rawlings' From *The Crystal Palace and its Contents*

*Journal of the Camden Society, founded by John Mason Neale and Benjamin Webb in 1839, with the hope of influencing church architecture in Britain.

prominent patron of Ford Madox Brown wrote to the painter in 1858 to counsel him about this:

> 'Our pictures seem to come out badly in the Reviews this year and is owing to nothing but the ugly female faces in the bulk of the Pre-Raphaelite work. Rossetti has much to answer for this, for he has constantly red hair and the same type of face in his models. I feel sure that this is a great obstacle to the popularity of the Pre-Raphaelite work. I consider you are not liable to this charge, but those who follow Rossetti are. Stanhope has spoiled his pictures by this defect. Even the *'Saturday Review'* and Ruskin have turned against the Pre-Raphaelite pictures this year, and so has *"The Times"*, and on this ground I do indeed hope that Jones will not get into it, or Morris and Prinsep in the work they have for me. I am sure you will get two or three pretty models for the young ladies in my pictures, and don't have red hair, please!'

Plainness, however, whether it came with red hair or not, was the object of the exercise — plainness in the name of Truth, Sincerity and Honesty — plainness as an antidote to the tired academicism extolled by the contemporary art world.

Sir Joshua Reynolds, first President of the Royal Academy, had established himself as the repository of academic virtue. Academicism in art suggests idealism, and idealism in portraiture suggests the submersion of the individual (and all that that means in terms of his humanity) into some general pool of manners and modes. In his *Discourses on Art (VII)*, Reynolds made it clear why he felt that the day-to-day peculiarities of individuals should be kept out of portraiture:

> 'No man for instance, can deny, that it seems at first view very reasonable, that a statue which is to carry down to posterity the resemblance of an individual, should be dressed in the fashion of his times, in the dress which he himself wore; this would certainly be true if the dress were part of the man: but after time, the dress is only an amusement for an antiquarian; and if it obstructs the general design of the piece, it is to be disregarded by the artist. Common sense must here give way to a higher sense.'

What he provides is a view of history, history seen as some grand and idyllic past, where deeds were noble and men were men, precisely because they are stripped of all the irritating little characteristics that make men human. The idea that the past is invariably better than the present is not exclusive to the eighteenth century. We still like to think that 'things aren't what they used to be', or that 'they don't make 'em like that any more'. The inconvenience of the past, the ephemera, the flotsam and jetsam of everyday routine, all this washes up on the beach as the tide pulls out from the present, leaving our view of history cleaner, less disorganised and less human than in our own day.

In the age of realism, of scientific enquiry and of fact, the notion of history, however, was changing. 'Give up the theory of constitutions and their mechanism, of religions and their system', demanded Hippolyte Taine, champion of the new historical approach, 'and try to see men in their workshops, in their offices, in their fields, with their sky, their earth, their houses, their dress, tillage, meals; as you do when landing in England or Italy, you remark faces and gestures, roads and inns, a citizen taking his walk, a workman drinking.'

History was seen to be science, nothing more than an infinite stretch of facts. All the myths and moral tales that had, until then, been part and parcel of history now became untied, let loose. The age-old morality of the Creation was cast into doubt now that Darwin could prove the world was so much older in origin than biblical conventions had thus far allowed. Divinities could be approached as ordinary mortals (Renan's *Vie de Jésus*), royalty as simply part of the common process of law (Stubbs' *Constitutional History of England*), and the ruling classes, according to Marx's *Communist Manifesto*, as no more than replaceable economic

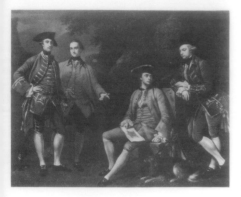

'A Group of Englishmen in
Rome' by Nathaniel Dance
The Earl of Seafield

factors within the larger organisation of things. Fact was the great leveller.

When Reynolds painted Mrs Lloyd, and wrote her name into the bark of a tree, he was not concerned with the state of her heart one day in 1776. He wanted to picture her as a love-goddess, dressed, appropriately enough for an archetypal deity, in a long, classically-inspired gown. When Nathaniel Dance painted his 'Group of Englishmen in Rome' (1760), he was not bothered about the temperamental differences between the four young men. He shows instead that these men are on the Grand Tour, and that as such, they come equipped with certain social attitudes, as well as set expectations. Dignified, but reticent, their status speaks for them and the voice is cool and impersonal. To sound a more personal note, one of warmth and immediacy, the painter would need the free and easy access into the heart of his sitter that is normally reserved for social equals. A comparison of the portraits of Gainsborough's friends — of Philip de Loutherbourg, J. C. Bach (and of his daughters, Margaret and Mary) — with commissioned portraits (such as those of 'Sophia, Lady Sheffield' and 'Sir Henry Bate-Dudley') shows instantly the difference made by lively, personal interest. Wit and vivacity sparkle from the former; the latter merely dissemble on the canvas, though with a practised grace.

Much of the controlled elegance of eighteenth-century portraiture was also due to the fact that the artist was the paid employee of his sitter. As a workman before his master, the artist seems to stand well back from his subject, keeping his distance, so to speak, a physical as well as an emotional distance. The amount of space the artist places between himself and the sitter is usually large: the figure does not come right forward to the picture's edge, but stands (or sits) with reserve somewhere in the middle distance. By 1848, such classical idealism had become an anachronism; it was worn out. When he visited the eightieth annual exhibition at the Royal Academy, the art critic of *The Athenaeum* singled out portraiture as a 'department which is rapidly falling into disrepute'. He complained that the portraits he saw were 'little better than *rifacciamenti* . . . reduced to commonplaces of action and obviousness of arrangement and accessory . . . there is small attempt to evoke character from the representation of human physiognomy. The art is fast degenerating which stood so high in the hands of a Raphael, a Titian, a Rembrandt, and a Reynolds though we still have Pickersgill, Watson, Gordon and Grant'. Posterity has not dealt kindly with the last four names on the list. It is to the Pre-Raphaelites, who formally declared themselves a Brotherhood in this same year, that it has turned its attention.

Compared to the dispassionate taste of most eighteenth-century portraits, Pre-Raphaelite portraits are the product of the engaged heart and mind. They frequently look messy and uncontrolled, obsessed as they are with the same face time and time again, often a face of great personal significance for the artist: a loved woman, a bosom friend, a member of his family. There were relatively few commissioned portraits for the Pre-Raphaelite brothers during the early, intense stage of the movement from 1848 – 56, and the majority of their portraits were done for love and pleasure; a matter of choice rather than of paid employment. In a society daily debating the problems of enfranchisement and political democracy, the Pre-Raphaelites were realigning the old relationship of artist to sitter. If the artist chooses his model, it is he who dictates terms. Painter and model sit as more equal partners, and within this artistic democracy the painter is free to create his own imaginative hierarchies. Where Reynolds painted his patrons in the dress appropriate to their status, Rossetti can make a queen out of a shop-girl, a goddess out of a stable-groom's daughter, a deity out of a Cockney trollop. Elizabeth Siddal, the milliner's assistant, becomes Regina Cordium, the Queen of Hearts; Jane Morris is Astarte, Proserpine; Fanny Cornforth (affectionately called 'the elephant' by Rossetti) is Lilith. In this new contract, the traditional constituents of aristocracy — blood, breeding, estate — are

'Regina Cordium' by
Dante Gabriel Rossetti
City Museum and Art Gallery,
Birmingham

cancelled. What counts is the artist's discrimination. It also forms the foundation of a new elitism.

The Pre-Raphaelite tendency to eliminate social distance has its physical side too. The artists do not stand well back from the sitter. Their subjects are brought right up to the picture's edge, and tilted forward slightly as if they are about to speak to you. Often the Pre-Raphaelite portrait is an abbreviated affair, focussing on the head only, without any appeal to the mitigating features of dress or furnishing. And then, the heads are not only shown in close-up, but in full-frontal, the most uncompromising pose of all. 'Daniel Casey' by Ford Madox Brown, 'Walter Deverell' by Hunt, 'Hunt' by Rossetti, 'Woolner' by Rossetti, 'Mrs Gaskell' by Burne-Jones — they all stare out, quite unabashed to be seen at such close quarters, proclaiming, as it were, that within their faces lies the full scope of personality. 'My face is my fortune', trills the pretty maid going a-milking in the popular nursery rhyme, expressing a sentiment that was rapidly gaining political weight. To some extent the 'mug-shot' objectivity of these portraits was influenced by the development of photography. The first photographic portrait studio was set up in London in 1841; twenty years later there were over two hundred such studios all over Britain. Certainly painters such as George Richmond, who had no connections with the Pre-Raphaelite movement, used the formula of the close-up portrait of the head (sometimes life size) in response to portrait photography. Like the Pre-Raphaelites, he wanted his portraits to present an honest likeness; unlike them though, it was honesty only up to a certain point: 'Ah!' he confessed, agreeing that it was truth he was after in his work, 'but the truth lovingly told'.

One painter whose portraits, as he became older, became loving to the point of sentimentality was Millais. Just how candid early Pre-Raphaelite portraits were can be judged by comparing his late society portraiture (Mary Millais as 'The Last Rose of Summer', Lillie Langtry as 'A Jersey Lily') with the 'advanced' portraits he painted when he was still associated with the group. His portrait of Emily Andrews, the first wife of Coventry Patmore, is direct and carefully observed; the poet's wife is not prettified like a *Keepsake** beauty. Her chaste features represent some of the ideas about clarity and purity which the Pre-Raphaelites were trying to put into their pictures. Robert Browning might well have been writing the manifesto of the Brotherhood (in absence of any other) when he composed *The Face,* a poem modelled from the features of Emily Andrews:

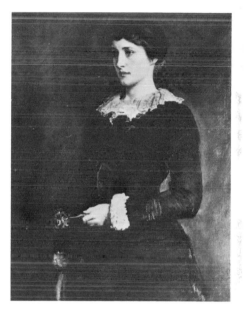

'A Jersey Lily' (portrait of Lillie Langtry) by John Everett Millais
States of Jersey

> If one could have that little head of hers
> Painted upon a background of pale gold,
> Such as the Tuscan's early art prefers!
> No shade encroaching on the matchless mould
> Of those two lips, that should be opening soft
> In the pure profile — not as when she laughs,
> For that spoils all — but rather as aloft
> Some hyacinth she loves so leaned its staff's
> Burthen of honey coloured studs to kiss
> Or capture, twixt the lips, apart from this,
> Then her little neck, three fingers might surround,
> How it should waver on the pale gold ground
> Up to the fruit-shaped perfect chin it lifts.

Browning was not the only artist in the Pre-Raphaelite circle to take note of Emily's virginal but sensuous beauty. Holman Hunt, Ruskin, Carlyle and Tennyson all admired her and made reference to her in their work. It is hardly surprising that they did; one of the chief principles on which the Pre-Raphaelites insisted was the use of friends rather than paid models in their art. The trouble with paid models, as Ford Madox Brown pointed out in an article for *The Germ,* is

13

* *The Keepsake* was a popular beauty magazine, published between 1827 – 52, where portraits of women were accompanied by coy titles such as 'Pearls of the Boudoir'.

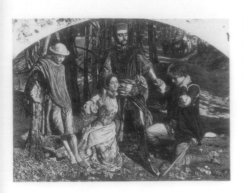

'Valentine Rescuing Sylvia from
Proteus' by William Holman
Hunt
City Museum and Art Gallery,
Birmingham

that they are 'stiff and feelingless, and as such tend to curb the vivacity of a first conception, so much so that the artist may believe an action impossible, through want of comprehension of the model, which to himself or a friend might prove easy'. In their early canvases, this principle worked to brilliant effect. Hunt used his friends James Aspinal and James Lennox Hannay (both barristers) and Elizabeth Siddal as models for his painting of 'Valentine rescuing Sylvia from Proteus'; he also made all the costumes himself. Ironically, Ruskin criticized 'the unfortunate type chosen for the face of Sylvia' (Hunt later repainted this), but according to Ford Madox Brown, who saw the work shortly before it was sent to the Royal Academy in 1851, the painting was breathtakingly vivid, 'without fault and beautiful to its minutest detail'. A host of other such examples could be given: Millais' 'Lorenzo and Isabella', Rossetti's 'Girlhood of Mary Virgin', Hunt's 'Awakening Conscience'. In the case of Hunt the principle was still active long after the Brotherhood had ceased to have a corporate identity. In his painting of 'London Bridge on the Night of the Marriage of the Prince and Princess of Wales' (1863), the crowds on the bridge include many familiar faces: Mr and Mrs Thomas Combe are on the far left of the picture; on a van behind them one can see Millais' father, his brother William and the painter Robert Martineau. Hunt himself appears on the balcony of the Fishmonger's Hall, together with the writer Thomas Hughes, his son and one of Millais' three sons. But this habit of painting only from intimates also had a negative side. It led eventually to an artistic snobbery, involving a close circle of initiates who placed their values in form and finer feelings, deliberately distinguishing between 'them' (the Philistines) and 'us' (the sensitive artists). By asserting his right to choose and by choosing only those who conformed to his own set ideals, the Pre-Raphaelite artist was defiantly cutting himself from the main body politic and declaring himself in a cultural vanguard. Only those who could demonstrate the same subtlety of taste (where taste was no longer the preserve of the titled aristocracy, but an acquisition made through the senses) could be admitted into this avant-garde enclosure. Once they were in, they were able to use as much noise, as much colour, as much wit and as much insolent weaponry as they could to shock and needle the dull mass of society which they had left behind. The aesthetic exclusivity which the Pre-Raphaelites later came to embrace was, in a way, its own religion, where the central creed was a reverence for the exquisite, where its worshippers all worshipped beautiful things and its rituals all tended towards a cult of the self. The culmination of this form of worship is in the 'greenery-yallery Grosvenor Gallery' aesthete, the narcissist and dandy, where the artist is transformed into an *objet d'art,* entirely self-created through his own choice of image and dress.

Tudor House, in Cheyne Walk, was the shrine of the aesthetes. It had been taken on by Rossetti in the autumn of 1862, soon after Elizabeth Siddal's death. The rent was high (£110 a year) and the plan was to share it with two other tenants. Swinburne was the first rent-paying occupant, but lasted only a year. Scenes of his screaming naked down the banister after he had been drinking, or of 'dancing all over the studio like a wild cat', as Rossetti described it, made things impossible. His excesses ended in a nervous breakdown, and he retired to the country to recuperate. When he applied for readmission in 1864, Rossetti refused. George Meredith, the next applicant did little better. The overwrought widower found the sight of Rossetti consuming a plateful of ham surrounded by six runny eggs for breakfast simply too much. He complained; Rossetti threw a cup of tea at him; Meredith departed. But the house continued to attract an exotic coterie: Frederick Sandys, who always appeared in a white waistcoat and patent leather boots, Charles Augustus Howell, William Allingham, Ruskin (who offered himself as a tenant, but was tactfully discouraged), Browning, Ellen Terry, Burne-Jones, Treffry Dunn, Watts-Dunton and Whistler. In this

romantic house, stuffed with blue china vases, pieces of Chinese lacquer and bronze, heavy curtains of Utrecht velvet, Venetian mirrors and chandeliers, musical instruments and all the curios picked up by Rossetti in junk shops in Lambeth and Hammersmith, the celebrants performed their slow dance around the altar of beauty. Local residents invested Rossetti with the status of bogeyman. 'He was only fit to be a bat', opines the Nurse in *A Book with Seven Seals* (an account of a Chelsea family in the 1860s and 1870s) 'and come out in the dusk, flitting up the Walk and in again to hide away from the sun in his great big house, where he painted pictures and kept a lot of poets and other wild beasts . . . She wasn't going to have the children frightened by him'. In the work of these aesthetes, form took on an ever-increasing importance, at the expense of content. Sensation counted most, 'the satisfying beauty of the design', as Oscar Wilde, high priest of dandyism, called it. Pater's desire that one should burn, always, 'with this hard, gemlike flame' was taken to its logical conclusion. Experience itself, rather than the fruit of experience, was the thing. Poetry was less important than being poetical. The languid ladies of Rossetti, Burne-Jones, Simeon Solomon *et al* have a highly-wrought intensity, but it comes from the surface, not from the depths. Their exquisite emotions are exquisitely cultivated, but somehow one suspects that beneath it all the feelings are rather vague. Most people were convinced, however, by this display of beauty. Henry James, often a shrewd art critic, was not. He went to the Burne-Jones' exhibition at the Grosvenor Gallery in 1877, and came away saying that 'it is the art of culture, of reflection, of intellectual luxury, of aesthetic refinement, of people who look at the world and at life not directly, as it were, and in all its accidental reality, but in the reflection and ornamental portrait of it furnished by art itself in other manifestations; furnished by literature, by poetry, by history, by erudition'. The Pre-Raphaelites had strayed a long way from an involvement with real life.

The personal proclivities of the Pre-Raphaelite circle, ranging from impotence and homosexuality to adultery, drug addiction, insanity and tragic or unrequited love, have often been the focus of attention. Indeed their private lives are frequently thought to be more interesting than their pictures. But no group more than they went out of their way to confuse the boundaries of life and art. How else could one explain why Simeon Solomon dressed up in Greek costume, complete with laurel wreath and lyre, sandals and long, flowing green drapery, if not to identify himself with the Greek poets to which Swinburne likened him? Or why Rossetti selected a seed-pearl clasp shaped exactly like his monogram to plant in his models' hair, if not to make some super-claim to his relationship with them? Or why Whistler charged two guineas for his unsigned prints and four for his signed ones, if he did not think his signature of equal value to his work? Time and again one finds that art and reality grow into one another – deliberately in the case of Watts-Dunton's novel, *Aylwin* (where the characters are thinly-veiled guises for the Pre-Raphaelites), unconsciously in the case of Millais' portrait of 'Ruskin at Glenfinlas' where between the start of the painting and its completion the sitter lost his wife to the artist. Like love letters, these portraits reverberate with the complicated intertwining of artist and sitter, sitter and the outside world. In 1848, the Pre-Raphaelites had called for truth and honesty in art, for plain talk. As the century grew older, much of their work became elaborate and remote. In *The Art of England,* written in 1883, Ruskin tried to defend and define Pre-Raphaelitism by saying:

> I must delay you a little, though perhaps tiresomely, to make myself well understood on this point; for the first celebrated pictures of the pre-Raphaelite school having been extremely minute in finish, you might easily take minuteness for a speciality of the style, — but it is not so in the least. Minuteness I *do* somewhat claim, for a quality insisted upon by myself, and required in the work of my own pupils; it is — at least in landscape —

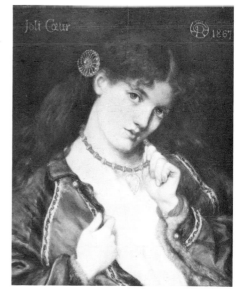

'Joli Coeur' by Dante Gabriel Rossetti
City Art Gallery, Manchester

Turnerian and Ruskinian — not pre-Raphaelite at all: — the pre-Raphaelitism common to us all is in the frankness and honesty of the touch, not in its dimensions.

Ruskin needed to offer this apology. By the 1880s Pre-Raphaelitism had largely lost its frankness, its honesty of touch. Formulas superceded individuals: a melancholy stare here, a pout there, a little fluffing up of the hair, a string of ceramic beads, and hey presto, one had a Pre-Raphaelite beauty. In the burgeoning days of mass-production, soulful stunners were as easy to press from the moulds as the decorative pantiles adorning every cheap villa in every suburban street in England. In the late portraits of Rossetti, Sandys and Burne-Jones, it is no longer truth to nature that counts, but truth to image. Their images became instantly recognisable, and, as such, marketable. It only needed a small step from the canvas to the silver screen, from Jane Morris to Theda Bara, from art to artifice.

Ford Madox Brown

16 April 1821 born in Calais, the son of a half-pay naval officer and his wife Caroline Madox; grandson of the noted Scottish physician, Dr John Brown. *1833* moved with his family to Belgium. Studied first at the Bruges Academy under Albert Gregorius, then at the Ghent Academy under Pieter van Hansel (both pupils of David), and finally at the Antwerp Academy under Gustave Wappers, from *1837-9*. *1840* moved to Paris following the death of his parents. Sent his first works for exhibition at the Royal Academy and married his cousin, Elizabeth Bromley. *1843* birth of his daughter, Lucy. *1844-5* returned to England and entered competition for the decoration of Westminster Hall. Work noted and admired by D.G. Rossetti. *1845-6* visited Rome and met the leading German Nazarene painters, Cornelius and Overbeck. Returned to settle permanently in England, though his wife died on the journey home. *1848* D.G. Rossetti introduced himself as an admirer of Brown's work and became a pupil for a short time; the Pre-Raphaelite Brotherhood was founded, but Brown remained a sympathetic onlooker rather than a member, contributing illustrations and articles for the Brotherhood's literary magazine, *The Germ.* Married for a second time: to Emma Hill. From *1851* began to produce pictures strongly identified with the Pre-Raphaelite group: 'The Pretty Baa-Lambs' (1851),

'Jesus Washing Peter's Feet' (1852); 'An English Autumn Afternoon' (1852-4), 'Work' (1852-65) and 'The Last of England' (1852-5). *1854* birth of his daughter Catherine; *1855* birth of his only son, Oliver. *1856-60* busy with the organisation of various Pre-Raphaelite exhibitions, teaching at the Working Men's College and the founding of the Hogarth Club. Started to acquire wealthy patrons by the end of the fifties. *1861* founder member of Morris, Marshall, Faulkner and Co. for whom he produced designs for a range of applied and decorative arts until *1874*. *1863* produced illustrations for *Dalziel's Bible Gallery*. *1865* held a one-man show in London which led to some prosperity and a modest degree of new patronage. Work became more noticeably influenced by Rossetti. *1874* death of his son; marriage of Lucy to William Michael Rossetti. *1876* Sydney Art Gallery bought 'Chaucer at the Court of Edward III', his first work to enter a public collection. *1878* commissioned by Manchester Corporation to paint a series of twelve works illustrating events in the history of Manchester for the city's Town Hall. *1881-7* lived in Manchester and painted eight murals for the commission; returned to London at the end of 1887 to complete the remaining four works on canvas. *1890* his second wife died. *6 October 1893* the artist died at his home, no. 1, St. Edmund's Terrace, Primrose Hill.

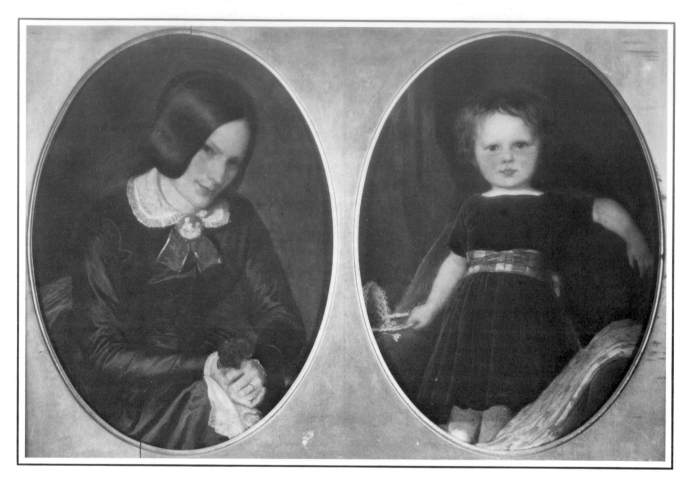

Mrs Madox Brown and Lucy (a pair)

Oil on canvas, 292 × 216 mm each (oval)
Private collection

This pair of portraits, of the artist's first wife and his two-year-old daughter, Lucy, was begun in Rome in 1845. Brown had married his first cousin, Elizabeth Bromley, in 1840, the year he left Antwerp to live in Paris; he was then twenty, his bride twenty-one. They were married in the British Ambassador's chapel in Paris and lived in the city for the next four years. In 1844 they returned to settle permanently in England, a move precipitated by Elizabeth's deteriorating health.

When Elizabeth did not recover, doctors recommended the warmer climate of Rome; the Browns started for Italy in 1845, passing through Basle where Brown could admire the work of Holbein. On his arrival in Rome, Brown met the German painters Cornelius and Overbeck, two of the most prominent members of the quasi-monastic order of German painters living in Rome, the Nazarenes. This brotherhood of artists, a precursor in many respects of the Pre-Raphaelite Brotherhood, was dedicated to the ideals of the regeneration of a national German art. They admired

the early Christian frescoes of Tuscany and attempted to introduce into their own painting something of the spirit of those earlier religious works, in particular their purity of line and clarity of colour. Brown's meeting with the Nazarenes and his reception of their ideas was subsequently to form an important link between the two movements.

After eight months the Browns were forced to return home: Elizabeth was dying of tuberculosis. She died on the journey, in a cab crossing Paris; Brown brought her body back to England, where she was buried in Highgate Cemetery, her grave marked by a monumental cross designed and carved by Brown, and still standing today.

Lucy Madox Brown, who was born in Paris in 1843, was taught to paint by her father and subsequently became a painter herself. In 1869 she began to exhibit watercolours at the Dudley Gallery (a sort of 'Salon des Refusés' founded in 1864, mainly for the exhibition of watercolours and drawings). Her works were romantic in character with subjects such as 'The Duel' and 'Romeo and Juliet'; her modest output dried up after her marriage to William Michael Rossetti on 31 March 1874.

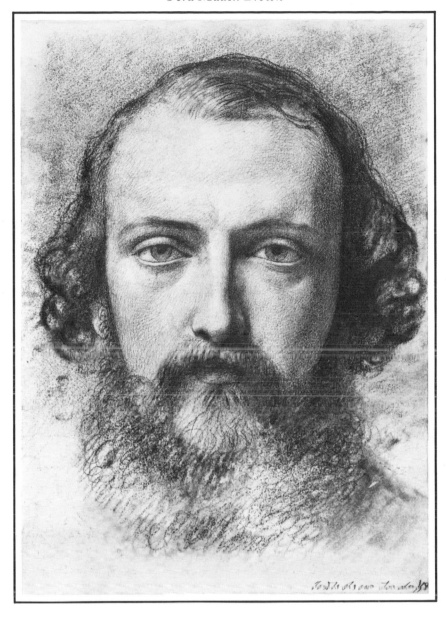

Daniel Casey

Black chalk on paper, 246 × 171 mm
Signed and dated: *Ford M Brown London/48*
City Museum and Art Gallery, Birmingham

Daniel Casey (d. 1885) was one of Brown's oldest and closest friends. Born in Bordeaux of Irish parents, Casey studied with Brown at Antwerp Academy under the fresco painter Baron Wappers. A student prank led to Casey's departure from Antwerp to Paris in 1840, and Brown, who had already begun to establish a practice as a portrait painter in Antwerp, soon followed his friend. In 1846, after the death of his first wife, Brown returned to live in England but Casey stayed in Paris, where from 1842 he had exhibited at the Salon, showing historical pieces such as 'The Amazons of Thermodon' and 'St Louis at Damiette'.

Brown's political sympathies brought him back to Paris in 1848, at the time of the Republican upheavals, and he stayed with Casey for three weeks. In his diary for 17 June 1848, he records spending seven hours working on a portrait of Casey, and this study is probably the result of that session, completed on Brown's return to London. Casey remained in Paris for the rest of his life, but kept in contact with Pre-Raphaelite affairs via the various friends of the Brotherhood who passed through the city. The painter Thomas Seddon (1821 – 56), for example, an old friend of both Brown and Holman Hunt, stayed with Casey in the summer of 1853, before going on to Dinan in Brittany to paint landscapes. Seddon accompanied Hunt on his first visit to the Middle East that same year, spending five months with him in Cairo and a further four months in Jerusalem. On his return from Jerusalem Seddon again stayed with Casey, working up some of his Egyptian landscapes in Casey's studio.

Casey himself remained faithful to academic painting throughout his life, and though his work was bought in small quantities by French provincial museums (the Museum of Auxerre, for example, commissioned 'The Martyrdom of St Hippolytus' from him), he died in poverty. It was Brown who initiated a subscription to assist his widow and children.

19

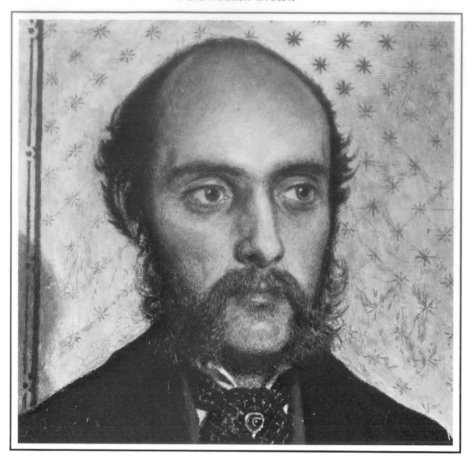

William Michael Rossetti by Gaslight

Oil on panel, 170 × 165 mm
Signed, dated and inscribed: *to WMR 1856 FMB* (initials in monogram)
The National Trust

'A saintly and sweet character whose whole life was given to his family, to providing for their needs and bearing their worries — William, who scarcely allowed himself the right to individual happiness.'

Such was Edith Sitwell's verdict on William Michael Rossetti. Historian, secretary and chronicler of the Pre-Raphaelite movement, William Michael Rossetti was the stolid, reliable counterpart to his imaginative and temperamental brother, Dante Gabriel. Of the four children born to the Rossettis, William Michael and his elder sister Maria were known by their father as 'the calms', while Dante Gabriel and the younger sister, Christina, were called 'the storms'.

William Michael provided dependable and necessary support for his brother throughout his life. His abilities were critical rather than creative and although he wrote some verse (chiefly for the Pre-Raphaelite magazine *The Germ*) and produced some lightweight drawings as a young man, his more prosaic gifts manifested themselves early on. He took on the editorship of *The Germ* in 1850, the year in which he became the unpaid art reviewer for *The Critic.* Though he gradually began to write professionally for journals such as *The Spectator* and *The Crayon* he retained his job as an official in the Inland Revenue Board from 1845 – 94, which provided him with the financial stability from which his brother also benefited.

Besides writing prolifically on the activities of the Pre-Raphaelites and in particular on the work and life of his brother, William Michael produced lucid reviews on contemporary literature: he was one of the first critics to recognise the merit of Arthur Hugh Clough's now most celebrated poem, *The Bothie of Toper-na-fousich*, (reviewed in *The Germ,* no. 1) and he prepared editions of the work of Walt Whitman, Shelley and Blake, as well as editing the Moxon Popular Poets series.

This portrait was begun on 8 November 1856, between 8 pm and midnight (it was subsequently completed in March 1857). It has a momentous, if tenuous, history in the annals of Pre-Raphaelitism in that it was during the painting of this work that Dante Gabriel Rossetti arrived in Brown's studio to announce that he intended marrying Elizabeth Siddal. (The marriage did not in fact take place for another four years.)

William Michael waited another eighteen years before announcing his marriage to Brown's daughter by his first wife, Lucy. He was then forty-five and Lucy thirty-one. As they were both agnostics they married in a civil ceremony, and it was on this occasion that Dante Gabriel wrote to Lucy Madox Brown:

'What return can I ever make now for all that my dear brother gave me so freely in early days, at a time when it is still a mystery to me how he could manage to give at all? To him and to your father I owe more in life than to any other man whatever.'

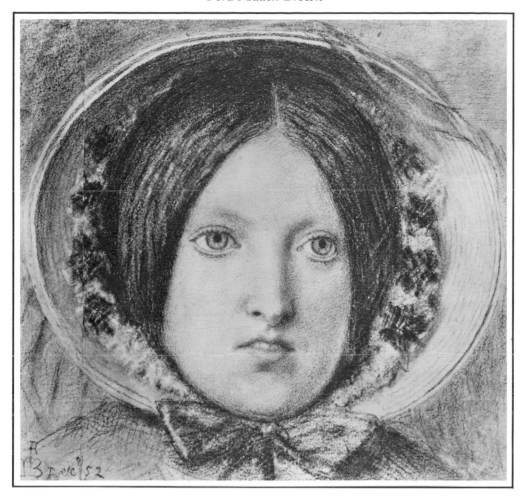

Emma (Study for "The Last of England")

Black chalk on paper, 162 × 175 mm
Signed in monogram and dated. *Dec '52*
City Museum and Art Gallery, Birmingham

Emma Hill was the daughter of a Herefordshire farmer. Brown met her in 1848 during a visit to Stratford-on-Avon where he was at work on a portrait of Shakespeare. Emma, then fifteen, had only a meagre rural education and met with stiff parental disapproval as far as her relations with Brown were concerned. Predictably, under these circumstances, the couple eloped. The honeymoon was spent at Pegwell Bay and they then moved to London, just at the moment when the Pre-Raphaelite Brotherhood was being formally launched.

Emma's youth and her comparative lack of education encouraged Brown to remain silent about his second marriage for some years, until such time as he felt Emma's 'improvement' warranted any publicity about the event. The pattern of this relationship was not uncommon in the Pre-Raphaelite circle. It was repeated by Frederick Shields and the sixteen-year-old Matilda Booth, by F. G. Stephens and his Clara (whom he taught to write) and by Holman Hunt and Annie Miller, Hunt's cockney model whom he hoped to educate and then marry, though as events turned out, he did neither. The faith in progress and the passion for improvement demonstrated by these amours suggests that several of the Pre-Raphaelite circle were far from being the romantic bohemians that legend has made them; they were, rather, upholders of orthodox Victorian views on the reciprocity of moral and social virtues.

This study of Emma as the female emigrant in one of the nineteenth century's most potent images, 'The Last of England', is a reminder of some of Brown's radical political sympathies. For behind this painting of a middle-class couple leaving the shores of England to find work and justice in a new society, is the voice of the philosopher Thomas Carlyle, fulminating against the disorder of contemporary society, its materialism and its increasing mechanicalism. The minute research for visual truth that Brown introduced into both the studies and the finished version of this painting is an equivalent of the atomistic patterns of speech that Carlyle made a peculiarity of his prose style.

Brown's championship of the working classes remained strong throughout his life and there were occasions, particularly later in their married life, when Emma, whose intellectual leanings in political directions were not marked, must have found trying the presence of various revolutionary guests such as Vlokhovsky, Kropotkin and Mazzini at her famed Fitzroy Square evenings. At the time this study was made, Emma would have been nineteen, and pregnant with her first child, Cathy (born in 1854). Her son Oliver was born in 1855.

21

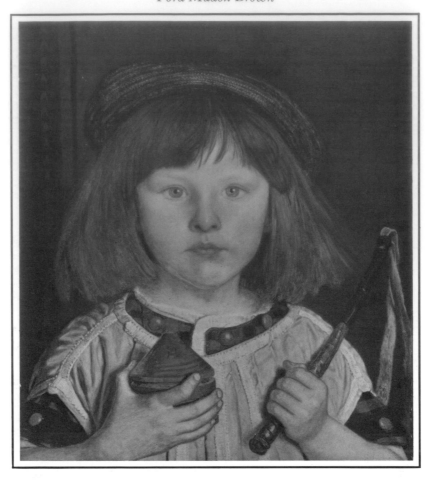

The English Boy (Oliver Madox Brown)

Oil on canvas, 381 × 324 mm
Signed and dated: *F. MADOX BROWN/60*
City Art Gallery, Manchester

Oliver, or 'Nolly', the artist's adored only son, was five when this portrait of him as 'The English Boy' was painted. It was commissioned by Thomas Plint, a stockbroker from Leeds, who also commissioned a companion portrait, 'The Irish Girl', from Brown the same year. (The model for this latter was an orange-girl Brown had come across while he was searching out Irish models for the navvies in 'Work'.)

Precocious and talented, Oliver began to produce accomplished watercolours at the age of ten, and by the time he was fourteen was exhibiting them at the Dudley Gallery. At seventeen, he had written his first novel, *The Black Swan,* published a year later as *Gabriel Denver,* and acclaimed by Brown as a work of great literary merit. In fact Brown's attachment to his son was such that he allowed him to become the touchstone whereby he gauged the friendship of others towards both himself and his family.

'An eccentric boy', in the words of William Bell Scott, Nolly's precociousness was indulged at the Pre-Raphaelite gatherings held in the Browns' Fitzroy Square home, where he would typically appear with white rats clinging to his arms. His work, not without literary interest, vibrates with tenebrous atmosphere and gothic romance, and he counted among his particular friends Samuel Butler, Rimbaud, Verlaine and two habitués of the Brown salon,

the blind poet Philip Bourke Marston and Arthur O'Shaughnessy. Rossetti, too, liked him, and wrote a sonnet, *Untimely Death,* on his tragically early death (from blood-poisoning) at the age of nineteen. He was also immortalised in one of Rossetti's most carefully finished drawings, 'The Sphinx' (1875), an allegorical work showing Youth dying on the threshold of Knowledge. On his own death-bed, Rossetti selected this drawing as the frontispiece to a miscellany of poems to be published posthumously. Typical of the rather exaggerated esteem in which Oliver's literary promise was held is the following critique by James Darmesteter, published in 1896:

'In the limbo of the paradise of poets, the souls of children floating in the mists of dawn, are frail, uncertain visions with little individual feature. The aureole is made of the vague glimmer of the future. They have done little and dreamed much; and in their dreams it is different to see how much is all their own. Mostly they shine by a reflected light. Oliver Madox-Brown is assuredly one of the most vivid, one of the most personal, of these touching phantoms. Chatterton was a prodigy, but rather of assimilation than invention, an echo rather than a voice. Oliver was a voice, a voice still young, broken, uncertain. But he spoke true in his death agony. Had he lived he would have ranked among the great. His qualities were those which cannot be imitated: intensity of vision, dramatic force, power of emotion.'

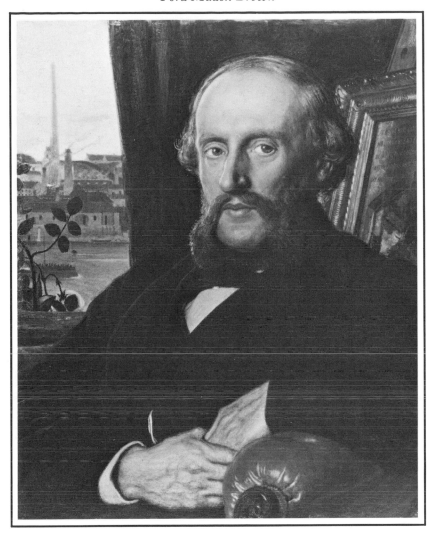

James Leathart

Oil on canvas, 343 × 279 mm
Leathart Family

An industrial magnate, James Leathart was typical of the self-made men who admired Pre-Raphaelite work and became their major patrons. Born in 1820 in Alston, Cumberland, the son of a mining engineer and scion of a family whose men had traditionally worked as lead miners, Leathart was first employed in the lead works in Gallowgate, Newcastle, at the age of fifteen, but quickly rose to become a managing partner in the firm. He was responsible for the expansion of the works to St Anthony's, a view of which is seen in the background of this portrait. By 1891 Leathart had become managing director of the works, and was also director of the Tyne Steam Shipping Company and of the shipbuilders, William Cleland and Co. Leathart's business prowess was coupled with a sense of civic responsibility; he sat on the county bench as JP for Gateshead and was for a short period Mayor of Newcastle. Despite these civic responsibilities Leathart had a retiring nature; his greatest love was for the arts, particularly for music and painting, nurtured through his contact with the painter William Bell Scott, Master of the Art School in Newcastle when Leathart was its Secretary.

In 1859 Leathart purchased Ford Madox Brown's 'Pretty Baa Lambs' and commissioned a replica of 'Work' from Brown; he bought several works by Rossetti, among them 'A Christmas Carol' and 'Sir Galahad at the Ruined Chapel', and he also took over the commission for 'Found' from Francis MacCracken, the shipping agent from Belfast who had first commissioned this painting from Rossetti in 1853. Although Scott advised Leathart on his purchases, and in fact acted as a scout for him when he moved to London from Newcastle in 1864, Leathart was independent enough to buy pictures by men such as Albert Moore, of whom Scott disapproved.

Leathart commissioned this portrait from Brown in 1863, as a pendant to the portrait of his wife painted by Rossetti a year earlier. Brown took care to match the canvas to that used by Rossetti, but qualified his acceptance of the commission with typical humility:

'I will endeavour to make a worthy pendant to Mr D. G. R.'s. With respect to likeness . . . I must say this however, that every human head has several quite distinct characters of likeness to it, quite different from a painted head which has but one.'

Leathart paid sixty guineas for the portrait in January 1864.

23

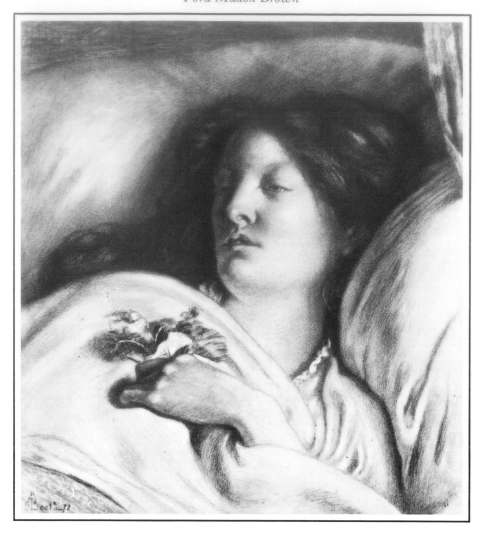

The Artist's Wife in Convalescence

Coloured chalks on paper, 471 × 432 mm
Signed in monogram and dated: *Oct 72*
City Museum and Art Gallery, Birmingham

The year 1872 saw illness in the Brown household. Brown himself suffered from gout, and Emma, approaching forty, contracted a near fatal fever. Mrs Brown's subsequent recovery emphasises with some irony the tragic fate of a young artist from Manchester, Henry James Holding. Holding was a comparatively little-known artist, who in 1871 had received a commission for a painting from Paris. With this commission Holding seemed poised to make his name but, very shortly after his arrival in Paris, he died of typhus. His widow was informed of his death by the arrival of a telegram from the municipal authorities requesting instructions for the disposal of the body. With characteristic generosity Brown set up a fund to help Holding's widow, donating this drawing of his convalescing wife to the appeal.

Another of Brown's preoccupations during 1872 was his candidature for the position of Slade Professor of Arts at Cambridge. He contested the post with Sidney Colvin, a young Cambridge don and art critic who had been brought into the Pre-Raphaelite circle by Burne-Jones in 1870 and to whom Brown eventually lost the chair. An event with a happier outcome that year was the marriage of Catherine Madox Brown, Emma's first child, to Dr Franz Hueffer, the music critic on *The Times*.

Although Ford Madox Brown and Emma both fell ill during 1872, financially this was a prosperous period in their lives. They had moved into a large stone-staircased house in Fitzroy Square in 1865 and for the following ten years held celebrated parties every fortnight at which Pre-Raphaelites of all degrees of intimacy would gather. Emma emerged as a hostess of talent and her salon boasted such literary lions as Turgenev, Mark Twain, Swinburne, Allingham, Edmund Gosse, the blind poet Philip Bourke Marston and his brother-in-law Arthur O'Shaughnessy. Such guests were supplemented by the core of the Pre-Raphaelite group: D. G. Rossetti, Christina and William Michael Rossetti, Holman Hunt, Arthur Hughes, Woolner, Morris and Burne-Jones; and by musicians such as Theophidus Marzials and Franz Hueffer. Mrs Howitt, a writer and journalist, and an old friend of Rossetti, attended one such Pre-Raphaelite 'crush', and described it as being 'very curious, like some hot, struggling dream, in which the gorgeous and fantastic forms moved slowly about'. She confessed that she found the 'uncrinolined women with their wild hair very beautiful, their picturesque dresses and rich colouring like figures out of the Pre-Raphaelite pictures'.

24

Edward Burne-Jones

28 August 1833 born in Bennett's Hill, Birmingham, the son of a modest picture-framer and gilder. His mother died shortly after his birth, his only sister in infancy. *1844-52* attended King Edward's School, Birmingham, where he was influenced by Puseyite doctrine (particularly after the arrival of Newman at the Birmingham Oratory in 1849), and decided to read for the Church. *1853* went up to Exeter College, Oxford, as a student of Divinity. There he met and formed a lifelong friendship with William Morris. *1854* saw Pre-Raphaelite paintings for the first time: Millais' in Oxford, Hunt's at the Royal Academy. *1855* saw Rossetti's illustrations to William Allingham's poems for the first time and was deeply impressed. Toured the cathedrals of Northern France with Morris and on his return home made the decision to dedicate his life to art, 'the most memorable night of my life'. *1856* met Ruskin and Rossetti in London, decided to leave Oxford without his degree and settled in London. Took some 'informal' classes from Rossetti and attended evening classes at Leigh's life class. *1856-8* shared rooms with Morris in Red Lion Square; *1857* participated in the painting of the Oxford Union Murals. *1859* visited Italy for the first time and began teaching at the Working Men's College. *9 June 1860* married Georgiana Macdonald. *1861* founder member of Morris, Marshall, Faulkner and Co.; birth of his son, Philip. *1862* toured Northern Italy with Ruskin. *1863* commissioned by the Dalziel Brothers for illustrations to their Bible.

1864 became an associate of the Old Water Colour Society, where he exhibited 'The Merciful Knight' to great critical hostility, although he began to attract the notice of patrons such as William Graham (Liberal M.P. for Glasgow) and Frederick Leyland, the Liverpool ship-owner. *1866* birth of his daughter, Margaret. *1867* moved to The Grange, North End Lane, Fulham, and began a romantic relationship with Maria Zambaco. *1870* resigned from the Old Water-Colour Society in protest over the criticism of indecency hurled at his entry for the year, 'Phyllis and Demophoon' *1877* exhibited at the newly opened Grosvenor Gallery, where his work was greeted with acclaim. He began to be regarded as a leader among the aesthetic set; his painting, 'The Golden Stairs' (1880) was the inspiration for Gilbert's opera, *Patience. 1878* showed 'The Beguiling of Merlin' at the Exposition Universelle Paris, and began to acquire an international name. *1883* made an honorary fellow of Exeter College, together with William Morris. *1885* became President of the Birmingham Society of Artists and accepted associateship of the Royal Academy. *1889* awarded the French Cross of the Legion of Honour. 1892-3 a retrospective exhibition held at the New Gallery. *1894* created a baronet. *16 June 1898* died at his home; a memorial service was held in Westminster Abbey on *23 June,* the first time a painter was so honoured. His ashes were buried in Rottingdean church.

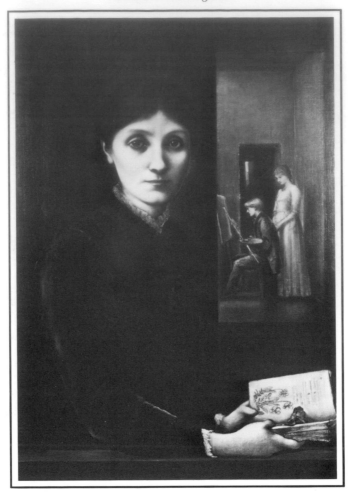

Georgiana Burne-Jones

Oil on canvas, 787 × 535 mm
Private collection

Georgiana Burne-Jones was one of eleven children born to the Methodist minister of Handsworth, Birmingham, George Browne Macdonald. All four of the sisters who married made interesting alliances: Alice became the mother of Rudyard Kipling; Louisa produced Stanley Baldwin; Agnes married the painter Edward Poynter and Georgiana, after an engagement of four years, married Edward Burne-Jones in Manchester Cathedral on 9 June 1860 (the anniversary of the death of Dante's Beatrice). Georgiana's emotional strength supported her well through the various crises of her marriage.

During the period of gradual estrangement from his own wife, William Morris began to visit the Burne-Jones' regularly, breakfasting with them on Sunday mornings and often staying the whole day. It was then that Morris found in Georgiana the sympathetic listener that Burne-Jones found in other women. Morris' letters to Georgie have a warmth and an unguardedness not found in his letters to his own wife; in gratitude he presented Georgie with two works of manuscript illumination: *A Book of Verse* in 1870 and an edition of *The Rubaiyat of Omar Khayyam* two years later.

Basically a practical, vigorous woman despite her frail figure, Georgie plunged into active political work in later life, standing as a member for Rottingdean Parish Council, an activity which Morris applauded but which Burne-Jones found wearisome.

This cool, still portrait of Georgie, begun in 1883, shows the two children of the marriage, Margaret and Philip, framed by the doorway. In her hands Georgie holds Gerard's *Herbal,* its pages held open by a bunch of heartsease. The *Herbal* describes heartsease as a flower which 'groweth in fields and in gardens also, and that oftentimes of itselfe; it is more gallant and beautiful than any of the wild ones'.

Also in 1883 Burne-Jones began the first of a series of tiny watercolours, each one bearing the common name of a flower: each watercolour was given to Georgie as it was finished, and the complete series of thirty-eight was eventually bound as *The Flower Book.* An entirely personal symbolism takes shape in these works: each one bears the title of a flower such as 'Morning Glory', 'Meadowsweet' or 'Golden Cup', but no botanical specimens are to be seen. Instead, the name of the flower acts as a trigger for the artist's imagination, so that 'Meadowsweet' shows Arthur in Avalon, while 'Golden Cup' shows a knight dying in pursuit of the Holy Grail. This development of a personal symbolism to some extent signals Burne-Jones' increasing withdrawal from conventional frames of reference, a retreat perhaps from the disappointments of his personal life too.

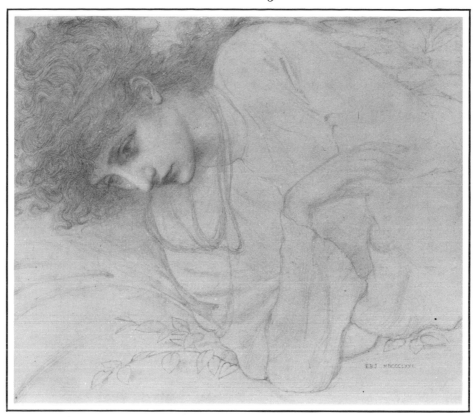

Maria Zambaco

Pencil on paper, 330 × 368 mm
Signed and dated: *EBJ.MDCCCLXXI*
Private collection, London.

Burne-Jones' involvement with Maria Zambaco, lasting from 1867–71, came close to breaking his marriage. Born in Athens in 1843, the daughter of a wealthy but shady cotton merchant, Maria was brought to England by her mother when her father, 'Hadji' Cassevetti, died in 1858. They sheltered under the wing of their relatives, the Ionides family. Alexander Ionides was then Greek Consul General in London, an interested patron of the arts and host to many artists at his home in Tulse Hill: among them Rossetti, Whistler, Du Maurier and G. F. Watts. When he moved to 1 Holland Park in 1864, the house was decorated by Philip Webb, William Morris and Walter Crane. Known collectively as 'The Greeks', the families of Ionides, Cavafy, Spartali, Cassevetti, Homeres and Sechiaris were all generous patrons, and members of the clan surface frequently in diaries and letters of the period in connection with artistic enterprises.

Maria was passionate and obstinate, 'rude and unapproachable but of great talent and really wonderful beauty', wrote George Du Maurier. Despite family opposition, she married a kind but dull physician, Demetrius Zambaco, in 1861, and lived with him in Paris where he was a physician to the Greek community. She left him in 1866 and moved back to the artistic circles of London. Independent (her father had left her £80,000), a good sculptress and medallist, and beautiful indeed (she was described as having 'glorious red hair and almost phosphorescent white skin' by her cousin Luke Ionides), she captivated Burne-Jones when she was taken to his studio by her mother. A certain vulnerability made her especially appealing to Burne-Jones who, as Georgiana observed, was affected by two qualities in particular 'beauty and misfortune and far would he go to serve either'. For Burne-Jones, Maria was 'like the billows of the sea', and his obsession with her, though it exhausted him emotionally, gave rise to a series of portraits unique in his work. The beautiful head, of which 'neither profile was quite like the other — and the full face was different again', looks poignant and fragile in these drawings. By 1868 he had attempted to break his relationship with her. In January 1869 she made an attempt to throw herself off Regent's Canal bridge, but she was frustrated by the arrival of the police.

Rossetti wrote to Ford Madox Brown on the subject in January 1869, distressed for both parties:

> 'Poor old Ned's affairs have come to a smash altogether, and he and Topsy [William Morris], after the most dreadful to-do started for Rome suddenly, leaving the Greek damsel beating up the quarters of all his friends for him, and howling like Cassandra. Georgie stayed behind. I hear to-day, however, that Top and Ned got no further than Dover. . . . She [Maria] provided herself with laudanum for two at least, and insisted on their winding up matters in Lord Holland's Lane. Ned didn't see it, when she tried to drown herself in the water in front of Browning's house &c. — bobbies collaring Ned who was rolling with her on the stones to prevent it, and God knows what else.'

Maria Zambaco

Opposite:
Gouache on paper, 763 × 550 mm
Signed, dated and inscribed: *Mary Aetat XXVI August 7th 1870 EBJ pinxit*
Clemens-Sels-Museum, Neuss, West Germany

Maria's attempted suicide of 1869 left Burne-Jones nervous and depressed but no more capable of breaking with her than before. That he still loved her is apparent from the large number of portraits he made of her between 1869 – 71. For the most part they are pencil drawings, precise and sharply drawn and without sentimentality, but at the same time exquisite evocations of Maria's unhappy love for the artist. In 1869 Burne-Jones asked Rossetti to paint a portrait of Maria for him, so that he could see her face by another hand. Rossetti agreed and was sympathetic to Maria, as he wrote to Jane Morris the following year:

> 'I like her very much and am sure that her love is all to her. She is really extremely beautiful when one gets to study her face. I think she has got much more so within the last year with all her love and trouble.'

Burne-Jones was more than grateful to Rossetti for taking on the task, particularly as it came at a time when Rossetti was busy preparing the publication of his poems, which came out in April 1870. Burne-Jones wrote to Rossetti to thank him, and the obvious agitation in his letter and the reference to what he had believed to be, at one time, 'all my future life', clearly show the strength of his attachment to Maria:

> 'I didn't bore you the other day, did I? It is hard not to behave quite badly — but all that portrait-making excited and exhilarated me and made me silly — I was so glad to have such a portrait, and for you to know her a little better — if ever so little — I thought you had little sympathy for me in the matter, before — and as I believed it all my future life this hurt me a bit. I can't say how the least kindness from any of you to her goes to my heart. Before you send it home let me have a frame made that has a door in it that locks up, and that I may return an evasive answer to an inquisitive world.'

Georgiana Burne-Jones took the matter with forbearance for as long as possible, but by 1869 was spending much of her time in the home of her family, leaving Burne-Jones alone to work at such paintings as this portrait of Maria, entitled 'An Allegorical Portrait', commissioned by Maria's mother, Euphrosyne Cassevetti. Maria's dress is of deep sea-green silk, and she holds in her hand iris and white dittany, respectively the emblems of 'a message' and 'passion' in the Victorian language of flowers. Cupid draws back the curtain, symbolising the presence of Venus, and Maria's arms lie across the pages of a book, open at a miniature of Burne-Jones' own work, 'Le Chant d'Amour'. Burne-Jones' first version of this work was called 'Blind Love' and was inspired by the lines from the troubadour song,

> *'Hélas! Je sais un chant d'amour*
> *Triste ou gai, tour à tour'.*

The arrow which lies untouched and isolated before her carries a paper with the letters '*E. B. J. 1870*'.

After the eventual demise of their relationship, Maria took up her work as a painter and medallist, first in Paris and later in London, where she achieved a modicum of success.

28

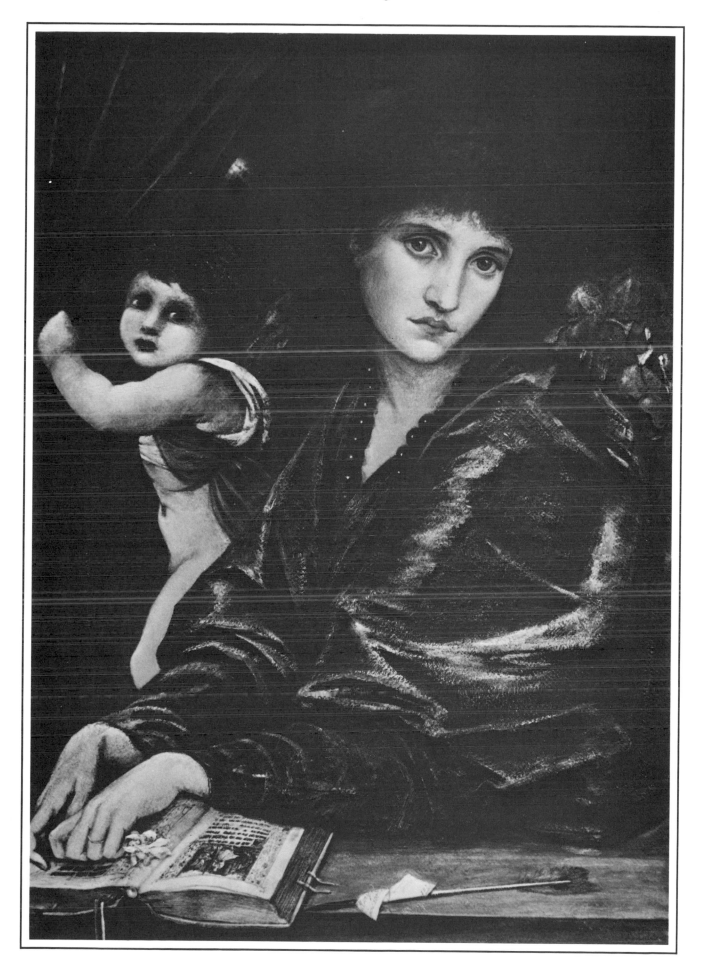

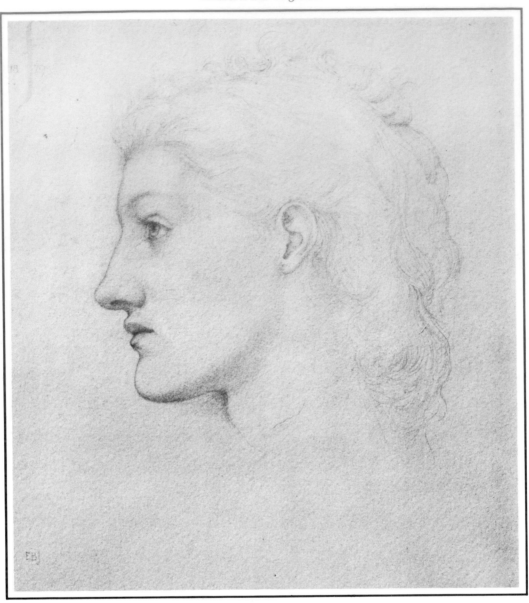

Frances Graham

Pencil on paper, 267 × 288 mm
Signed: *EBJ*
Private collection

Frances Graham was the daughter of one of the staunchest Pre-Raphaelite patrons, William Graham, an India merchant and Liberal MP for Glasgow. Graham began to buy Pre-Raphaelite work in the late 1860s, commissioning 'Dante's Dream' and a portrait of Jane Morris from Rossetti in 1869. Graham was more than a patron: he was a friend to many of the artists whose work he purchased, and made social visits to their homes. One such visit with his daughter Frances to Burne-Jones' home, The Grange, in North End, Fulham, prompted a relationship between Frances and Burne-Jones that lasted for over thirty years. The affection which developed between them coloured the whole of Frances' life, and certainly touched depths of the artist's feeling which few other relationships satisfied. She features frequently as a model in Burne-Jones' work: for example as the bride in 'The King's Wedding' and as Eurydice in 'Orpheus and Eurydice'.

Although Burne-Jones wrote constantly to Frances, maintaining a fiction with her that one day they would run away and live 'dishonoured in lodgings' (a phrase she reminded him of in 1898), he was upset when she eventually married a barrister, John Fortesque Horner, in 1883. He could not bring himself to write to her for a year after her marriage, but he did manage to correspond with Ruskin at the time, to talk about the many designs he had made for her and from her:

> 'Sirens for her girdle, Heavens and Paradises for her Prayer books, Virtues and Vices for her necklace-boxes — ah! the folly of me from the beginning — and now in the classic words of Mr Swiveller ''she has gone and married the gardener''. Well, I can't remember a tithe of the folly there.'

Frances wrote her own account of her relationship with Burne-Jones in *Time Remembered,* published in 1933.

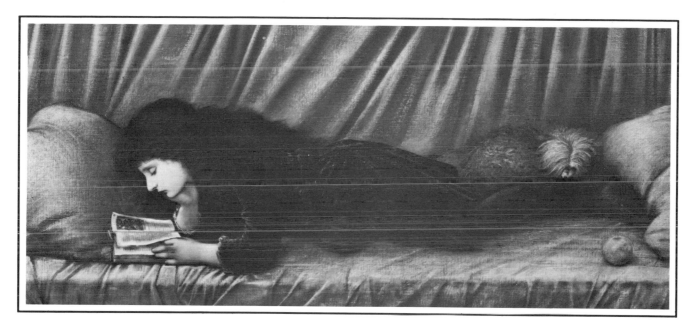

Katie Lewis

Oil on canvas, 600 × 1270 mm
Signed and inscribed: *ERJ to GBL*. Dated on the pages of the book:
1886
Private collection

Katie Lewis was the youngest daughter of Sir George Lewis, an eminent solicitor, and both friend and lawyer to Burne-Jones. Lewis was born in the same year as Burne-Jones (1833) but being Jewish he was not allowed entry to Oxford; instead he was articled as a clerk to a firm of solicitors run by an uncle. Specialising in cases of fraud and commercial libel, Lewis soon built up an extensive practice. An exemplary poor man's lawyer, he prepared Whistler's bankruptcy petition and also acted for the defence in several society scandals. Burne-Jones befriended Lewis' youngest daughter shortly after the disappointment of Frances Graham's marriage.

Such friendships between celebrated men in their early middle age with assertive young girls have a familiar ring: Lewis Carroll with Alice Liddell, Ruskin with Constance Hilliard and his romance with his 'mouse-pet', Rose La Touche. This was the time of fairy tales (Charles Kingsley's *Water Babies*) and fairy paintings (Richard Dadd's 'The Master Fairy Feller's Stroke'), for as William Empson lucidly commented on the Victorian condition, 'the world of the adult made it hard to be an artist'.

After Lewis' second marriage to Elizabeth Eberstadt in 1867, the Lewis home became a centre for London's artistic community. This portrait of Katie was commissioned by Lewis and begun in 1882. Katie is outstretched on Burne-Jones' studio couch, her face displaying some of the acerbity that made her a 'trenchant critic of life', as Oscar Wilde described her to her mother before she was ten years old. During the two years that he spent working on the portrait, Burne-Jones wrote a series of letters to his young friend published in 1925 as *Letters to Katie*. Illustrated with scenes of butterfingered waiters letting drop the tea-tray, or plump piglets nuzzling up to a sow, these letters also show that Katie stirred Burne-Jones' fears of growing old and losing touch. He represents himself as an untidy gauche figure — trying to join the world of art by putting his foot through one of his own canvases or being taught to dance by a winsome girl which only accentuates his own clumsiness in 'polite society'.

The portrait of Katie delighted Lewis, and it was hung over the mantle of the drawing-room fire in his Portland Place home. In the studio diary kept by Burne-Jones' assistant, T. M. Rooke, Burne-Jones noted how pleased Lewis was with this portrait and also reported how this adroit lawyer was himself made inadequate in his attempt to thank the painter:

> 'Although he knew how to hang half the Dukes and Duchesses in the kingdom he couldn't think how to thank me. He fidgeted about and finally gave me as many boxes of cigars as he could lay hands on.'

31

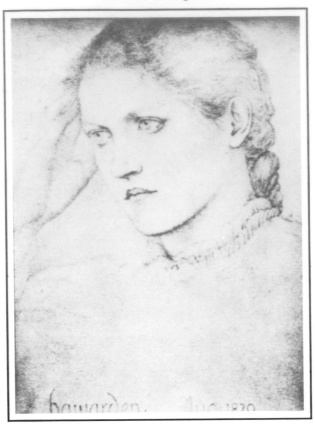

Mary Gladstone

Pencil on paper, 260 × 210 mm
Private collection
Inscribed: *Hawardern Aug 1879*

Born in 1847, Mary Gladstone was the fifth of William Gladstone's eight children and was perhaps the only female confidante of Burne-Jones not to have been blessed with lovely looks. She was, however, frank, sensible and direct and remained a loyal and doughty friend of the artist until his death. Mary had been introduced to Burne-Jones in 1874 by Frances Graham, and she gradually brought him into the society of her family and friends at Hawarden Castle. He was there in 1879, but shunned the throng of people gathered in that brilliant house, preferring to lie outside where 'there was such a depth of green and bright, breezy weather', as Mary confided to her diary, that the time was spent 'mostly lying on the grass under the trees while Mr B. J. drew and I sat to him and an ideal portrait he made'.

A good musician, Mary never properly exploited her abilities. The Gladstone sons were educated at Eton and Oxford; Mary, with her evident musical gifts, never received the disciplined support which might have enabled her to be a pianist of professional standing. But she was positive, energetic and determined, and when she became her father's unofficial secretary in the 1880s, she was regarded by several political figures as a formidable member of the Gladstone entourage. She took charge of the social and domestic arrangements at 10 Downing Street and held special responsibility for the ecclesiastical appointments within her father's ministry. Mary Ponsonby, wife of Queen Victoria's private secretary, travelled with Mary to Germany in the 1870s and described her as 'difficult to know; she was certainly not commonplace, a capital musician, and a kind of latent force about her reminding one of her father'. Mary's forcefulness failed, however, to win the support of her father over the question of female suffrage. Gladstone had opposed several attempts to introduce amendments in favour of votes for women during his years as Prime Minister, including one to his Franchise Act in 1884. Mary tried hard to convert her father to her own ardent championship of votes for women, but failed: Gladstone held that the theory might be good, but that the practice would prove harmful to women. At the end of 1885 Mary surprised her family by becoming engaged to an unassuming curate, eight years her junior. As a woman of thirty-eight, she was considered a confirmed spinster, and Harry Drew, her fiancé, seemed to have inspired nobody but Mary. 'A *small* marriage', was the dry comment made by Eddy Hamilton, Gladstone's private secretary on hearing of the event. In fact, it turned out to be a marriage of real happiness, and Burne-Jones for one recognised the virtue of being 'out of the great world at last', as he wrote to Mary, congratulating her on her engagement. He was, in theory, now against the notion of marriage, as he lamented to Mrs Gaskell: 'Ah me I do hate marriage and I think it a wicked mechanical device of lawyers for the sake of property and such beastliness.' On the other hand he hated just as much the country-house life in which Mary had grown up and recognised that she too would be glad of the escape to a quieter and more private way of life.

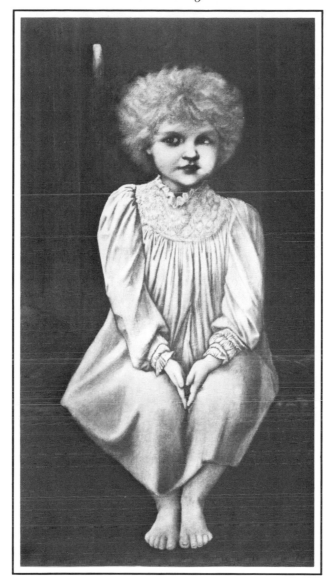

Dorothy Drew

Oil on canvas, 740 × 430 mm
Private collection

Dorothy Drew was born on 11 March 1890, the only child of Mary Gladstone, then aged forty-two. Mary's only other child, a boy, had died at birth four years earlier. 'Dossie', as she was known, grew into a sturdy, cherubic figure, with a head of uncontrollable golden curls, the apogee of delectable childhood. She was constantly requested by photographers to pose with her grandfather, William Gladstone, and the resulting shots of the Grand Old Man and his impish wild-haired granddaughter — Sagacity and Innocence — were bought by the public in their thousands.

Burne-Jones had a talent for friendship with children, and in particular young girls. Inordinately fond of his granddaughter, Angela Mackail (later to become the novelist Angela Thirkell), he portrayed her as the stubby angel in the predella to the three-light stained window he designed for Rottingdean in 1893, windows which he dedicated to his only daughter, Margaret. He was solicitous in his friendship for two aristocratic sisters he taught to draw, Olive and Mary Maxse, and it was to Olive that he wrote wryly later in the 1890s, 'I have been a bad man and sorry for it, but not sorry enough to try to be a good one'. Mary Gladstone's daughter was another of his favourites. His work list of 1893 contains four portraits, including one of Dossie which was to be a present from Mary and her husband Harry Drew to William Gladstone. Dossie, however, only three years old at the time, proved an exasperating, impossible sitter, so much so that Burne-Jones was reduced to having photographs of her taken in Kensington, so that he could work from them, a practice he rarely employed. He apologised to Mary in a letter, but explained the circumstances after one agonising sitting:

'What a day!!! What a morning — and you left me to it, and neither came to help nor sympathize. [A drawing of a child who is a whirlwind and windmill combined in one is inserted here.] And that's all I've done today: ask the nurse. In the main I must do it from memory — a sort of impressionist work — and you will be horribly disappointed, and I shall suffer exceedingly; but that is the only way.'

33

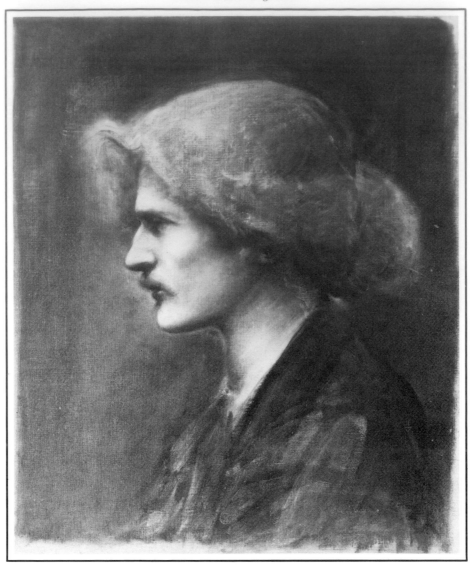

Ignace Paderewski

Oil on canvas, 609 × 508 mm
Royal College of Music, London

In May 1890 three London piano recitals were announced by the Polish musician, Ignace Paderewski: they were to be held in Old St James' Hall. Paderewski, aged thirty, was already an acclaimed musician, though Burne-Jones had not seen him before. Burne-Jones was fond of music: not only was he an innovator in piano design, but he frequented the private concerts of the Dolmetsches and Henschels.

Paderewski was lionised when he came to London. His godmother, Lady Barrington, introduced him to society figures such as Lord Balfour and Henry James; one of the social necessities was to sit for one's portrait and Paderewski was duly taken to Burne-Jones. Paderewski, however, maintains in his *Memoirs* that the portrait was the result of a far more extraordinary meeting between the two men:

> 'Burne-Jones, it seems, passed while walking serenely along the street one day and after a moment of swift and astonished contemplation, of which I was quite unconscious, he walked on a few steps, then hurried back and passed me for a second time for another swift look, then turned abruptly and returned to his studio in hot haste proclaiming upon arrival that he had seen an Archangel — an Archangel with a splendid halo of golden hair, treading the London pavements! That he must put his Archangel on paper at once, that he must draw that halo from memory before the image faded. Ah, that was my hair, you see, for there were quantities of it in those youthful days and it looked then exactly as it does now in his famous drawing.

> And now for the dénouement, the climax of the story. When I was taken to his studio a complete stranger, a few days afterward, he was so surprised at the sight of me on his threshold, that he greeted me with a shout of delight — ''My Archangel'', he cried and without another word set to work immediately to complete his drawing, while I stood silent and mystified until it was explained to me later on.'

Paderewski also relates that Burne-Jones drew very quickly, making four or five sketches of him in the space of two hours, but this oil painting was never completed.

34

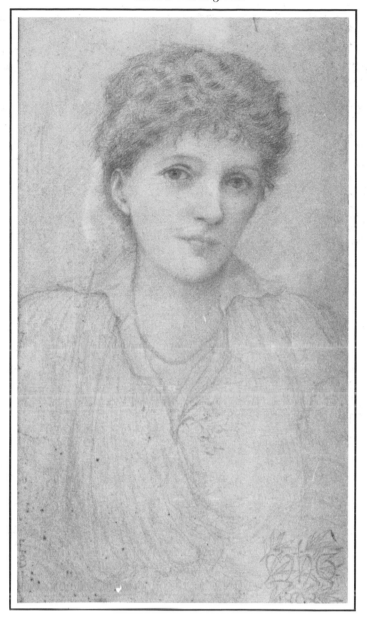

Mrs Gaskell

Pencil on paper, 432 × 245 mm
Signed, dated and inscribed: *EBJ HMG 1898*
Private collection

Mrs Helen Mary Gaskell, born in 1858 and known as 'May', was the daughter of Canon Melville of Worcester. She had married a Captain Gaskell of the Ninth Hussars, who had been in the Middle East with Holman Hunt, and they had two grown children by the time she was introduced to Burne-Jones by Frances Horner in 1892. Frances Horner was one of several beautiful young women for whom Burne-Jones developed tender sympathies and whom he enlisted as both confidante and Muse — 'Souls' as he called them. Mrs Gaskell, too, was a 'Soul'. Sir William Harcourt's remark that all he knew about Souls was that they had very beautiful bodies, would not perhaps be misplaced in the case of Mrs Gaskell. Though of considerable means (she owned three substantial properties: Beaumont in Oxfordshire, Kidlington Hall in Lancashire and a London home at Cumberland Gate), Mrs Gaskell had not, according to Burne-Jones, encountered spiritual and artistic beauty; he set about remedying this. For her part, she touched Burne-Jones deeply and, though he was fifty-nine when he met her, and painting with diminishing energies, she made him feel alive and responsive in a way which made him exclaim that she touched 'the root of the well of loneliness that is in me'.

Between 1892 and 1895, Burne-Jones wrote frequently to Mrs Gaskell, grateful and passionate letters, such as the one dated 26 October 1894, where he declares:

'I suppose I have learned my lesson at last . . . the best in me has been love, and it brought me the most sorrow but it has this supreme excellence, that in its sight no mean thing can exist.'

This portrait of her, painted in 1898 — the last Burne-Jones produced — shows Mrs Gaskell wearing lilies-of-the-valley. In the Victorian language of flowers, lilies-of-the-valley signify 'love revived'.

James Collinson

1825 (?) born in Mansfield, Nottinghamshire, the son of a well-to-do bookseller. He worked as an illustrator during his youth and in *1847* entered the Royal Academy schools, exhibiting 'The Charity Boy's Debut' in the Royal Academy the same year. The painting so impressed Rossetti that he sought Collinson's friendship and in *1848* had him formally elected a founder member of the Pre-Raphaelite Brotherhood. Two of Collinson's Pre-Raphaelite pictures show strong leanings towards Catholicism: 'Italian Image Makers at a Roadside Alehouse' (1849) and 'The Renunciation of Queen Elizabeth of Hungary' (1851), based on Kingsley's story of *The Saint's Tragedy.* As a young man, he had been encouraged by Cardinal Wiseman to become a Catholic and throughout his early life he suffered religious doubts. *1850* contributed *The Child Jesus,* a devotional poem, to the February issue of *The Germ,* as well as the etched frontispiece. Renounced Catholicism to become engaged to Christina Rossetti but resigned both his membership of the Brotherhood and his engagement in *1850,* when he returned to Catholicism. *1852* entered Stonyhurst as a Jesuit novice. *1854* left Stonyhurst and returned to London as a genre painter, showing works such as 'The New Bonnet' and 'Good for a Cold' at the Royal Academy where he exhibited regularly until 1870, and at the Society of British Artists, of which he was a Fellow until *1880.* He married the daughter of John Rogers Herbert, another Catholic convert, and after *1854* lived a very retired life, passing out of memory of nearly all his old associates. He died on *4 January 1881.*

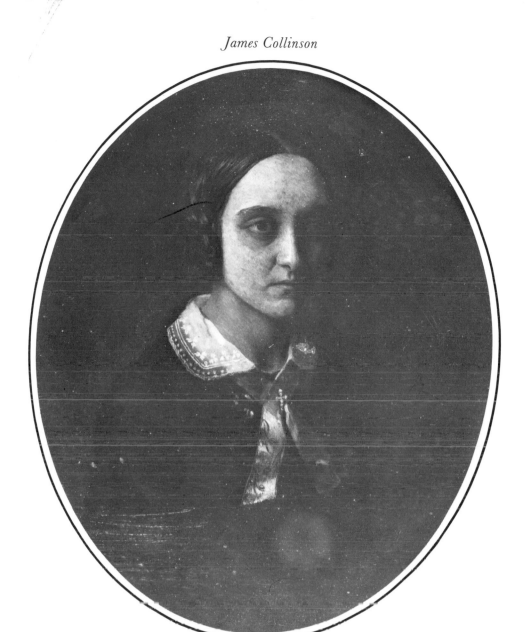

Christina Rossetti

Oil on canvas, 185 × 155 mm (oval)
Signed: *J. Collinson P.R.B.*
Private collection

James Collinson was a contemporary of Rossetti, Hunt and Millais at the Royal Academy schools and it was due to Rossetti's impulsive enthusiasm for his work that he was propelled into the Pre-Raphaelite Brotherhood. He was consequently introduced to the Rossetti family and fell in love with the younger of the two daughters, Christina. Christina was seventeen at the time, a devout Anglican and already a masterful poet. Her contributions to *The Germ*, published shortly after her friendship with Collinson began, already expressed the sense of resignation and denial that are the hallmark of her work. Self-denial was the keynote of her romance with Collinson. She rejected his first proposal of marriage on the grounds of their religious difference: Collinson had converted to Catholicism shortly before joining the Pre-Raphaelite Brotherhood. He reverted to Anglicanism, and for a year, between 1849 – 50, the couple were engaged. They were undoubtedly mis-matched. In the words of William Michael Rossetti Collinson was:

> 'a meek little chap . . . a small thick-necked man, chiefly a domestic painter, who began with careful and rather timid practice; in demeanour modest and retiring . . . he could rarely see the fun of anything, although he sometimes laughed in a lachrymose manner.'

He was noted especially for his sluggishness and timorous nature. Christina was quick-witted and astringent. One can only speculate that had she been presented with conditions where her mind had been properly sharpened, her poetry would not repeatedly sound the notes of self-abnegation. Certainly she needed a mind a great deal more stimulating and more energetic than that of Collinson to vivify her sentiments. As it is, the negative qualities of her verse, its morbidity even, suggest the lack of any channels into which aggressive, active impulses could run, and her poetry settles into resigned acceptance, depression and a yearning for death. It is rare to find in her work writing where these introvert feelings are overcome and allowed to flower into joy.

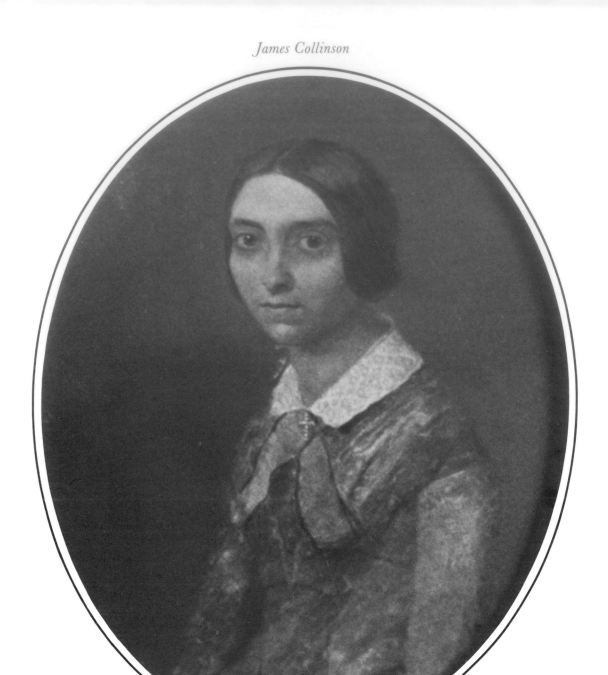

Maria Rossetti

Oil on canvas, 160 × 190 mm (oval)
Private collection

Maria Francesca Rossetti was born on 17 February 1827. The first of the four Rossetti children, Maria promised to be the most erudite of the brood. She had a good memory and intellectual curiosity, and by the age of five could read both English and Italian fluently. She also taught herself Greek when her two brothers learned it at school, and her love of *The Iliad* prompted the eleven-year-old Dante Gabriel to draw twenty-seven illustrations to the different books as a present for Maria (Private collection). Reflecting later on his two sisters, Dante Gabriel said that his older sister was 'the *Dante* of our family. Maria was a born leader; Christina a born apostle. In my boyhood I loved Maria

better than anyone in the world.'

Maria became a governess in the home of Lady Charles Thynne in the early years of the 1850s, but hated it. 'I hope you told Lady Charles that poor Maggy is not to be bullied and badgered out of her life by a lot of beastly brats', wrote Dante Gabriel to his mother. She returned shortly afterwards to the home in Charlotte Street, from where she and her mother set out to give daily Italian lessons in the homes of private pupils. After the death of her father she became the authority on correct Italian within the family and a scholar of Dante. She wrote several pedagogic works and religious papers, and in 1871 published *A Shadow of Dante,* an exploration of Dante's universe. Like Christina she was a devout Anglican and two years before her death entered an Anglican sisterhood.

Lowes Cato Dickinson

27 November 1819 born in Kilburn, the son of a stationer and publisher of lithographs. He was educated at Topsham school (Devonshire) and Dr. Lord's school in Tooting, before joining his father in his print business in a shop in Bond Street. It was this connection that led to his meeting the Rossetti brothers, and though not formally admitted to the Pre-Raphaelite Brotherhood, he was present at many of their earlier meetings and social gathcrings. *1848* began to exhibit at the Royal Academy and to establish a name as a portraitist. *1850-53* lived in Italy with the support of a wealthy benefactor; on his return to England he took a studio next to Millais in Langham Chambers. He was keenly interested in social reform and together with F.D. Maurice, Charles Kingsley, Tom Hughes, John Malcolm Ludlow and Llewelyn Davies formed the Christian Socialists. One important outcome of this association was the foundation of the Working Men's College, where Dickinson taught drawing in its early days, together with Ruskin and Rossetti. He painted the portraits of Maurice, Kingsley and Hughes for the walls of the college, as well as a further three portraits of those men in *1858* for the publisher, Alexander Macmillan. *1857* married Margaret Ellen, daughter of William Smith Williams, who, as reader to Smith, Elder and Co. discovered the Brontes. *1860* active in the formation of the 'Artists' Volunteers Rifle Corps'. He achieved considerable celebrity as a portrait painter, notably among politicians and social reformers: Thomas Hare, the Inspector of Charities, Richard Cobden, the political reformer, Gladstone, Lord Cairns, John Bright and Dean Stanley all sat for him. *15 December 1908* died at his home in Hanwell; he was buried in Kensal Green cemetery. His seven children founded the 'Lowes Dickinson Memorial Studentship' at the Working Men's College in his name, designed for the study of art abroad. His youngest son was the Cambridge philosopher and writer, Goldsworthy Lowes Dickinson.

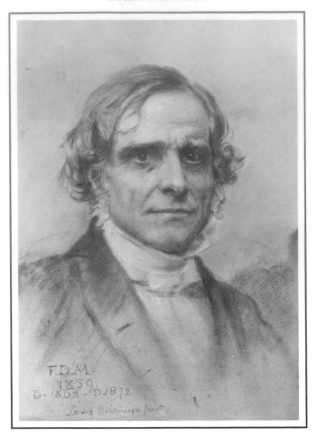

Frederick Denison Maurice

Coloured chalks on paper, 342 × 267 mm
Inscribed: *F.D.M./1859/Lowes Dickinson fecit*
Richard Ormond

'No man, I think, will ever be of much use to his generation who does not apply himself mainly to the questions which are occupying those who belong to it.'

Maurice's words to Derwent Coleridge were echoed throughout his life in word and deed. Leader of the Christian Socialist movement and founder of the Working Men's College (at which Ruskin, Rossetti and Ford Madox Brown all taught), Maurice was also the moving force behind the establishment of the first institution for the higher education of women, Queen's College, London.

Maurice was born in 1805, the son of a Unitarian minister. While at Cambridge he made lasting friendships among his fellow 'Apostles': Tennyson, John Sterling and Richard Chenevix Trench (later Archbishop of Dublin), all of whom supported his subsequent efforts for reform. An early admirer of Pestalozzi, Maurice also published his views on women's education, exposing the 'mean and insignificant studies' and the 'trivial pursuits' which passed for learning in most places of female education. After he took orders, Maurice's beliefs in the application of theology to social involvement became increasingly canvassed and, together with Charles Kingsley, he advocated the need for greater class awareness and for the necessity of providing a satisfying life for workers in a modern industrial society. As Carlyle, Ruskin and Morris were all to argue, the reduction of the labourer to a mindless automaton demanded a reassessment of society's attitude to labour. In 1843

Maurice was already in correspondence with Daniel Macmillan about producing simply phrased pamphlets and articles specifically for the working classes. By 1848 he was a committed worker in the socialist cause. 'Our great desire is to Christianise Socialism', he wrote to his friend Ludlow, 'for Christian Socialism is in my mind the assertion of God's order'.

One of the main questions occupying his generation was that of work and wages. Carlyle articulated it in *Past and Present*:

'Cash-payment never was, or could except for a few years, be the union-bond of man to man. Cash never yet paid one man fully his deserts to another; nor could it, nor can it, now or henceforth to the end of the world.'

Carlyle is seen standing next to Maurice in Ford Madox Brown's most organised painting on the same subject, 'Work'. By the time Brown had begun this painting, Maurice was already in difficulties with the Anglican establishment at King's College, where he was Professor of English Literature and Modern History, and at the recently founded Queen's College in Harley Street. Both he and his assistant, Charles Kingsley, were criticised for teaching 'a sort of modified pantheism', as the *Quarterly Review* put it. Maurice eventually resigned from both posts, although he subsequently returned to Queen's in 1856 and lectured there for a further ten years.

At the time of his resignation, in 1853, the Committee of Education proposed that a portrait of Maurice be commissioned and hung in the college. This is a study for the portrait, which hangs in Queen's today.

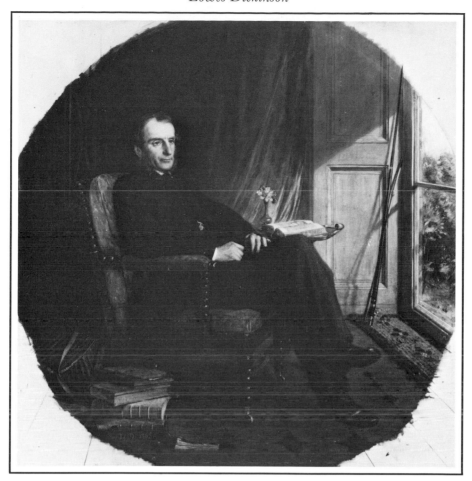

Charles Kingsley

Oil on canvas; 901 mm diameter (unfinished)
Signed and dated: *L.D. 1862*
National Portrait Gallery

Painted in the year Kingsley was writing *The Water Babies*, this portrait shows the writer in a pose of uncharacteristic relaxation. Excitable and restless, he could rarely sit still through a meal; to calm his nerves he indulged his love of tobacco, a love he happily attests to in *Westward Ho!* Much of Kingsley's energy and literary output was devoted to social and religious reform. Shortly after he was ordained in 1842, he began writing a life of St Elizabeth of Hungary (*The Saint's Tragedy* published in 1848 with a preface by F.D. Maurice), in which he expounded his dislike of ascetism and sacerdotalism, the main vices, as he saw it, of Newman's Oxford Movement. The pleasure of medieval life, its community and its colour, recommended the book to the Pre-Raphaelites, and James Collinson painted his most important Pre-Raphaelite canvas after this book. Kingsley's deepest sympathies though lay with the poor, and together with Maurice, whom he met in 1844, he attempted to give a Christian direction to the socialist movement, just beginning to grow conspicuous at this moment. *Cheap Clothes and Nasty, Alton Locke* and *Yeast* were but a few of his publications to reveal his passionate concern for Christian justice. His 'socialism' however, made him suspect. After delivering a sermon entitled 'The Message of the Church to the Labouring Man,' he was forbidden by the Bishop of London to preach again in his diocese; and the *Guardian* attacked him for the 'immorality' of his novel, *Yeast*, particularly for the vigorous denunciation of game-preservers in the ballad of the 'poacher's widow'. Partly as a result of these offences, partly due to overwork (he was a parish priest besides being a regular contributor to journals such as *Politics for the People, Christian Socialist* and *Fraser's*), he became less of an active agitator after the first years of the fifties. Though his writing still showed undiminished concern for social reform (*Hypatia, Two Years Ago*) prejudice against him gradually waned. By 1859 he became one of the Queen's chaplains in ordinary. In May 1860 he was appointed Professor of Modern History at Cambridge. He was not a great success in the post; academics scoffed at him for producing lectures that read more like historical novels than systematic treatises, and he was relieved to be able to resign in 1869. It gave him time to develop his interests in natural history, in scientific theory (he embraced Darwinism as in full accordance with theology) and in social justice (he was an ardent supporter of J.S. Mill's advocacy of women's rights). 'He was,' said Matthew Arnold, 'the most generous man I have ever known; the most forward to praise what he thought good, the most willing to admire, the most free of all thought of himself, in praising and admiring, and the most incapable of being made ill-natured or even indifferent by having to support ill-natured attacks himself.'

Henry Treffry Dunn

1838 born in Truro, Cornwall, the son of a prosperous tea and spice merchant with premises in Lemon Street. He showed an early talent for drawing, but was discouraged from becoming an artist by his father, who wanted him to go into his own business. He rejected the idea and was articled as a clerk in the Cornish Bank. *1862* abandoned the bank and Cornwall and moved to London to take his chances as an artist. Enrolled at Heatherley's ('this nursery for beginners'), the first art school in London to admit men and women. (His sister Edith, later noted as a painter under her married name of Edith Hume, followed him there.) Introduced to Charles Augustus Howell who got him to copy two heads of Dante belonging to D.G. Rossetti. The latter was so pleased with the result he engaged Dunn for further copying work. *1867* Dunn moved into 16 Cheyne Walk as general factotum; remained until *1881,* when he returned to Truro to work on the new cathedral and to earn more money than Rossetti was prepared to pay. *1882* returned to London following Rossetti's death; completed many of the unfinished commissions, produced replicas and helped organize the estate. Six months after Rossetti's death, he painted his portrait for the Uffizi Gallery, Florence. *1884* steady decline into alcoholism, necessitating several 'cures' in St Thomas' Hospital. Found refuge at the home of the Watts-Duntons at The Pines in Putney, where together with Swinburne, he could be seen out for a stroll, or off to The Green Man for a restricted drink. *February 1899* died in St Thomas' of chronic alcoholism. Five years after his death his *Recollections of Dante Gabriel Rossetti and His Circle (Cheyne Walk Life)* was published.

Dante Gabriel Rossetti and
Theodore Watts-Dunton

Watercolour on paper, 540 × 819 mm
Signed and dated: *H. Treffry Dunn/1882*
National Portrait Gallery, London

Rossetti's mental and physical health broke down in 1872, two years after the publication of his *Poems*. The volume had provoked vituperative cricitism, notably a review by Robert Buchanan calling Rossetti the leader of 'The Fleshly School of Poetry'. Rossetti's decline, though not entirely attributable to this hostility, was undoubtedly affected by it. He moved to Kelmscott, the Cotswold home of the Morrises, for solace, and it was here that he became friendly with the solicitor Theodore Watts-Dunton. A year later Rossetti was writing to Ford Madox Brown that Watts-Dunton 'is a first-rate companion and a first-rate fellow — few equal to him in sterling qualities and cultivation'.

In the years that followed and until his death, Rossetti sought Watts-Dunton's company constantly, not only for help in legal and financial matters, but as his amanuensis in all things literary and sentimental. In this portrait by Dunn, Rossetti reads poetry to his friend in the parlour of his house at 16 Cheyne Walk, Chelsea. For besides being a solicitor, Watts possessed a rare sympathy with men of literary talent. His relations with Swinburne were no less remarkable than those he developed with Rossetti. When Swinburne's excesses bordered on depravity, Watts-Dunton took over his guardianship and carried him off to the unlikely health-spa of his suburban home, The Pines, in Putney. Watts-Dunton's caring friendship of the poet for over twenty years ensured that he lived to a good age.

Although Watts-Dunton is supposed to have been nominated by Rossetti as his official biographer, he never managed to publish any memorial to his friend, perhaps because his intimacy with Rossetti ultimately inhibited it. He did, however, publish a fictional work, *Aylwin,* in 1896, in which the characters are barely veiled portraits of the denizens of Cheyne Walk in the 1870s. Rossetti appears as the painter D'Arcy-Haroun Al Raschid, James Smetham as the Spiritualist painter Wilderspin, Frederick Sandys as the bohemian Cyril Aylwin and Charles Augustus Howell as De Castro. *Aylwin's* literary merits may be dubious, but its sidelong glance at the Pre-Raphaelite circle of Cheyne Walk offers a singular view of the exotic menagerie surrounding Rossetti in the decade before his death.

Arthur Hughes

27 January 1832 born in London. Educated at Archbishop Tenison's Grammar school. *1846* entered the School of Design in Somerset Place, where he studied under Alfred Stevens. *1847* entered Royal Academy schools after winning an Art Studentship; distinguished himself as a draughtsman and in *1849* won the Silver Medal for Antique Drawing. *1849* exhibited his first work at the Royal Academy, 'Musidora', a conventional piece of academicism. *1850* read *The Germ* and was encouraged to seek out the company of Rossetti, Madox Brown and Hunt; his hitherto conventional genre paintings underwent a sudden conversion to Pre-Raphaelitism of the most exacting kind. Met Trypheena Foord, later to become his wife *(1855)* and mother of his five children (three girls and two boys). *1852* exhibited 'Ophelia' at the Royal Academy; met Millais. *1853* began painting 'The Long Engagement' outdoors, directly from nature, in strict Pre-Raphaelite fashion. Shared a studio with Alexander Munro and together they were approached by Rossetti in 1857 to help with the decoration of the Oxford Union Murals. Munro carved the relief over the door to the vestibule to the Debating Chamber;

Hughes painted 'The Passing of Arthur' at the south end of the room. He had already painted the most important of his Pre-Raphaelite canvases: 'April Love' (1855), 'The Eve of St. Agnes' (1856) and 'Home from the Sea' (begun in 1857 but not completed until 1863). *1858* left London to live in the suburbs, where he gradually lost touch with his Pre-Raphaelite acquaintance and its necessary astringent influence. Apart from his graphic output, his work subsequently softened to the point of woolliness. *1861* made stained glass designs for Morris' firm, but began to concentrate on illustration, particularly for children's books. *1866* illustrated Tennyson's *Enoch Arden. 1867* illustrated George MacDonald's *Dealings with Fairies. 1868* began to produce illustrations for *Good Words for the Young,* the periodical which provided him with the greatest outlet for his delicate, fantastic drawings. *1871* illustrations for MacDonald's *At the Back of the North Wind. 1872* made 125 drawings for Christina Rossetti's book of children's poems, *Sing Song. 1874* illustrated Christina Rossetti's *Speaking Likenesses.* Died in comparative obscurity in his home in Kew on *23 September 1915.*

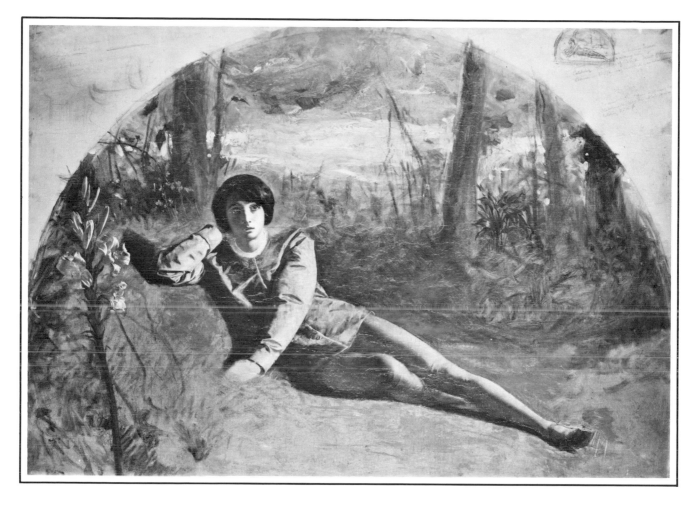

The Young Poet (Self-portrait)

Oil on canvas, 635 × 914 mm (arched top)
City Museum and Art Gallery, Birmingham

Hughes was only seventeen when he painted this tremulous portrait of himself as a young poet. His gentleness and almost quivering sensibility was an attribute noted by all who came in contact with him, as William Michael Rossetti, for one, noted:

> 'If I had to pick out, from amid my numerous acquaintances of the male sex, the sweetest and most ingenuous nature of all, the least carking and querulous, and the freest from "envy, hatred and malice, and all uncharitableness", I should probably find myself bound to select Mr Hughes.'

He narrowly missed election into the Pre-Raphaelite Brotherhood, but again, as William Michael noted:

> 'If the organisation had been kept up a little longer, and if new members had ever been admitted [a point which encountered some difference of opinion], Mr Hughes would doubtless have been invited to join.'

Nicknamed 'Cherry' by fellow students at the Royal Academy schools, Hughes never displayed much gift for poetic writing. He was, however, very enthusiastic about *The Germ*, which was circulated in the Royal Academy schools and which impelled him to associate himself with the Pre-Raphaelite painters. He does not appear to have met them before 1852, for he recalled, in a letter to Millais' son, the incident when Millais first approached him. It was at the 1852 Royal Academy exhibition, when Millais and Hughes both submitted paintings entitled 'Ophelia'. Hughes' painting had been skied, but he was greatly cheered by Millais who, after looking at Hughes' work, approached the artist and asked:

> ' "Aren't you he they call Cherry?". I said I was. Then he said he had just been up a ladder looking at my picture, and that it gave him more pleasure than any picture there, but adding also very truly that I had not painted the right kind of stream. He had just passed out of the Schools when I began them, and I had a most enormous admiration for him, and he always looked so beautiful — tall, slender, but strong, crowned with an ideal head, and (as Rossetti said) "with the face of an angel".'

Hughes continued to admire Millais during the next decade, and it is with Millais' work that his own is most frequently compared.

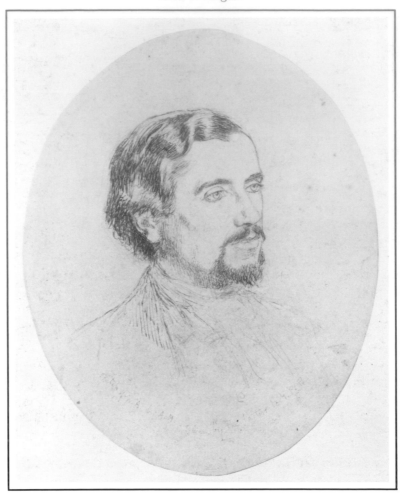

William Allingham

Pen and ink over pencil on paper, 164 × 126 mm, (oval)
Inscribed: *Sketch of W.A. by A.H. — given by the latter to G.P.B.*
The Whitworth Art Gallery, University of Manchester

Allingham (1824 – 89), the Irish poet from Ballyshannon,
is best remembered for his *Faery Poem:*

Up the airy mountain
Down the rushy glen
We daren't go a-hunting
For fear of little men

His fame within the Pre-Raphaelite circle though is largely
due to the publication of his volume of verse *The Music
Master . . . and Two Series of Day and Night Songs* (1855), with
five illustrations by Hughes, one by Millais, and one by
Rossetti. Rossetti's illustration for *The Maids of Elfen-Mere*
enjoyed wide influence in particular. Burne-Jones saw it
while still an undergraduate at Oxford. At the time he was
dejected by his loss of religious faith (he was reading
Divinity) and was in the process of discovering a new ideal
— that of medieval romance and legend. He and William
Morris wanted to form a Brotherhood at Oxford, modelled
on the lines of the Pre-Raphaelite Brotherhood, and
together with friends from the 'Birmingham set' (Cromell
Price, Charlie Faulkner and William Fulford), they
published a magazine in emulation of *The Germ, The Oxford
and Cambridge Magazine.* In the January issue, Burne-Jones

wrote a laudatory account of Rossetti's woodcut for
Allingham's poem:

I think [it] the most beautiful drawing for an
illustration I have ever seen, the weird faces of the maids
of Elfinmere, the musical timed movement of their arms
together as they sing, the face of the man, above all, are
such as only a great artist could conceive.

Burne-Jones' admiration for Rossetti led to their eventual
meeting and Burne-Jones' subsequent entry into the world
of art.

Allingham himself had been introduced to Rossetti in
1849, when he was in London visiting Coventry Patmore,
then a junior assistant at the British Museum. Patmore was
a particular friend of Thomas Woolner and it was through
this association that Allingham got to know members of the
Pre-Raphaelite group. His 'eyes of Celtic glamour' as
William Michael called them and his handsome and
assured presence appealed to Rossetti and the two became
friends, corresponding regularly until Elizabeth Siddal's
death in 1862. For a short period in the mid 1850s,
Allingham was also close to Hughes. For *The Music Master*
Hughes prepared five illustrations that gave a hint of the
delicate sense of fantasy and goblin whimsy that came fully
to the fore in 1872, when he made one hundred and twenty-
five drawings to illustrate Christina Rossetti's book of
children's poems, *Sing Song.*

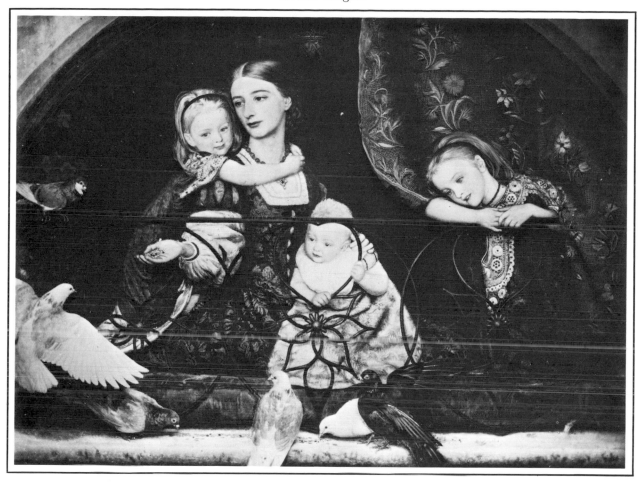

Mrs Leathart and three children

Oil on canvas, 775 × 1041 mm
Signed: *Arthur Hughes*
Private collection

Hughes visited Italy in 1862 and, like so many British artists before him, was moved by his experiences there. Before this date, he employed a curiously mannerist palette, with predominant notes of mauve and lime, emerald and taupe. The visit to Italy encouraged him in the use of bolder colour and tighter composition, both of which are evident in this portrait. While in the Piazza San Marco in Venice, Hughes had been struck by the sight of a family grouped in an *entre-sol,* and had sketched them thus. The sketch subsequently formed the basis for this commissioned portrait of Mrs Leathart and three children that Hughes received from Leathart in 1863. Rossetti had already completed a commissioned portrait of Leathart's wife, Maria, by this time, and Hughes, undaunted by Rossetti's success, embarked on a work more European in feel than any comparable Pre-Raphaelite work of the period.

Manet's portrait of 'Berthe Morisot on a Balcony' finished in 1868, only three years after Hughes completed his portrait of Mrs Leathart and her children makes an interesting comparison with this work. Although Hughes' work is more elaborate, and its surface more fussy than Manet's, it nevertheless begins to approach the spirit of realist portraiture that was consolidated in France at that time. It is perhaps surprising that more Pre-Raphaelite work did not display an awareness of European realism, for the aesthetic concerns of the Pre-Raphaelite Brotherhood were very close to Realist ideals. The Pre-Raphaelites called for sincerity in art as early as 1850, when they brought out their house magazine *The Germ.* In July 1856, Louis-Emile Duranty, the French Realist critic, brought out a magazine similarly devoted to the arts, entitled *Le Réalisme.* It lasted for only six issues, but its chief contributors — Flaubert, Champfleury, Sainte-Beuve and Duranty himself — insisted on the primacy of sincerity in art and in creating from one's own experience, ideas which had been promoted in *The Germ* six years earlier. The Pre-Raphaelites have been criticised for their insularity, but though their working methods may not have been developed in such a way as to best accommodate their own ideas, their artistic motivations were in the vanguard of European thought.

Hughes' portrait was completed in 1865 and exhibited at the Royal Academy the same year. Ford Madox Brown, who had seen the work in progress, wrote to Mrs Leathart expressing his admiration for it:

> 'Your head, I think, is a perfect likeness and with all that sweetness of expression which Hughes is so capable of imparting . . . of rendering.'

Leathart bought the painting in 1866 for 250 guineas. He commissioned a further family portrait from Hughes in 1878, this time portraying eleven of his fourteen children.

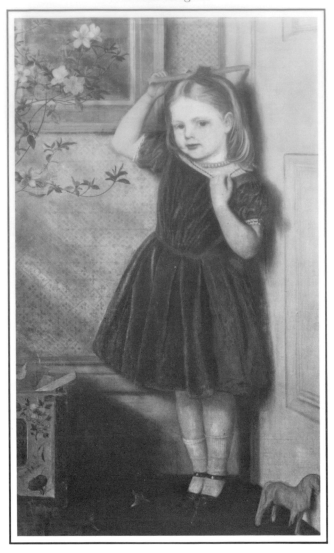

Cecily Palgrave

Oil on canvas, 700 × 400 mm
Ashmolean Museum, Oxford

Cecily Palgrave was the daughter of William Turner Palgrave (1824 – 97), a minor poet and critic whose name crops up in Pre-Raphaelite history from 1860 on. He became assistant private secretary to Gladstone in 1846 and afterwards entered the Education Department. His close friendship with Tennyson began in the 1850s, and they visited Tintagel and the West of England together, where they were joined by Woolner, Hunt and Val Prinsep, to pay homage to the 'birthplace of the great King [Arthur]'. During this visit Palgrave discussed the idea for an anthology of poetry with Tennyson; this was to be his most notable contribution to literature, *A Golden Treasury of Songs and Lyrics,* published in 1864. The second edition was published in 1896, a year after Palgrave retired as Professor of Poetry at Oxford.

Palgrave's friendship with the sculptor Woolner, who had made a portrait of Palgrave's father, Sir Francis, in 1861, led to a minor scandal. It was 1862, the year of the International Exhibition at the Palace of Art and Industry (now the site of the Natural History Museum) and much

Pre-Raphaelite work was on view, including Woolner's. Palgrave had written the official handbook of the exhibition and it contained a prejudiced account of all the sculpture in the exhibition save Woolner's, for whose work his praise was fulsome. It was particularly important for Woolner to be reviewed in a favourable light as he hoped to win the commission for the statue of Macauley, against his chief rival Marochetti. Palgrave lambasted Marochetti's work, calling it a 'colossal clumsiness'. Palgrave's bias became the subject of a scathing letter to *The Times,* which disclosed the fact that Woolner and Palgrave shared the same house. Woolner won the commission in the end, but his relations with the rest of the Pre-Raphaelite circle were badly damaged in the skirmish.

Cecily Ursula, the eldest of Palgrave's four daughters, was born on 7 December 1863; she was four when this portrait was painted. William Michael Rossetti considered that Hughes' paintings of children:

'. . . are always delightful creations, to begin with they are lovely in a point of mere beauty and they are so replete with harmless sweetness, and happy yet not unthoughtful innocence that the work rises immediately above the bed and board level of domesticity.'

William Holman Hunt

2 April 1827 born in Cheapside, the son of a warehouse manager and his wife Sarah, nee Hobman (*sic*). *1839-42* articled as a clerk to an estate agent, though his interest in drawing was already apparent. Attended drawing classes at the Mechanics Institute and took painting lessons from Henry Rogers, a portrait painter. His family did not encourage his ambitions to become a painter until *1843,* when his father reluctantly assented. Started to copy in the London galleries and to produce hack portraits. *1844* met J.E. Millais and attended the Royal Academy schools lecture. On his third attempt, he succeeded in becoming a Probationer for the Royal Academy schools. *January 1845* became a full student. *1846* first exhibited at the Royal Academy and began to evolve a more hardened style than that taught by his masters. *1848* worked in Millais' studio and met D.G. Rossetti and Ford Madox Brown. Became a founder member of the Pre-Raphaelite Brotherhood. *1849* toured France, Belgium and Holland with Rossetti and prepared designs for *The Germ*. Painted his first Pre-Raphaelite pictures, 'A Converted British Family sheltering a Christian Priest from the Druids', 'Claudio and Isabella' and 'Valentine rescuing Sylvia from Proteus'. *1851* met Thomas Combe, his most important single patron. *1852* met Edward Lear and advised him on painting in oils; Robert Braithwaite Martineau became his pupil. 'Strayed Sheep' won the Birmingham Prize and his work was generally praised. Ruskin commended him for 'The Awakening Conscience', shown at the Royal Academy in *1854*. *1853-4* made his first journey to the Middle East; joined by Thomas Seddon in Cairo and Giza. *1856* returned to England; became a member of the Hogarth Club (1858) and gave up thoughts of marrying Annie Miller in *1859*. Friendship with Rossetti waned. *28 December 1865* married Fanny Waugh. *1866-7* visited the Holy Land, though Fanny died on the way, in Florence, after giving birth to a son. *1867* returned to England and painted family portraits. *1869* visited Florence, where he designed a memorial to his wife, and met Ruskin where their old friendship was renewed. Arrived in Jerusalem in *1869* where he stayed until *June 1872*. *1873* back in London; married Edith Waugh in Neufchatel, Switzerland, on *14 November 1873*. *1875* set out for his third visit to the Middle East. His daughter Gladys was born in *1878*. *1882* moved to Draycott Lodge, Fulham and started to write a history of Pre-Raphaelitism. *1892* visited Italy, Greece and Palestine. Eyesight began to fail but he completed a life-size replica of 'The Light of the World' in 1904, for St. Paul's Cathedral. *1905* publication of his two-volume history of Pre-Raphaelitism; awarded the Order of Merit and an honorary degree from Oxford. Died on *7 September 1910* at his home in Melbury Road, Kensington. Buried in St. Paul's Cathedral.

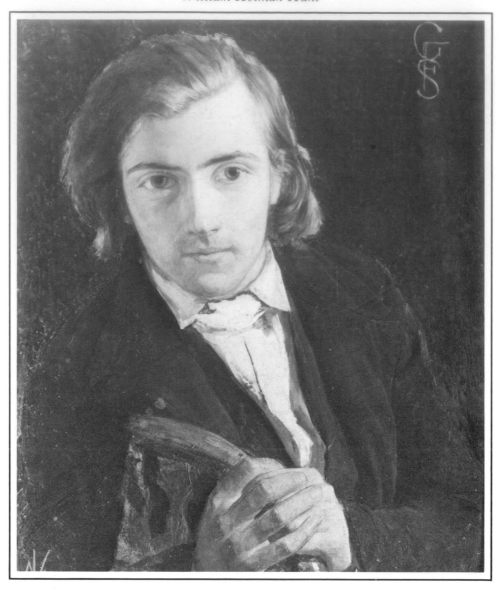

Frederick George Stephens

Oil on panel, 201 × 174 mm
Signed in monogram dated and inscribed: *W h h 1847 FGS*
Tate Gallery, London

A founding member of the Pre-Raphaelite Brotherhood, F. G. Stephens was a student at the Royal Academy schools when he met Hunt. They shared a fervent belief in the moral purpose of art and Stephens in particular was well versed in the styles of earlier schools of art. Before his election to the Brotherhood (made chiefly at the instigation of Hunt), Stephens had done very little painting, and he did very little afterwards. But he did write an important article for the February issue of *The Germ,* entitled 'The Purpose and Tendency of Early Italian Art', in which he defines his concern with the moral sphere of art and explains why the primitive Italian painters should be an example to contemporary artists:

'The most successful school of painters has produced upon us the intention of their earnestness at this distance of time . . . let us follow in their path . . . and then reply that we shall obtain the same success and equal or greater

power such as is given to the age in which we live. This is the only course which is worthy of the influence which might be expected by means of the Arts upon the character of the people.'

This is perhaps one of the clearest pronouncements by a member of the Brotherhood on why the Pre-Raphaelites were so styled.

Stephens had, as William Michael called it 'an uncommonly well-moulded and picturesque face', and he was used by Millais as the model for Ferdinand in 'Ferdinand Lured by Ariel' and by Ford Madox Brown for the figure of Jesus in 'Jesus Washing Peter's Feet'. He acted as Hunt's assistant in the restoration of the frescoes at Trinity House, London in 1850, and painted with Hunt and Rossetti at Sevenoaks in 1851, shortly before he gave up painting and devoted himself to writing. In 1860 he published a monograph on Hunt to coincide with the exhibition of his 'Finding of the Saviour in the Temple' and in the following year became Art Editor of *The Athenaeum,* submitting reviews and articles to it for close on forty years. His friendship with Hunt ended after a quarrel in 1880.

New College Cloisters (Canon Jenkins)

Oil on panel, 355 × 236 mm
Signed in monogram, dated and inscribed: *Whh Oxford/1852*
The Principal and Fellows of Jesus College, Oxford

'I never knew a man more pure in mind and deed than Canon Jenkins. It was a boon to have known him', Holman Hunt wrote to Thomas Combe in 1876, about the man whose portrait he had painted while staying with Combe in Oxford fourteen years earlier.

Hunt was in Oxford in the summer of 1852, and the Reverend John David Jenkins (1828 – 76) was then a Fellow of Jesus College. The Chaplain of Christ Church, the Reverend Hackman, asked Hunt to paint this portrait of Jenkins in June 1852. The Combe household was a stronghold of Tractarianism, and the High Church accents, which flavour many early Pre-Raphaelite paintings, are clear in this portrait. The ivy which springs through the mullioned windows of the cloister suggests the tenacity with which High Church Anglicanism was still gripping Oxford, the city from which Cardinal Newman's influence emanated. Newman's appeal for a return to the mystery of Catholicism (its real antagonist being Rationalism rather than Protestantism) was in part reflected in the original religious content of early Pre-Raphaelite work, which attempted, through its emulation of quattrocento Italian art, to revive piety and wonder. Many of the ideas of the Tractarian movement were therefore keenly felt by the Pre-Raphaelites. However, where the Tractarians believed that contemporary Protestantism was unable to rescue the age from spiritual decay and looked towards Catholicism for salvation, the Pre-Raphaelites vested their hopes in art as the moral and spiritual regenerator of the age. But the two movements shared a belief that somewhere between the sixteenth century and their own, real morality had been lost, and that a return to an earlier period was necessary in order to regain it; or, as Hurrell Fronde put it, 'The Reformation was a limb badly set – it must be broken again in order to be righted'.

In 1853, the Reverend Jenkins moved to Natal to become Canon of Maritzburg. He returned to Jesus College in 1865, as Dean and Bursar.

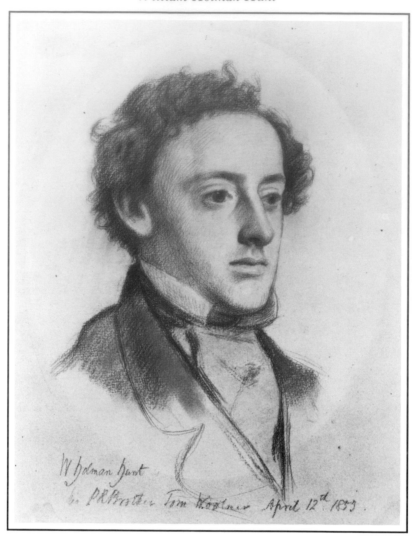

John Everett Millais

Coloured chalks on paper, 266 × 209 mm
Signed, dated and inscribed: *W. Holman Hunt/P R Brother Tom
Woolner April 12 1853*
National Portrait Gallery, London

Millais was twenty-four when this portrait sketch was made
in 1853 — altogether a tumultuous year for him. The Pre-
Raphaelite Brotherhood was beginning to disintegrate, but
Millais' own success had been assured a year earlier, when
he had shown 'A Huguenot' at the Royal Academy to great
acclaim. In June 1853 he was invited by Ruskin to visit
Scotland, stopping on the way to spend a week with the
Trevelyans at Wallington, then on to spend a couple of
months in the company of Ruskin and his wife, with whom
Millais fell in love and later married. He was particularly
interested in the Academy elections to be held in
November, for he had been elected an Associate of the
Royal Academy in 1850, but the appointment had been
quashed because of his youth. His brother William Millais
relates the anxiety Millais experienced while waiting to
hear whether he had been elected that year:

'On the day when the result of the election of Associates
at the Royal Academy of Arts was to be made known, my
brother, self, Wilkie and Charlie Collins all started off to
spend a whole day in the country to alleviate our excite-
ment. Hendon was the chosen locality. My brother wore
a large gold goose scarf-pin. . . . We had been walking
along a narrow, sandy lane and meeting a large three-
horse waggon, had stepped aside to let it pass, when we
resumed our way and shortly afterwards Jack's pin was
gone! ''Now, Wilkie'', said my brother, ''how about my
luck? This is an ominous sign I shall not get in''.'

Eventually the pin was found and they went straight to the
Royal Academy, where Charles Landseer greeted them:
'Well, Millais, you are in this time in earnest', punning on
the fact that Millais' name had been wrongly entered as
John Ernest instead of John Everett. The following day,
Rossetti wrote to his sister Christina: 'Millais, I just hear,
was last night elected an Associate, so now the whole Round
Table is dissolved'.

It is ironic to reflect that this portrait was drawn as an
affectionate reminder to Thomas Woolner of the ties of the
Brotherhood in the year that Millais virtually defected from
it; the Pre-Raphaelite Brotherhood had been formed to
combat the academicism and sterility its young members
found among the members of the Academy. Now Millais
was being enfolded in its arms, only too anxious, by all
accounts, to receive its embrace.

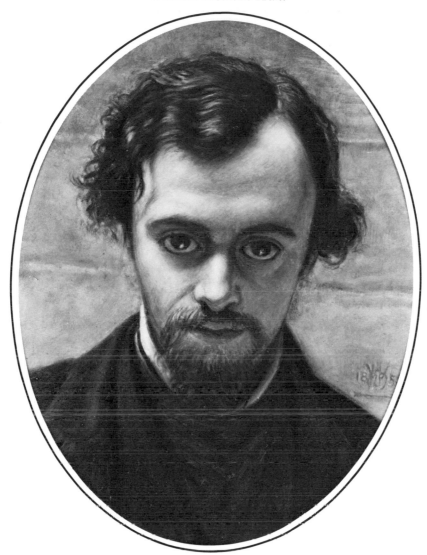

Dante Gabriel Rossetti

Oil on panel, 292 × 216 mm (oval)
Signed in monogram and dated: *18 Whh 53*
City Museum and Art Gallery, Birmingham

In July 1852, Thomas Woolner set sail for the goldfields of Australia. The remaining six members of the Brotherhood met, at Rossetti's suggestion, on Friday 12 April 1853, in Millais' Gower Street studio to make sketches of one another to send to Woolner. Hunt and Rossetti drew one another, Hunt using 'Swiss chalks' for his drawing. In a letter to Woolner of 16 April, Rossetti exclaimed:

'Are not Hunt's sketches wonderful? They are made with "Swiss Chalks" not Creta Levis. The "Swiss" are softer than Creta, but I think much more beautiful in colour. Hunt will send you out some of both'.

The softness of the chalks Hunt used was clear when William Michael was given the drawing by Woolner after the death of his brother in 1882. It had been out to Australia and returned with Woolner in 1854 and had become rubbed in the process. Hunt thought it was in danger of obliteration. He borrowed it from William Michael to make this oil copy, which he signed with the date of the original. (The chalk drawing is now in Manchester City Art Gallery.)

A sad postscript to these portrait sketches made on the occasion of Woolner's emigration is given by F. G. Stephens. He is talking about one such meeting here:

'This meeting was one of the latest "functions" of the Pre-Raphaelite Brotherhood in its original state. Collinson had seceded, and Woolner emigrated to the "diggings" in search of gold he did not find. Up to that time the old affectionate conditions still existed among the Brothers, but their end was near. Millais was shooting ahead; Mr Holman Hunt was surely, though slowly, following his path towards fortune: D. G. Rossetti had retired within himself, and made no sign before the world; W. M. Rossetti was rising in Her Majesty's service; and I was continually drawn towards that literary work which brought me bread.'

These portraits, ostensibly made in memory of Woolner's emigration, are therefore gestures of another migration: that of the idealism, already now outgrown, of the original Brotherhood towards the diverse directions the movement was poised to take.

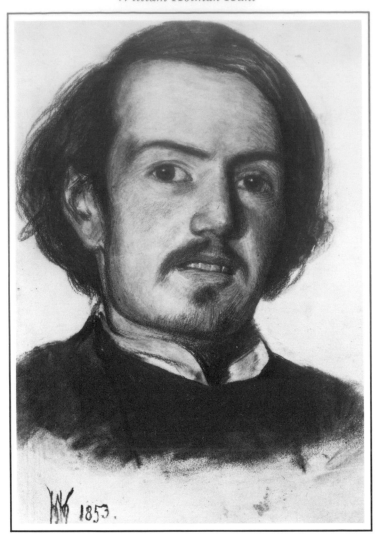

Walter Deverell

Black and red chalks on toned paper, 355 × 260 mm
Signed in monogram and dated: *Whh 1853*
City Museum and Art Gallery, Birmingham

Walter Howell Deverell (1827 – 54) was born to English parents in Charlottesville, Virginia, where his father was a schoolmaster. The family returned to England when Deverell was two; his father became Secretary of the Government School of Design. In 1846 Deverell entered the Royal Academy schools and two years later was appointed Assistant Master in the Government School of Design. Rossetti, who liked him enormously, introduced him to the Pre-Raphaelite circle, but he was not formally made a Brother, possibly on account of the appointment he held. He was described by Arthur Hughes as 'a manly young fellow, with a feminine beauty added to his manliness; exquisite manners and a most affectionate disposition'; and by William Michael Rossetti as 'artistic, clever, genial and remarkably good-looking'. It was Deverell who 'discovered' Elizabeth Siddal, subsequently Rossetti's wife, when he accompanied his mother to a bonnet-shop in Cranbourne Alley. What he saw, according to William Michael, was:

'a most beautiful creature, with an air between dignity and sweetness, mixed with something which exceeded modest self-respect, and partook of disdainful reserve; tall, finely formed, with a lofty neck, and regular yet somewhat uncommon features, greenish-blue unsparkling eyes, large perfect eyelids, brilliant complexion, and a lavish heavy wealth of coppery-golden hair.'

Deverell asked his mother to request her to sit for him, to which she must have agreed since she is the model for the head of Viola in Deverell's painting 'Twelfth Night', shown at the Royal Academy in 1850.

In 1851, Deverell shared studios with Rossetti in Red Lion Square. In 1853 his father died and he was left in extreme poverty to support a large family. The same year Deverell contracted Bright's Disease. Millais was solicitous for his health, paying for a nurse in the evening, reading to him and writing on his behalf to Mrs Combe and to Ruskin for help. The latter did all he could, getting his father to send him 'chicken and jellies', and Hunt and Millais together bought one of his pictures, 'A Pet', to help tide him over financially. Hunt recalls that it was on completion of this purchase that he visited Deverell to tell him the news and this portrait study was made on that occasion. Deverell died in February 1854.

54

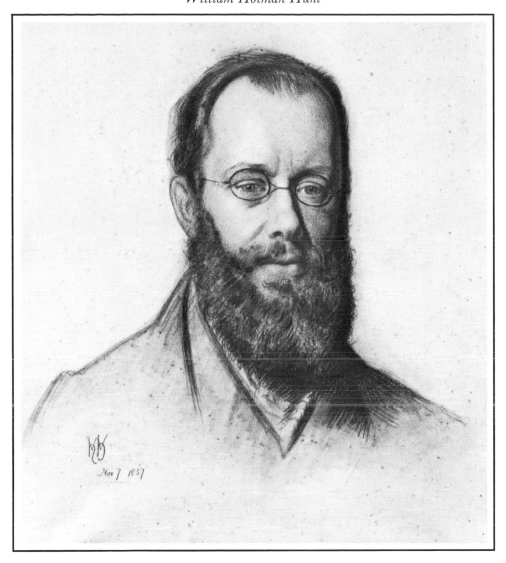

Edward Lear

Black and red chalks on toned paper, 613 × 489 mm
Signed in monogram and dated: *Whh/Nov 7 1857*
Walker Art Gallery, Liverpool

Edward Lear (1812 – 88), the nonsense poet and landscape painter, was introduced to Hunt by the painter Robert Martineau, then sharing Hunt's studio in Prospect Place, Chelsea. One of twenty-one children, Lear had received little formal training as an artist, but had been employed by the Zoological Gardens as a draughtsman, had given drawing lessons to Queen Victoria, and had published several volumes of ornithological drawings by the time he met Hunt in 1852. Hunt describes the meeting:

> 'About this time Robert Martineau spoke to me of Edward Lear, and gave me an invitation to his chambers in Stratford Place to see his numberless drawings, which were in outline, with little to indicate light or shade. Lear overflowed with geniality, and at the same time betrayed anxiety as we turned over the drawings, avowing that he had not the ability to carry out the subjects in oil; in some part of them he had written in phonetic spelling the character of the points which the outlines would not explain – ''Rox'', ''Korn'', ''Ski'' — indulging in his love of fun with these vagaries.'

Despite the fact that Lear was an accomplished draughtsman and fifteen years Hunt's senior, he was keen for Hunt to teach him how to translate his drawings into oils. They took rooms in the autumn of 1852 in Fairlight, Sussex, for the purpose, and were later joined by Millais. Lear was shown the Pre-Raphaelite method of laying in a ground of wet white paint on the canvas before painting the surface. He was full of admiration for the two younger men, calling Hunt 'Daddy' or 'Pa' and Millais 'Uncle' — or even occasionally 'Aunt'. Hunt became one of Lear's regular correspondents, receiving from him humorous and affectionate letters, usually concerning painting. Lear took up the 'wet-white' method with enthusiasm, and attempted to paint out-of-doors, but found that the English weather was not always an ally in such enterprises. Painting Windsor Castle the following year he wrote to Hunt complaining that the appalling weather was making it 'utterly impossible to do this view on a strictly P. R. B. principle'.

As a landscape painter, Lear came to consider himself a Pre-Raphaelite follower or, in his own phrase, 'child' of the Pre-Raphaelite Brotherhood.

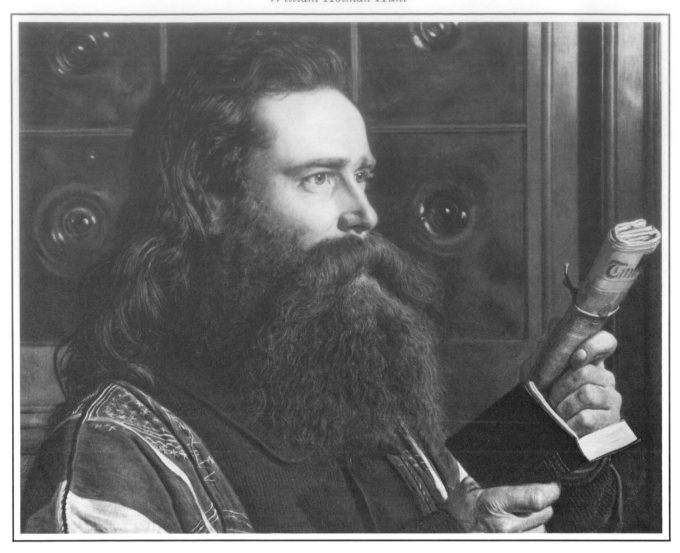

Henry Wentworth Monk

Oil on canvas, 508 × 660 mm
Signed in monogram and dated: *Whh 1858*
National Gallery of Canada, Ottawa

Henry Wentworth Monk (1827 – 96) was born in Carleton Country, Ontario, and was an early Zionist and advocate of World Peace. Hunt met him in the Middle East on his first visit to Palestine in 1854. Hunt's own urgent sense of religion and the Pre-Raphaelite stricture of painting as directly from nature as possible impelled him to make the journey to the biblical lands, hoping thereby that the religious subjects that he would paint there would have a degree of veracity impossible to achieve in England.

Hunt was impressed by Monk's ideas. 'His knowledge of history, and his enthusiasm for the progressive thought stored in the Bible, made him of special interest to me', he wrote, '. . . on his study of the past he built his plan for the abolition of war among all nations, revering the God of Abraham'. Monk's ideas about the 'progressive thought stored in the Bible' clearly reflected Hunt's own views about the regenerative spirit of religion, and in his paintings as well as his writings the zealous quality of his thought is often prominent. He saw himself as 'a priest in the temple of Nature', and the paintings which he made

while on his first visit to the Middle East, such as 'The Scapegoat' and 'The Finding of the Saviour in the Temple' exhibit the vatic mission of Hunt's zeal.

The question of how best to paint religious pictures in the mid-Victorian period was a vexed one, and James Smetham recalled a conversation with Ruskin on the subject, held during the year Hunt met Monk. Ruskin felt that in accordance with his own views on realism in painting, contemporary pictures on religious themes should not be historically costumed, but rather be painted in modern dress and in contemporary settings. He qualified his statement, however, by saying that 'if it would not look well, the times are wrong and their modes must be altered'. Smetham agreed that it should be possible to employ contemporary props, indeed 'that it would be a very great deal easier (it is a backward, lame action of the mind to fish up costume and form we never saw), but I could not do it for laughing'. It was the laughable element within so many mid-Victorian attempts at religious painting to which Hunt was unwilling to reconcile himself, and it was the search for a more plausible setting for spiritual subjects that impelled him to visit the Middle East, returning three times after his first visit of 1854, in 1869, 1875, and finally in 1892.

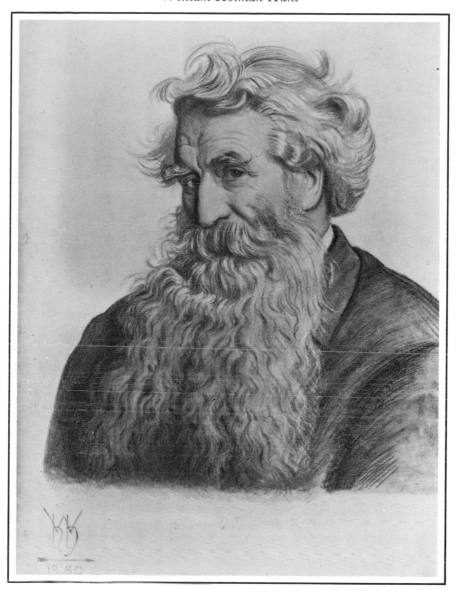

Thomas Combe

Red and black chalks on paper, 670 × 476 mm
Signed in monogram, dated and inscribed: *Whh/1860/Oxford*
Ashmolean Museum, Oxford

Thomas Combe (1797 – 1872) first became associated with the Clarendon Press in Oxford in 1837, and by 1848, the year in which he met Millais, he was Printer to the University of Oxford. On Millais' recommendation he acquired, in August 1850, one of Hunt's most important early Pre-Raphaelite works, 'A Converted British Family sheltering a Christian Priest from the Persecution of the Druids', thus becoming one of the first serious patrons of Pre-Raphaelite work. He subsequently bought other important paintings by Hunt, notably 'The Light of the World' and the 'Afterglow in Egypt'. With the exception of 'The Light of the World', which was given to Keble College, Combe's entire collection was left to the University of Oxford, and is now housed in the Ashmolean Museum.

Of all the Pre-Raphaelites, Hunt was the painter Combe preferred. They met in the autumn of 1851, when Hunt,

Charles Allston Collins and Millais were staying on a farm in Surrey painting landscapes. The Combes paid them a visit, and must have discussed with them the question of religious paintings and the possibility of travelling to the Holy Land in search of subjects; for in a letter to Mr Combe from the farm that autumn Millais wrote to say that:

'Hunt and self are both delighted by your letter, detecting in it a serious intent to behold us plant the artistic umbrella on the sands of Asia. He has read one of the travels you sent us, *The Camp and the Caravan,* and considers the obstacles as trifling and easy to be overcome by three determined men, two of whom will have the aspect of ferocity, being bearded like the bard. Hunt can testify to the fertility of my upper lip, which augurs well for the under soil. It therefore (under tropical sun) may arrive at a Druidical excellence.'

Nicknamed 'The Early Christian' by Millais, Combe remained a life-long friend of Hunt and maintained a steady correspondence with the artist until his own death in 1872.

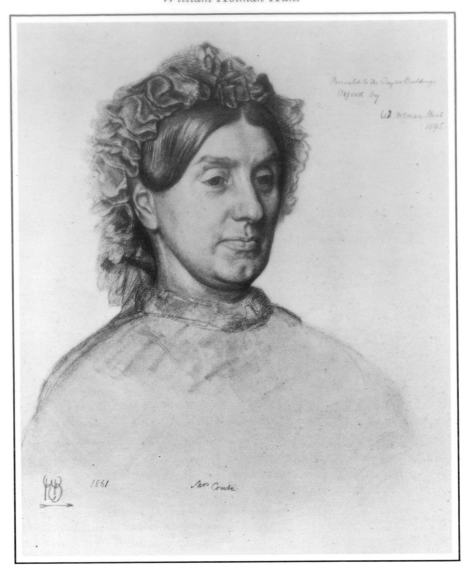

Mrs Combe

Black and red chalks on paper, 721 × 476 mm
Signed in monogram and dated: *Whh 1861*; inscribed: *Mrs
Combe/Presented to the Taylor Building/Oxford by/W Holman Hunt/1895*
Ashmolean Museum, Oxford

Martha Howell Bennett Combe (1806 – 93) was the wife of
Thomas Combe. She was as involved in the work of the Pre-
Raphaelites as her husband, and a frequent recipient of
letters from Millais (who addressed her as Mrs Pat), in
which he explained to her at length and in detail the
canvases he was working on. Millais introduced Hunt to
the Combes, and encouraged Mrs Combes' uncle, Mr
Bennett, to buy Hunt's painting, 'A converted British
Family sheltering a Christian Priest from the Persecution of
the Druids', as a present for his niece's husband. Hunt
subsequently stayed with the Combes in Oxford, his own
Early Christian ideals fanned by the High Church tone of
the Combe household. Mrs Combe was a maternal figure
to the young Pre-Raphaelites. Millais wrote to ask freely for
supplies of props for his pictures, about the merits of his
artist friends and, not least, about purely domestic matters:

'July, 1851. You will see that I am writing this from
Kingston, where I am stopping, it being near the river
that I am painting for ''Ophelia''. We get up (Hunt is
with me) at six in the morning, and are at work by eight,
returning home at seven in the evening. The lodgings we
have are somewhat better than Mistress King's at
Botley, but are, of course, horribly uncomfortable. We
have had for dinner chops and suite of peas, potatoes,
and gooseberry tart four days running. We spoke not
about it, believing in the certainty of some change taking
place; but in private we protest against the adage that
''you can never have too much of a good thing''. The
country-folk here are a shade more civil than those of
Oxfordshire, but similarly given to that wondering
stare, as though we were as strange a sight as a
hippopotamus.'

[The first hippopotamus was seen in London in
1850.]

When in accordance with her husband's wishes, Mrs
Combe presented Hunt's 'Light of the World' to Keble
College, she provided in her will the funds to build a chapel
to house it.

58

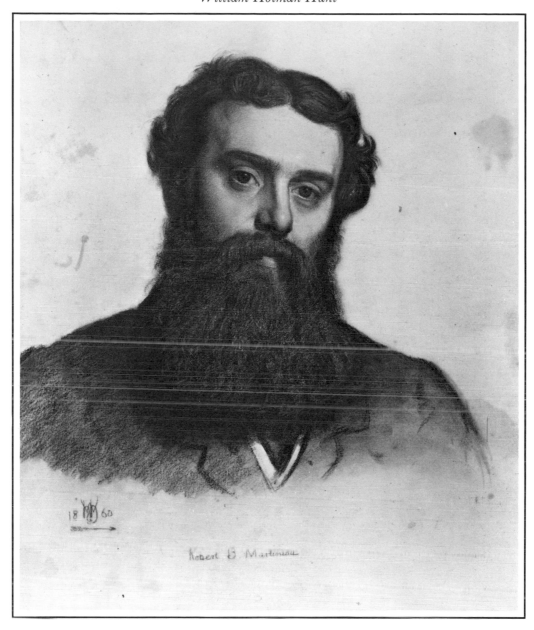

Robert Braithwaite Martineau

Red and black chalks on toned paper, 762 × 533 mm
Signed in monogram and dated: *18 Whh 60*
Walker Art Gallery, Liverpool

A year older than Holman Hunt, Martineau spent four years articled as a solicitor's clerk before entering the Royal Academy schools in 1846. He was encouraged to give up the law by his mother, the amateur watercolourist, Elizabeth Batty. In the schools Martineau became friendly with Hunt and in 1851 he became Hunt's pupil, working in his studio at 5 Prospect Place, Chelsea. Here Martineau produced his first Royal Academy work, 'Kit's Writing Lesson'. The accretion of detail in this painting, all scrupulously worked, betrays his sympathy with Hunt's own working methods although Martineau's work never displays the fervid morality of Hunt's. After Hunt's first visit to the Middle East in 1854, he again shared a studio with Martineau, now at 49 Claverton Street, Pimlico.

Martineau's meticulous and laboured method of painting meant that his output was modest, and he only reached public acclaim with one painting, 'The Last Day in the Old Home' shown in an exhibition with Hunt's work in 1862. The painting tells the cautionary tale of a gambler who has lost everything on horse-racing; he drinks champagne in his ancestral home, the contents of which are being disposed of to settle his debts. Pre-Raphaelite only in as much as its detail is microscopic, it provides an excellent follow-up to Frith's 'Derby Day', where the gambling is only just beginning.

Martineau exhibited with the Pre-Raphaelites frequently, and was one of their number in 1857 when a private exhibition of their work was shown in Fitzroy Place. This exhibition foreshadows those run by the Hogarth Club, a sort of 'Salon des Refusés' organised by the Pre-Raphaelities a year later. Portraits of Martineau are few but he does appear as the model for the silk-hatted gentleman on horseback in Ford Madox Brown's 'Work'.

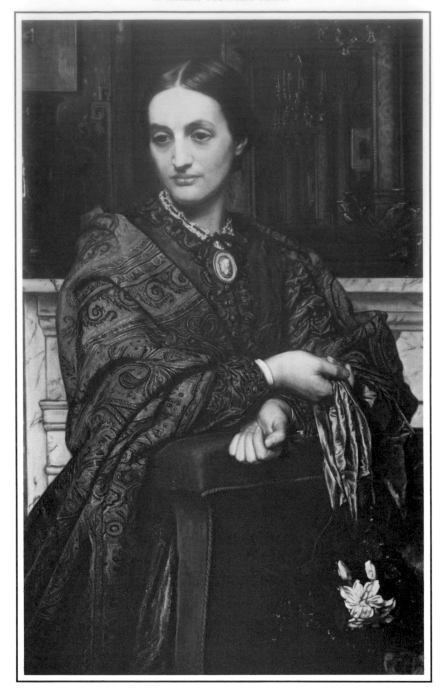

Fanny Holman Hunt

Oil on canvas, 1067 × 736 mm
The Toledo Museum of Art, Ohio

Fanny Waugh (1833 – 66) was introduced to Holman Hunt by the sculptor and Pre-Raphaelite Brother Thomas Woolner in 1861. Woolner, who had been paying court to Fanny for two years, had been impressed by her on their first meeting in 1859 and had written to Mrs Tennyson to say so: 'She is one of the grandest creatures I ever saw and her face is not far from what I want for my Lady'. (His Lady is a reference to the sculpture group of a Madonna and Child he was working on for Pauline Trevelyan, commissioned for the Central Saloon at Wallington.) Woolner proposed to Fanny in 1861, but was rejected. He subsequently married a younger sister, Alice, in 1864.

Fanny and Hunt were married in 1865 and eight months after the marriage set out for the Middle East. Hunt's protracted courtship of Fanny had delayed his plans of painting in Palestine for some years, but the delay proved even longer than anticipated. Travelling through Italy the couple were detained in Florence where an epidemic of cholera had broken out, preventing movement both to and from the city. Fanny here gave birth to a son, Cyril, but died some weeks afterwards on 20 December 1866, of septicaemia. Fanny's sister Edith set out from London to take care of the baby to whom she gave the second name Benone, meaning Son of Sorrow in Hebrew. In this portrait of Fanny, begun in Florence, but not completed until 1869, her pregnancy is modestly concealed by the back of the armchair.

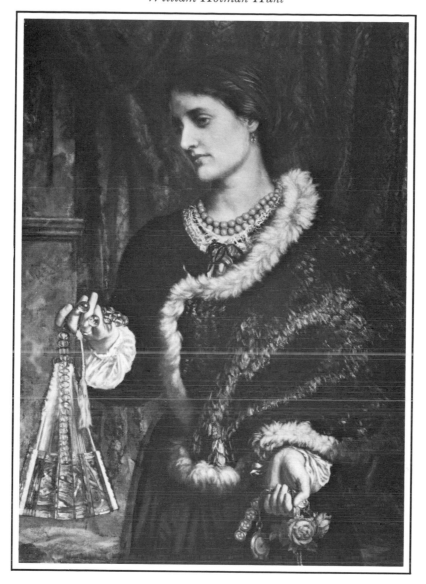

Edith Holman Hunt (The Birthday)

Oil on canvas, 1016 × 711 mm
Private collection

Edith (1846 – 1931) was the youngest of the eight daughters born to the chemist Dr George Waugh, druggist to the Queen. She was fifteen when she first met Hunt, who visited the Waugh household with Thomas Woolner, then paying court to her older sister Fanny. Woolner subsequently married Edith's sister, Alice, a year older than herself, and Hunt married Fanny. Edith was, on her own admission, attracted to Hunt early on, and after the death of her sister Fanny took care of Hunt's infant son. During the years following his wife's death Hunt completed many family portraits; this portrait of Edith, painted to celebrate her twenty-first birthday, was to be a companion to the portrait of Fanny he had begun in Florence in 1866. Edith appears with the presents given to her for her birthday and is wearing a cameo brooch given to her by Holman Hunt, formerly the property of her sister. Both this portrait by Hunt of Edith and another of her mother were exhibited at the Royal Academy in 1869; Tom Taylor, the art critic of *Punch,* took exception to them both and criticised the paintings for their 'repulsively ugly' sitters.

Edith gradually supplanted Fanny in Hunt's affections, although no question of marriage was possible between the two. Both the Deceased Wife's Sisters Act and the Table of Affinities prohibited such a marriage, and Hunt's awareness of his position as a religious painter made him vulnerable to public criticism about the flouting of religious mores. In 1869 he returned to Florence, both to continue the journey to the Middle East that had been truncated by Fanny's death, and to sever his relations with Edith. On his return to London however, in 1872, Edith was waiting, and the two decided to marry despite enormous family opposition. Even such a close friend as Woolner, cooled towards Hunt, and his own father struck him out of his will; Edith had to leave home before the marriage to take refuge from family opprobrium and stayed with F. G. Stephens and his wife Clara.

The couple were eventually married in Neufchâtel, Switzerland in November 1875, where under Swiss law their marriage was legal. Though of a different temperament to her sister, Edith proved an adoring wife and bore Hunt two children, a son, Hilary, and a daughter, Gladys.

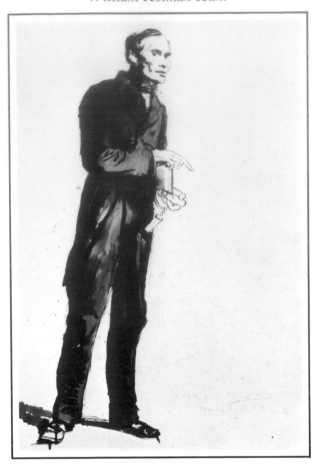

A Porter to the Hogarth Club

Pen and ink with sepia wash, 463 × 317 mm
Inscribed by F. G. Stephens: *A Porter to the Hogarth Club/drawn by
W. Holman Hunt*
City Museum and Art Gallery, Birmingham

The Hogarth Club was founded in 1858 as a *contre-salon* to
the Royal Academy, where for several years works tainted
with Pre-Raphaelitism were either badly hung or denied
exhibition. In 1856 several members of the Pre-Raphaelite
circle, including Thomas Seddon, Arthur Hughes, Robert
Martineau and Alexander Munro, met to discuss the
possibility of setting up an independent exhibition of their
own. Nothing happened until the death of Thomas
Seddon, in November 1856, an artist closely associated
with the Pre-Raphaelite Brotherhood. As a memorial to
him his friends decided to organise an independent
exhibition, mostly of their own work; Ford Madox Brown
was the effective organiser, encouraging artists to put
paintings in the show, finding the rooms in Russell Street,
meeting many of the costs himself and cajoling funds from
his fellow artists.

The exhibition opened in June 1857, with works by
Rossetti, Brown, Millais, Hunt, Lowes Dickinson, Charles
Collins, Arthur Hughes and Martineau. It was a great
promotional, if not financial, success as one of the visitors to
the exhibition was the American scholar and critic, Charles
Eliot Norton, later to become the first Professor of Art
History at Harvard. He proposed that the pictures be taken
to the New World and as a result of his initiative the
majority of works on show were seen later that year in New
York, Philadelphia and Boston. The success of the
exhibition encouraged the group to organise further
independent exhibitions of their work, and at the end of
1858 the Hogarth Club was founded for the purpose.
Brown, Rossetti and Hunt had long regarded Hogarth as
England's greatest painter, identifying with his revol-
utionary preferences for modern moral subjects over the
academic stalwarts of history and allegorical painting: thus
they were eager to enlist his name in their cause. At this
time thirty-eight artists were registered as members, with
Ruskin, Philip Webb, and the Liverpool artists Davis,
Bond and Windus included among them. Patrons such as
Thomas Plint, a Leeds stockbroker, were also members
and among the seven honorary members was the name of
Eugène Delacroix. The venture lasted for three years, but
finally broke up as a result of dissension among the
members. Ford Madox Brown was the first to experience
opposition from the committee. He had submitted designs
for furniture to the club, but they were rejected on the
grounds that they were not 'fine art'. Brown immediately
resigned and factions of all colour formed. The arguments
were not all related to the serious business of art: as the
lesions between individual members opened, petty
squabbling over such items as whether there should be a
billiards room in the club, and whether or not they should
open on Sundays became frequent. The club was finally
disbanded at the beginning of 1862.

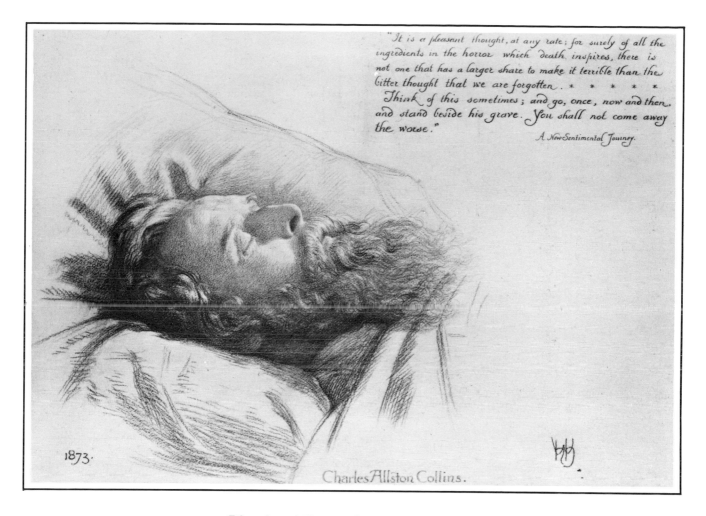

"It is a pleasant thought, at any rate; for surely of all the
ingredients in the horror which death inspires, there is
not one that has a larger share to make it terrible than the
bitter thought that we are forgotten . * * * *
Think of this sometimes; and go, once, now and then,
and stand beside his grave. You shall not come away
the worse."

A New Sentimental Journey.

1873.

Charles Allston Collins.

Charles Allston Collins in Death

Black and red chalks on toned paper, 487 × 700 mm
Signed in monogram and dated: *1873.* Inscribed with a quotation
relating to death from Collins' work, *A New Sentimental Journey,* and
the name: *Charles Allston Collins*
City Museum and Art Gallery, Birmingham

Charles Allston Collins (1823 – 73) was a member of a
distinguished Victorian family, son of the Royal
Academician, William Collins, and brother of the novelist,
Wilkie Collins. He attended the Royal Academy schools
with Hunt and Millais and remained close to both of them
until his death. He was never formally admitted as a
Brother by the Pre-Raphaelites on the grounds that 'he was
very much of a conventional who would be out of his
element with us'. He does not appear to have been much
out of his element with either Millais or Hunt, however, for
he spent the autumn of 1850 with Millais in Oxford (while
Millais worked on 'The Woodman's Daughter'), and he
began work on 'Convent Thoughts'. In 1851 he went to
paint with Hunt and Millais at Worcester Park Farm in
Surrey, where the three of them, according to Millais, lived
'as happily together as ancient monastic brethren'. Collins
had cause to feel aggrieved by his ineligibility as a Pre-
Raphaelite Brother, for his 'Convent Thoughts', finished

in 1851, became the focus of critical abuse against the Pre-
Raphaelites; as one contemporary reviewer put it, in
Collins' painting:

'We discern something of that paltry affection for middle
age ecclesiasticism with which the Pre-Raphaelites as a
body have been too hastily charged.'

The reception of Collins' work depressed him utterly and
he finally abandoned painting in 1858 and devoted himself
to literature, contributing to Dickens' *Household Words* on a
regular basis and other magazines such as *All the Year Round.*

Collins became closely identified with Dickens and in
1860 married his youngest daughter Kate. She herself was
an amateur watercolourist of some distinction; she also sat
as model in Millais' 'Black Brunswicker' in 1859. (After
Collins' death she married the Neapolitan painter,
Perugini.) While Collins had been together with Millais
and Hunt at Worcester Park Farm in the early 1850s, he
had begun work on a canvas which remained unfinished at
the time of death. Millais records with poignancy that:

'When the end came, Holman Hunt, who was called in
to make a sketch of his friend, was much touched to find
this very canvas . . . lying on the bed beside the dead
man. The tragedy of vanished hopes!'

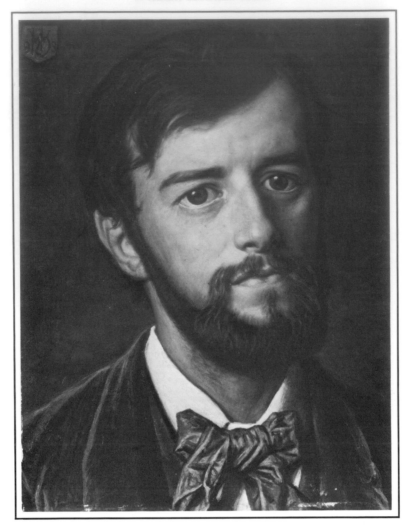

Harold Stewart Rathbone

Oil on panel, 232 × 178 mm
Signed in monogram and dated (in a shield): *9 Whh 3*
Walker Art Gallery, Liverpool

The Rathbones were a prominent Liverpool trading family with artistic interests. Harold's father was Chairman of the Arts Committee of the Walker Art Gallery, and Harold himself organised the subscription list to buy Hunt's 'Triumph of the Innocents' for the Gallery in 1891, at which time he would have become acquainted with the artist. Harold had trained as a painter in Paris and at the Slade School, and when Ford Madox Brown moved to Manchester in 1881 to work on the decoration of Manchester Town Hall, Harold became his student for a time. He had great admiration for Brown, declaring him to be a man in the same mould as Shakespeare, Homer and Dante, and he later wrote of him:

> 'Whatever artistic and practical success I have had with the Della Robbia Pottery I attribute mainly to his influence, and I consider it constantly a duty to hand on those traditions to my pupils.'

The Della Robbia Pottery at Birkenhead was founded by Rathbone in December 1893, with a controlling council that included Conrad Dressler the sculptor, and William Holman Hunt, with the aim of specialising in architectural embellishments. The establishment of 'art potteries' began in England in the 1870s, reflecting in the realm of the applied arts the same concern for the revival of craft traditions that the Pre-Raphaelite painters had earlier brought to the fine arts. The introduction of an 'English majolica' as a new ceramic marvel had been planned as early as 1851, by the art manager of Minton, and during the 1870s several leading potteries began to produce 'art pottery' alongside their range of commercial ware. But the smaller 'art potteries' such as those run by Ault at Linthorpe, the Martin Brothers in Southall and by William de Morgan at Merton, began to produce works for which the individual artist was totally responsible — both shape and glaze — and which were then signed in the manner of paintings.

At the Della Robbia Pottery, a name which in itself is a declaration of Rathbone's links with the Pre-Raphaelite movement, young art students were encouraged to produce their own designs with a combination of painted and sgraffito decoration. Although the characteristic style of the pottery was only an approximation of Italian majolica, the modelled decoration and thick coloured glazes of its wares catered to an 'intellectual' art market, made aware through the teachings of William Morris of the effects of industrialism and thus in full reaction against it.

John Everett Millais

8 June 1829 born in Southampton, son of an officer in the Jersey Island militia. *1833* moved with his family to Jersey; moved again in *1835* to Dinan, Brittany, and again in *1837* back to Jersey, near St. Helier. An early talent for drawing was encouraged by the Lempriere family. *1838* an introduction to Martin Archer Shee, President of the Royal Academy, was effected; the family moved to London so that Millais could take lessons at Sass' Art Academy. *1840* accepted as a student at the Royal Academy schools, where he remained for six years. *1844* met Holman Hunt. *1845* met James Wyatt at Oxford. *1846* exhibited his first painting at the Royal Academy, 'Pizarro seizing the Inca of Peru'. *1848* met D.G. Rossetti and became a founder member of the Pre-Raphaelite Brotherhood. *1849* exhibited his first Pre-Raphaelite work, 'Lorenzo and Isabella'; met Thomas Combe, who became a friend and patron. *1851* met Ruskin, who championed his paintings. *1853* visited Scotland with Ruskin and elected associate of the Royal Academy. *1854-6* showed no work at the Royal Academy; *25 April 1854* Effie Ruskin left her husband and received decree of nullity on *15 July*. *1855* married Effie Ruskin and divided his year between Bowerswell in Scotland and a London studio. *1856* birth of his son, Everett. *1857-60* his painting became increasingly fluid and popular; censored by Ruskin; birth of his second son, George in *1857*, and first daughter, Effie, in *1858*. *1859* received commission to illustrate Trollope's novels, a task which took him five years to complete. *1860* birth of his fourth child, Mary; *1862* birth of Alice, his third daughter; settled in London at 7 Cromwell Place, South Kensington. *1863* elected full member of the Royal Academy; paintings of a sweet domestic genre proliferate and reward him with great public acclaim; Geoffrey, his sixth child, born. *1865* visited Italy with Sir William Harcourt; a seventh child, John, is born. *1868* visited Paris with W.P. Frith; Sophie, his eighth child is born. *1870* began to paint popular subject pictures such as 'The Boyhood of Raleigh' and 'The Princes in the Tower' (1878), society portraits such as 'Lily Langtry' (1878) 'Carlyle' (1877) and 'Gladstone' (1879), and large Scottish landscapes. *1871* founded the Artists' Benevolent Institution. *1875* visited Holland to see the Rembrandt collection in The Hague. *1878* moved into his newly built house at 2, Palace Green, Kensington (designed by Philip Hardwick); awarded the French Medal of Honour. *1881* invited by the Uffizi Gallery, Florence, to paint a self-portrait; exhibition of his collected works held at the Fine Art Society. *1882* elected member of the German order, Pour le Merite. *1885* accepted offer of baronetcy. *1886* retrospective exhibition at the Grosvenor Gallery; painted 'Bubbles', a portrait of his grandson, William James. *1889* instrumental in setting up the National Portrait Gallery. *1892* cancer of the throat diagnosed. *1896* elected President of the Royal Academy following the death of Leighton, *20 February*. *13 August 1896* died of cancer of the throat; buried in St. Paul's Cathedral.

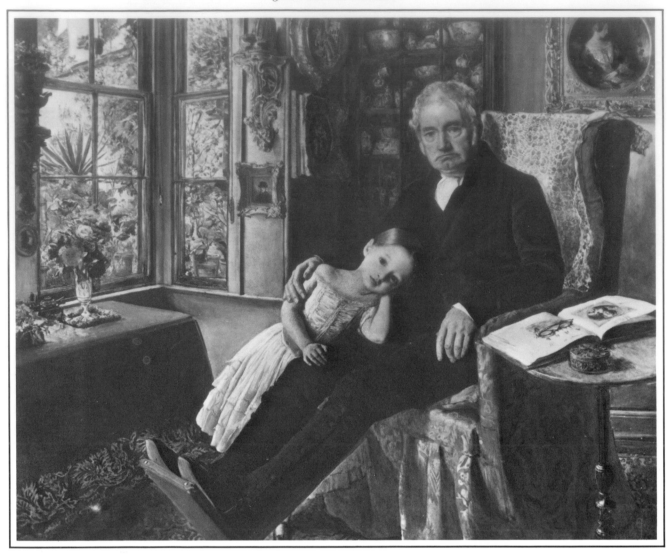

Mr James Wyatt and his Granddaughter Mary

Oil on panel, 352 × 450 mm
Signed in monogram and dated: *JEM 1849*
Private collection

James Wyatt (1774 – 1853) was an Oxford picture dealer and frame-maker, an important civic figure who had been Mayor of the city from 1842 – 3. He bought Millais' 'Cymon and Iphigenia' which had been painted in 1847 for the 1848 Royal Academy Exhibition but had been rejected. Mr Wyatt was, however, so delighted with this picture that he invited Millais to his home and commissioned him to paint two portraits, one of himself and his granddaughter, and another of his daughter-in-law with her daughter Sarah.

Both portraits are interesting in the light of Millais' contact with Pre-Raphaelitism in 1848; technically the portraits that he made for Mr Wyatt are more tautly painted than 'Cymon and Iphigenia'. The comments of a contemporary critic reflect the influence of Pre-Raphaelite teachings on Millais' painting at this date:

'The infinite patience and imitative skill in draughts-manship, the brilliancy of execution, and the power of reproducing the brightness of sunlight, have manifestly been acquired before the lesson had been learned of harmonious effect and of subordinating the parts to the whole. This portrait of Mr Wyatt, the print and picture dealer and frame-maker of Oxford, who died in 1853, is unflinchingly true and as matter-of-fact, despite its character, as the flowers in the room and in the garden, or the family china in the case behind him. It has all been set down with pitiless and remorseless solicitude. The quaint little Dutch doll-like child has received the painter's most earnest attention, and the head of Mr Wyatt has been stippled up as carefully as that of Mr Combe, at Oxford.'

It was while Millais was at Oxford to paint this double portrait that he first met Thomas Combe, who was among the first serious patrons of Pre-Raphaelite work. He and his wife took a kindly personal interest in the nineteen-year-old artist, and invited him to their home the following year to paint Combe's portrait. Millais duly did both these things, completing not only a portrait of Combe during the autumn of 1850 (Ashmolean Museum, Oxford) but also two oils, 'The Moated Grange' and 'Ferdinand lured by Ariel', this latter bought by James Wyatt.

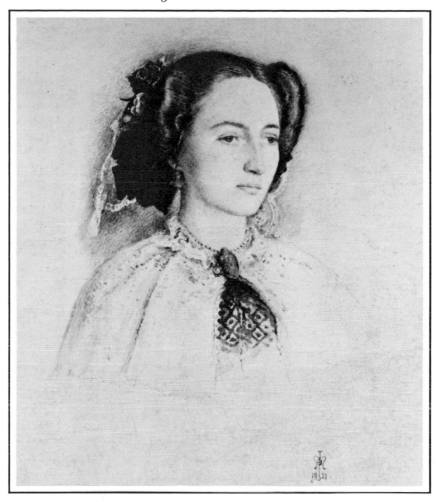

Effie Ruskin

Watercolour on paper, 254 x 216 mm
Signed in monogram and dated: *1853*
Private collection

Effie Ruskin (1828 – 98) was born Euphemia Chalmers Gray, daughter of George Gray, of Bowerswell, Perth, an old friend of Ruskin's father, and by profession Writer to the Signet. She married John Ruskin on 10 April 1848. Effie at the time was vivacious, clever, pretty and proud of a husband who already commanded esteem in London's critical and artistic circles. Pauline Trevelyan, who called on her early in her marriage, reported to her father that indeed 'she seemed to think nobody like John'. The marriage proved untenable, and when Effie was planning to leave Ruskin in 1854, she confessed in a letter to her father what she considered to be the true reason behind the failure of her marriage:

> 'I had never been told the duties of married persons to each other and knew little or nothing about their relations in the closest union on earth. For days [this was during the honeymoon] John talked about this relation to me but avowed no intention of making me his Wife. He alleged various reasons. Hatred to children, religious motives, a desire to preserve my beauty, and finally this last year . . . that he had imagined women

were quite different to what he saw I was, and that the reason he did not make me his Wife was because he was disgusted with my person the first evening.'

By 1852 Effie's marital worries seem to have been well aired in society, not least as a result of Effie's indiscreet conversations on the subject to various acquaintances; Effie herself suspected that Ruskin's father was trying to compromise her with Millais, then a frequent visitor to the Ruskins' home in Herne Hill. Nevertheless Millais was invited to accompany the Ruskins on holiday in Perthshire and they made the journey via Wallington Hall, Pauline Trevelyan's home in Northumberland. The party arrived at Wallington on 22 June and stayed until the 29th. It was Millais' first visit to the North and he delighted in the scenery. It was during the stay at Wallington that he drew this sketch of Effie, 'very beautiful, rapidly done and a good likeness', as Pauline's husband Calverley wrote. In all probability Millais and Effie established some form of friendship during this stay, for William Bell Scott, though not always the most reliable source, alludes to the visit in his memoirs:

> 'Already apparently before they reached Northumberland, the handsome hero had won the heart of the unhappy Mrs Ruskin, whose attentions from her husband had it seems consisted in his keeping a notebook of the defects in her carriage or speech.'

John Ruskin at Glenfinlas

Opposite:
Oil on canvas, 787 × 679 mm
Signed in monogram and dated: *JEM 1854*
Private collection

This portrait of Ruskin was begun in July 1853 on an eventful holiday that Millais and his brother William took with the Ruskins in Perthshire. Millais had been introduced to Ruskin shortly after Ruskin had championed the Pre-Raphaelite cause in several letters to *The Times* in May 1851. Millais at this date was singularly ignorant of Ruskin's writings and had not read Ruskin's influential discussion on the nature of sincerity in art in *Modern Painters* (Vol. 1, 1843). Ruskin, however, lauded Millais' art through the columns of *The Times,* maintaining that nothing so earnest and complete had yet been achieved in art as his painting, 'Mariana'; he went even further in his Edinburgh lectures of 1853, when he told his audience:

> 'I thank God the Pre-Raphaelites are young, and that strength is still with them, and life, with all the war of it, still in front of them. Yet Everett Millais, in this year, is of the exact age at which Raphael painted the 'Disputa', his greatest work. . . .'

Millais and the Ruskins arrived in Callander on 3 July 1853, having spent a week with Pauline Trevelyan at Wallington. Millais and his brother put up at the New Trossachs Hotel while the Ruskins stayed at the Manse, some five hundred yards away. Millais' attention was caught by a bend in the river Finlass and he selected it as the spot for a portrait of Ruskin, who was an amateur botanist and geologist of some distinction. As Ruskin wrote to his father within three days of their arrival in Callander:

> 'Millais has fixed on his place, a lovely piece of worn rock, with foaming water and weeds and moss, and a whole overhanging bank of dark crag; and I am to be standing looking quietly down the stream; just the sort of thing I used to do for hours together. He is very happy at the idea of doing it, and I think you will be proud of the picture, and we shall have the two most wonderful torrents in the world, Turner's "St Gothard" and Millais' "Glenfinlas". He is going to the utmost possible pains with it, and says he can paint rocks and water better than anything else. I am sure the foam of the torrent will be something quite new in art.'

In fact Millais experienced not a little difficulty in painting the rocks and left the portrait unfinished when he left Scotland at the end of October. He returned in the following spring to the Trossachs to complete it. The painting in many ways asserts Ruskin's views of truth to nature in painting, but behind it lies a record of the loosening of Ruskin's personal hold over Millais. For it was while on this same holiday in Scotland that Millais fell in love with Ruskin's wife Effie, leading eventually to the annulment of Ruskin's marriage and Millais' own marriage to Effie in 1855. The inevitable anxieties to which Millais was subjected during the Scottish holiday were productive of some of Millais' finest drawings, delicate as the emotional tightrope which he must have felt he was walking at the time. Ruskin showed an objectivity towards Millais' painting at the time which falls little short of noble. He wrote to his father in November 1853, after the holiday was over, to say of Millais that:

> 'I have watched him painting, have led him to a kind of subject of which he knew nothing, and which in future he will always be painting. I have had a wonderful opportunity of studying the character of one of the most remarkable men of the age — and have arrived at conclusions which fifty years of mere *reflection* could never have opened to me. . . .'

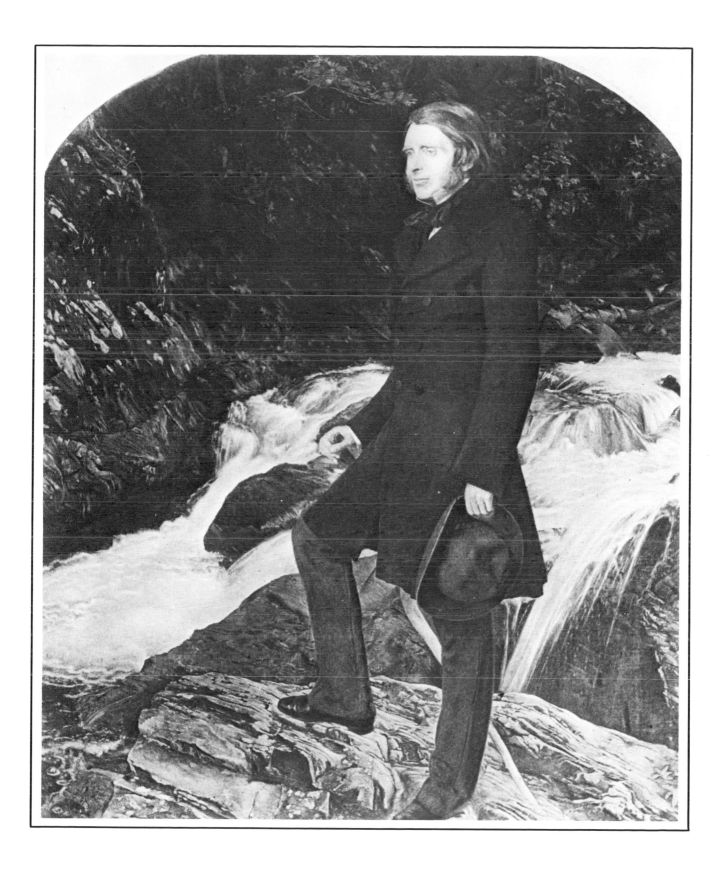

Effie in Natural Ornament

Pen and sepia ink, 235 × 233 mm
City Art Gallery and Museum, Birmingham

In June 1853 Millais and his brother William were invited by Ruskin and his wife to join them on a holiday in Scotland. They stayed for several weeks in Callander, Perthshire, and in August Millais wrote to Mr Combe in Oxford about some of their occupations.

'Ruskin and myself are pitching into architecture; you will hear shortly to what purpose. I think now I was intended for a Master Mason. All this day I have been working at a window, which I hope you will see carried out very shortly in stone. In my evening hours I mean to make many designs for church and other architecture, as I find myself quite familiar with constructions, Ruskin having given me lessons regarding foundations and the building of cathedrals etc. etc. This is no loss of time — rather a real relaxation from everyday painting — and it

is immensely necessary that something new and good should be done in place of the old ornamentations.'

Ruskin at the time was preparing a series of lectures on Architecture and Painting which he was to deliver to the Edinburgh Institute in November. In them he was to expound his views on the decoration and ornamentation of buildings. He wanted to see the use of ornament derived from natural forms, and while on holiday with Millais in Callander, got his young friend to draw examples of fauna and flora as embellishments to both domestic and ecclesiastical buildings. In this sketch of Ruskin's wife, Millais has taken the idea to its logical conclusion. Effie is adorned with a necklace of trailing convulvus, a bracelet and epaulettes of crawling lizards, a bodice of squirrels and pineapple and a floral diadem surmounted by a squirrel and ears of corn. To her left a wall cupboard is supported by a bracket in the shape of an owl with a mouse in its beak, and two outstretched bats on either side.

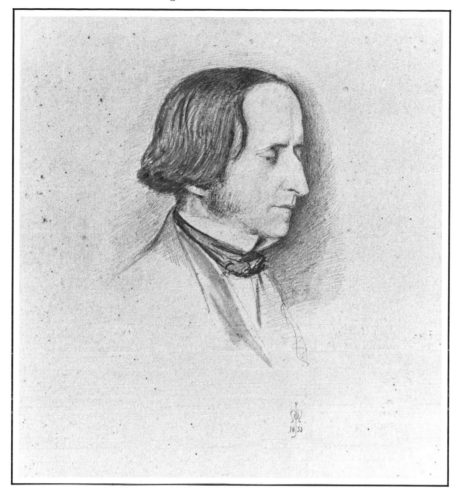

Henry Wentworth Acland

Pencil touched with watercolour on paper, 368 × 263 mm
Signed in monogram and dated. *JEM 1853*
The Ruskin Galleries, Bembridge School, Isle of Wight

The eminent physician, Dr Henry Acland (1815 – 1900) was at Christchurch College, Oxford, with Ruskin and remained a close friend of the critic throughout his life. Through Ruskin he became acquainted with many members of the Pre-Raphaelite circle, and in 1853, when this drawing was made, joined Ruskin, Effie and the two Millais brothers on their fateful holiday in Scotland.

Acland was called by Ruskin to diagnose the weakness of Lizzie Siddal in 1854, and his judgement, that her ill-health was due to 'mental power long pent up and lately over-taxed', was probably as accurate an assessment of the neurotic feature of her sickness as could be given at the time; other medical advisers had suggested weak lungs or incipient tuberculosis as the cause of her phthisis. Ruskin had also shown Acland Lizzie's drawings and the good doctor was impressed that 'a girl brought up in London within a street or two of the Elephant and Castle' could produce such imaginative work: she later presented him with one of her best watercolours, an illustration to Wordsworth's *We are Seven*.

For a short period in 1855 Lizzie moved to Oxford under the care of Acland, who introduced the Pre-Raphaelite stunner to admiring Oxford dons. Acland's reputation was itself admirable. A Reader in anatomy and Fellow of Christchurch and All Souls, Acland became a recognised authority on hygiene and sanitary reform after an outbreak of cholera in Oxford in August 1854. He took a leading part in the relief work and later published important evidence connecting river pollution with the disease. His research earned him the Regius Professorship of Medicine at Oxford in 1857 and he was one of the principal founders of Woodward's Oxford Museum and Science Library. His interests in natural history brought him into close contact with Sir Walter Calverley Trevelyan, the owner of Wallington, with whom Ruskin was also extremely close.

Acland's friendship with Ruskin was intimate and privileged beyond the bounds of common acquaintance. Acland was one of only two friends (Trevelyan being the other), to whom Ruskin confided the full details concerning his marital affairs. In fact he revealed himself to Acland more unreservedly and injudiciously than to any other correspondent. He wrote to Acland, shortly after the dissolution of his marriage, from France, where he had been ruefully witnessing the crude efforts at restoration at Rouen and other Gothic cathedrals in northern France. 'My real griefs are about other matters', he wrote off-guardedly, in a conversation concerning his feelings about his recent marital break, 'I could get another wife, if I wanted one, but I cannot get back the north transept of Rouen Cathedral.'

Alexander Munro

Pencil on paper, 260 × 222 mm
Signed and dated: *John Everett Millais/12 April 1853*
William Morris Gallery, Walthamstow

The sculptor Alexander Munro (1825-71) was closely connected with the Pre-Raphaelite Brotherhood but never elected a member of the group. He was a particular friend of Rossetti, and it was Rossetti who confided in him the meaning of the secret initials 'P. R. B.' which the Brotherhood used to sign their canvases in the early days of the movement. Munro purportedly divulged this information to the press and it unleashed a storm of criticism among the picture reviewers. They were worried that such secrecy and fraternity hinted at an attempt to subvert British art and they berated the first P. R. B. efforts loudly:

> 'A school of Artists whose younger members unconsciously write its condemnation in the very title which they adopt — that of Pre-Raphaelite. . . . Their ambition is an unhealthy thirst, which seeks notoriety by means of mere conceit. Abruptness, singularity, uncouthness are the counters with which they play for fame. Their trick is to defy the principles of beauty and the recognised axioms of taste.'

Despite this breach of confidence and the abuse which followed, Munro remained a close friend of Rossetti's, and was heavily influenced by his ideas; his most successful sculpture, 'Paola and Francesca', shows not only the influence of Rossetti's Dantesque imagination, but also exhibits how some of the Pre-Raphaelite ideas about simple contour and linear composition were adapted to the difficult medium of sculpture. He also carved the relief of 'King Arthur and his Knights' from a design of Rossetti's for the vestibule of the Oxford Union Debating Hall, whose halls Rossetti and his group of followers were invited to decorate in 1857.

Munro happened to call on Millais' studio in Gower Street on the evening when the members of the Brotherhood met to draw portraits of one another to send to Woolner in Australia. Arthur Hughes related the circumstances by which Millais drew this portrait of Munro.

> 'While Wooner was in Australia his Pre-Raphaelite Brothers agreed to draw one another and send the drawings out to him; and one day when two or three of them were about this at Millais' house, Alexander Munro, the sculptor, chanced to call. Millais, having finished his Pre-Raphaelite Brotherhood subject, got Munro to sit, and drew him and afterwards accompanied him to the door with the drawing in his hand, to which Munro was making some critical objection that Millais did not agree with. There happened to be passing at that time a couple of rough brick-layers fresh from their work — short pipes and all. Millais suddenly reached out from the doorstep and seized one, to his great surprise, and there and then constituted them judges to decide upon the merits of the likeness, while Munro, rather disconcerted, had to stand in the street with his hat off for identification.'

Ford Madox Brown

Pencil and watercolour on paper, diameter 114 mm
Signed in monogram and dated: *JEM 1853*
Ashmolean Museum, Oxford

Millais' relations with Brown were cordial though never specially warm. Shortly before the Pre Raphaelite Brotherhood was formed, another artistic association, The Cyclographic Club, was in existence; many of its members were later part of the Pre-Raphaelite group, among them Millais, Hunt, Deverell, Hughes and Rossetti. Millais in particular was irritated by Brown's refusal to join the club, and opined that Brown was 'a peevish old chap'. Brown was initially more generous in his assessment of Millais. In May 1851 he wrote to Lowes Dickinson in Rome, to tell him the latest news of Pre-Raphaelite affairs:

'As to the pure white ground, you had better adopt that at once, as I can assure you you will be forced to do so ultimately, for Hunt and Millais, whose works already kill everything in the exhibition for brilliancy will in a few years force everyone who will not drop behind them

to use their methods. . . . For my own opinion, I think Millais' pictures as small pictures, more wonderful than any I have yet seen.'

Brown, however, grew disillusioned with Millais. In 1852 Brown was working on his picture of 'Jesus washing Peter's Feet', but twelve days before the sending-in date for the Royal Academy, he gave up in despair. It was Millais who prompted him to continue and who gave him advice on how to lay in the ground. Brown subsequently recorded in his diary that:

'The picture was painted in four months, the flesh painted on *wet white* at Millais' lying instigation; Robertson's medium, which I think dangerous like Millais' advice.'

This relaxed portrait of Brown is rather different from the more tautly drawn portraits of him by Rossetti. It is ironic that 1853, the year that this drawing was made, Brown ceased to exhibit further at the Royal Academy, while Millais was elected to its ranks as an Associate Member.

John Leech

Watercolour on paper, 266 × 216 mm
Signed in monogram and dated: *JEM 1854*
National Portrait Gallery, London

Millais was first introduced to Leech (1817 – 64), the celebrated cartoonist and illustrator of *Punch*, in 1851; it was the start of a life-long friendship. By all accounts an amusing and genial companion, Leech was intimate with Thackeray, Trollope, Frith and Du Maurier, and it was the latter who described him as:

> '. . . tall, thin and graceful, extremely handsome, of the higher Irish type, with dark hair and whiskers and complexion, and very light greyish-blue eyes; but the expression of his face was habitually sad, even when he smiled.'

Leech was an avid huntsman and introduced Millais to the sport despite Millais' initial aversion. The initiation gave rise to one of Leech's most famous cartoons for *Punch*, which Millais' son tells as follows:

'Leech had introduced him to a bootmaker in Oxford Street for his first "tops"; and according to his account . . . the incident was not lacking in amusement. Being but a stripling of twenty-one or thereabouts, his calves were but in embryo state so mortifying to young manhood. He was delighted therefore when, on measuring him, the shopman said with an air of admiration, "Ah, sir, what a fine leg for a boot!" But the conclusion of the sentence was not quite so satisfactory – "Same size all the way up". Leech was so amused with this that he immortalised the scene in *Punch*, and on more than one occasion afterwards my father sat as a model for some of his clever drawings in that periodical.'

In fact Leech was often Millais' guest in Scotland where he lived part of the year after his marriage to Effie Ruskin, and Leech drew cartoons illustrating the exploits of a Mr Briggs, caricaturing his own experiences as Millais' deer-stalking, grouse-hunting companion on the Scottish moors.

Wilkie Collins

Oil on panel, 266 × 178 mm
Signed in monogram and dated: *JEM 1850*
National Portrait Gallery, London

The novelist Wilkie Collins (1824 – 89) was a close friend of Millais from early Pre-Raphaelite days, and he and his brother Charles Allston Collins were his frequent companions in the early 1850s. Millais and Collins were together when an incident took place which is said to have triggered the story of Collin's classic thriller, *The Woman in White:*

> 'One night in the fifties Millais was returning home to Gower Street from one of the many parties held under Mrs Collins' hospitable roof in Hanover Terrace, and, in accordance with the usual practice of the two brothers, Wilkie and Charles, they accompanied him on his homeward walk through the dimly-lit, and in those days semi-rural roads and lanes of North London. It was a beautiful moonlight night in the summer time, and as the three friends walked along chatting gaily together, they were suddenly arrested by a piercing scream coming from the garden of a villa close at hand. It was evidently the cry of a woman in distress; and while pausing to consider what they should do, the iron gate leading to the garden was dashed open, and from it came a figure of a young and very beautiful woman dressed in flowing white robes that shone in the moonlight. She seemed to float rather than run in their direction, and on coming up to the three young men, she paused for a moment in an attitude of supplication and terror. Then seeming to recollect herself, she suddenly moved on and vanished in the shadows cast upon the road.
>
> "What a lovely woman!" was all Millais could say. "I must see who she is and what's the matter", said Wilkie Collins, as, without another word, he dashed off after her. His two companions waited in vain for his return, and next day, when they met again, he seemed indisposed to talk of his adventure. They gathered from him however that he had come up with a lovely fugitive and had heard from her own lips the history of her life and the cause of her sudden flight. She was a young lady of good birth and position, who had accidentally fallen into the hands of a man living in a villa in Regent's Park. There for many months he kept her prisoner under threats and mesmeric influence of so alarming a character that she dared not attempt to escape, until, in sheer desperation, she fled from the brute, who, with a poker in his hand, threatened to dash her brains out.'

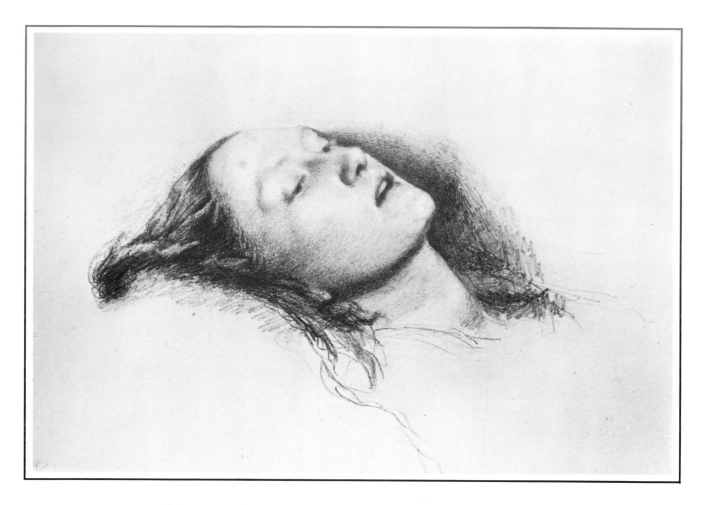

Elizabeth Siddal (Study for the head of Ophelia)

Pencil on cream paper, 190 × 266 mm
City Museum and Art Gallery, Birmingham

'Ophelia' was the only painting by Millais for which Elizabeth Siddal sat as his model. Millais had begun work on it in the summer of 1851, beside the river Ewell near Kingston upon Thames. He continued work on the background at Worcester Park Farm where he joined Holman Hunt and Edward Lear later that summer, and in December invited Elizabeth Siddal to sit for him in his Gower Street studio. The conditions under which she modelled illustrate Millais' concern for accuracy at this date and are recalled by Millais' son:

> 'Miss Siddal had a trying experience whilst acting as model for "Ophelia". In order that the artist might get the proper set of the garments in water and the right atmosphere and aqueous effects, she had to lie in a large bath filled with water, which was kept at an even temperature by lamps placed beneath. One day, just as the picture was nearly finished, the lamps went out unnoticed by the artist, who was so intently absorbed in his work that he thought of nothing else, and the poor lady kept floating in the cold water till she was quite benumbed. She herself never complained of this, but the result was that she contracted a severe cold, and her father . . . wrote to Millais, threatening him with an action for £50 damages for his carelessness. Eventually the matter was satisfactorily compromised.'

William Michael Rossetti thought the resulting portrait of Lizzie the most like he had ever seen, and testimonies to the photographic exactness of the finished painting of 'Ophelia', which was first exhibited at the Royal Academy in 1852, poured in from all quarters. Many years later a Professor of Botany was seen to take his class into the Guildhall, where the picture was on view in 1892, to lecture on the botanical specimens in the canvas as he was unable to take his pupils out into the countryside to study the flora at first hand.

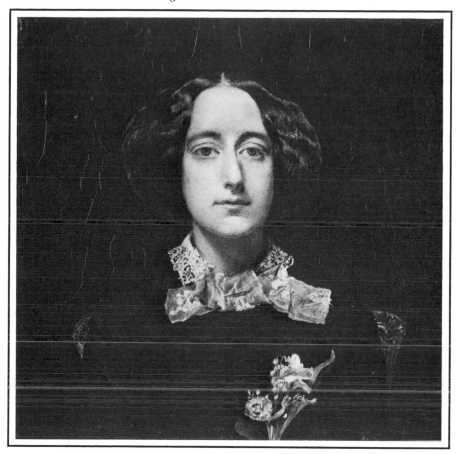

Mrs Coventry Patmore

Oil on panel, 196 × 203 mm
Fitzwilliam Museum, Cambridge

Emily Augusta Andrews was the first wife of the poet Coventry Patmore, who was nicknamed 'the Vampire' by the Pre-Raphaelites. Patmore had published a slight volume of poems in 1844 and on the strength of this was nominated by Rossetti somewhat rashly as a 'stunner'. He contributed two poems to *The Germ* in 1850 and helped the young artists by encouraging Ruskin to defend them against critical abuse in the press. Patmore's wide acquaintance with the literati of the day was also helpful to the Pre-Raphaelites, and his hospitable home in Highgate Rise was frequently the scene of literary gatherings where Tennyson, Carlyle, Browning, Woolner and Rossetti gathered in relaxed and informal company.

Many of these literary lions acknowledged Emily Patmore's virtues: Millais painted this portrait of her in 1851 and Browning used her as the model in his poem *The Face,* where he celebrates the ideal of beauty held by the Pre-Raphaelites in the early days of the movement. But the poem in which Emily was most elegantly praised was in her husband's panegyric on married love, *The Angel in the House,* the first part of which was published in 1854. Here Patmore's ideal of womanhood is exposed: a woman should be modest, gentle, attentive, utterly devoted to the needs of her husband, and yet maintaining a distance from him that will nurture the essence of romance between them:

He who would seek to make her his
Will comprehend that souls of grace
Own sweet repulsion, and that 'tis
The quality of their embrace
To be like the majestic reach
Of coupled suns, that, from afar,
Mingle their mutual spheres, while each
Circles the twin obsequious star.

Despite romance, Emily managed her practical duties with singular capability. An orphan, she married Patmore when she was twenty-three, bearing him six children in quick succession and keeping a household with careful economy on his small earnings as assistant librarian at the British Museum. She wrote books for children, published a manual of domestic service, *The Servants Behaviour Book,* and in ministering to the cares of her husband she was exemplary — 'feeling', as Patmore gave testimony, 'every vibration of my irregular moods, yet never showing impatience'.

The Angel in the House was one of the most successful poems of its time, a standard nuptial gift, in red morocco binding, until the turn of the century, and admired by Ruskin as 'blessedly popular, doing good wherever it goes'.

Emily died before the final volume of the poem was published. Ironically Patmore's idealistic portrayal of womanhood was at odds with the 'lusts of the flesh' which he confessed that he suffered throughout his life. On his death a set of reprints of the world's erotic literature was found in his library.

William Morris

24 March 1834 born in Walthamstow, the son of a well-to-do discount broker. *1840* family moved to Epping Forest; Morris educated at a preparatory school in Walthamstow, and in *1848* entered Marlborough College; removed by his mother in *1851* following student riots. *1853* went up to Exeter College, Oxford to read Divinity in preparation for a career in the church. Met Burne-Jones and a group of literary men known as the 'Birmingham Set': Richard Dixon, James Faulkner and William Fulford. They discussed forming a Brotherhood; both Morris and Burne-Jones were thinking seriously of becoming Roman Catholics at this stage. *1854* first trip abroad, to Belgium and Northern France. *1855* attained his majority and an annual income of £900; toured Northern France with Burne-Jones and Fulford and decided to become an artist. Took his degree, and in *1856* apprenticed himself to G.E. Street. *1856 The Oxford and Cambridge Magazine* was founded by the 'Birmingham Set', to which Morris contributed articles, prose romances and poetry. (It ran for twelve months.) Met Rossetti, Ford Madox Brown and Holman Hunt in London and decided to leave Street's offices. *1857* participated in the painting of the Oxford Union Murals; met Jane Burden in October. *1858* published *The Defence of Guenevere. 1859* married Jane Burden. *1860* moved into the newly built Red House, designed by Philip Webb from Street's office. *1861* birth of his daughter, Jenny; foundation of his decorating firm, Morris, Marshall, Faulkner and Co. *1862* birth of his second daughter, May, and production of his first wallpaper design, 'The Trellis'. *1867* publication of *The Life and Death of Jason. 1868* publication of the first part of *The Earthly Paradise;* he became interested in Norse saga and began studying the language. *1869* published *The Saga of Gunnlaug Worm Tongue;* followed by *The Volsung Saga* and *A Book of Verse* the next year. *1871* took on the joint tenancy of Kelmscott Manor with Rossetti; first visit to Iceland. *1873* visited Iceland again and published *Love is Enough. 1875* Morris, Marshall, Faulkner and Co. dissolved and reconstituted as Morris and Co.; published his translation of *The Aeneid. 1877* founded the Society for the Protection of Ancient Buildings (later known as Anti-Scrape); Morris and Co. moved to premises in Oxford St. *1878* family moved to Kelmscott House, Hammersmith. *1879* increasing political involvement; became Treasurer of the National Liberal League. *1883* joined Democratic Federation. *1884* published *Art and Socialism* and *A Summary of the Principles of Socialism.* Founded the Socialist League, *December, 1884. 1885 The Commonweal: Chants for Socialists* first published, a weekly paper with Morris as editor. *1889* attended the Second International in Paris. *1891* founded the Kelmscott Press in Hammersmith. *1893* wrote volubly on Socialism, including *How I became a Socialist* in *1894.* Work on the Kelmscott Chaucer begun. *3 October 1896* died at his home in Hammersmith; buried in Kelmscott Village churchyard.

William Morris (Self-portrait)

Overleaf:
Pencil on paper, 220 × 280mm
Signed in monogram and dated: *July 29th*
Victoria and Albert Museum, London

This self-portrait was probably drawn in 1857 when Morris was twenty-three, at which age he was dominated by the personality of Rossetti. Both Morris and Burne-Jones had gone up to Oxford in 1853 intending to take orders. While at university, however, they were influenced by Ruskin and, after seeing Pre-Raphaelite pictures, they left the university in 1856 determined to devote their lives to art. Burne-Jones moved directly to London and placed himself under the informal supervision of Rossetti; Morris was articled for a few months to the Oxford architect G. E. Street, but encouraged by Rossetti to become a painter, soon abandoned architecture and moved to London to share a studio with Burne-Jones.

> 'Topsy [Burne-Jones' nickname for Morris] and I live together in the quaintest room in all London, hung with brasses of old knights and drawings by Albert Dürer. We know Rossetti now as a daily friend, and we know Browning too, who is the greatest poet alive. . . . Topsy will be a painter, he works hard, is prepared to wait twenty years, loves art more and more every day. He has written several poems, exceedingly dramatic — the Brownings, I hear, have spoken very highly of one that was read to them; Rossetti thinks one called *Rapunzel* is equal to Tennyson. . . .'

Although clearly caught in the web of Rossetti's intensely medieval imagination, both Morris and Burne-Jones helped to weave the pattern a little more richly, and contributed not a little, through their mutual appreciation of all things Gothic, to the remarkably intense series of watercolours on Arthurian legends that Rossetti painted during the 1850s.

At Oxford their enthusiasm for Tennyson and Walter Scott led Morris and Burne-Jones to an independent discovery of Mallory's *Morte d'Arthur,* a book which, unbeknown to them, Rossetti had already named, together with the Bible, as 'the two greatest books in the world'. Their mutual delight in such Frossartian pleasures provided the perfect context in which the commission to paint the wall of the Oxford Union Debating Hall was undertaken in 1857. Rossetti and Morris had visited Oxford in June 1857 with the architect Benjamin Woodward to see the two new buildings he was working on, the University Museum (for natural history) and the Debating Hall at the Union. Dr Acland, one of the moving spirits behind the construction of the University Museum, was also a close friend of Ruskin and had been advising Lizzie Siddal on her health since 1855. Both Acland and Ruskin were anxious to interest Rossetti in the decoration of the Museum. In the event Rossetti was less interested in the scientific themes proposed for the murals (for example, 'Newton gathering pebbles on the shore of the ocean of Truth'), than in the liberty to choose his own subject for the Debating Hall. He gathered about him a team of seven inexperienced enthusiasts, including Morris and Burne-Jones, and chose *Morte d'Arthur* as the theme.

Morris's chosen idyll was *Sir Palomydes' jealousy of Sir Tristram,* a story which was later to have a tragic parallel in his own life: that of the despised lover. In 1857, however, Morris was the reverse of the rejected lover. During the painting of the Murals, the 'Jovial Campaign' as it was called, the artists were frequently in pursuit of 'stunners'. One such stunner was Jane Burden, the handsome daughter of a Holywell groom whom Rossetti and Burne-Jones spotted at the theatre. She was subsequently introduced into the Pre-Raphaelite group, and sat for both Rossetti and Morris. Eighteen months later, in April 1859, she and Morris were married in the church of St Michael at the North Gate, a stone's throw from the Union.

Caricature (right) by Edward Burne-Jones.

Charles Fairfax Murray

3 September 1849 born in London to a family of modest income. After a scant formal education he was placed as a clerk in an engineering office; his love of drawing flourished and he taught himself by copying in the National Gallery. While still in his teens he attracted the notice of Rossetti, Burne-Jones, Webb and Morris, with all of whom he remained on terms of intimacy until their deaths. Ruskin so admired his skill as a copyist that he sent him to Italy to make copies of the Old Masters; his copies of Carpaccio and Botticelli were among the principal treasures of the St. George's Guild, and Ruskin said of him that 'he is beyond compare the most skilful of the group of artists' he employed. *1867* began exhibiting at the Royal Academy with 'Children in the Woods'. Employed by Rossetti at a nominal weekly sum as a copyist and general factotum: 'he was always ready to do any friendly and good-natured service to my brother, such as copying his poems from the original manuscript, or sending him photographs . . . from Italian works of art interesting or useful to him.' (W.M. Rossetti). Also employed by Burne-Jones to transfer his cartoons to glass and did general work of the same nature for Morris, Marshall, Faulkner and Co. More critical than creative, he began to amass a private collection of Old Masters, rare books and manuscripts, 18th-century English paintings and Pre-Raphaelite works. He was closely associated with Agnews, advising them particularly on the purchase of Italian pictures, and gained a reputation as a 'marchand amateur'. 'Some people wonder,' he said, 'how it comes about that a man like myself, who started without a sixpence, should have got together so big a collection — but the fact is I have got a natural instinct for detecting artistic quality.' *1879* started to exhibit successfully at the Grosvenor Gallery, his works closely influenced by Burne-Jones. Donated important works to the National Gallery, Dulwich Picture Gallery and the Fitzwilliam Museum. His huge collection of drawings was sold to Pierpont Morgan, all except for the Pre-Raphaelite drawings, which are now in Birmingham City Art Gallery. *25 January 1919* died at his home in Chiswick.

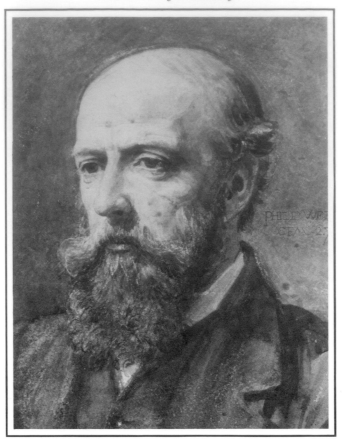

Philip Webb

Oil on canvas, 314 × 254 mm
Signed: *PHILIP WEBB/C.F.M. 2.7.73/*
National Portrait Gallery, London

Born in Oxford, the architect Philip Webb (1830 – 1915) was an important collaborator with Morris in the effort to reform British design standards. Webb trained as an architect in the office of the Reading architect John Billing, and in 1852 he became chief assistant to G. E. Street, one of the most original Gothic revival architects of the period. Street was then experimenting with coloured materials, deftly simplifying Gothic detail in the rectories, churches and village schools he was building, and gradually formulating an architectural language which Webb later exploited.

Morris joined Street's Oxford practice in 1856 where he stayed only a few months. His friendship though with Webb, whom he met there, lasted a lifetime and their admiration for Gothic architecture was based on a shared concern for fundamental social equality. For Morris the greatness of Gothic architecture was that:

'. . . it is common to the whole people; it was free, progressive, hopeful, full of human sentiment and humour . . . the outcome of corporate and social feeling, the work not of individual but collective genius, the expression of a great body of men conscious of their union.'

For Webb the same sentiment prevailed, though he phrased it characteristically in less universal terms: 'I never begin to be satisfied until my work looks commonplace'. In 1859 Webb's fortunes became identified with those of Morris. He left Street's practice to set up independently and one of his earliest commissions was for Morris' first marital home, Red House in Upton, Kent.

An elegant resolution of Street's and Butterfield's Gothic designs, Red House featured steep-tiled rooves, sash windows, brick walls and tall battered chimney breasts that were to become hallmarks of Webb's work, and which Webb saw as a 'common tradition of honest building'. More important than the design of the building, however, was Webb's discovery, made while looking for appropriate furnishings for the house, that British design was execrable. Both he and Morris had to design most of the furnishings for the house themselves, and their activities made them take seriously Ford Madox Brown's suggestion that they should establish an art decoration business. The Firm, as it later became known, was founded in 1861, and influenced design reform and the revival of craftsmanship for the remainder of the century.

In 1862 Webb designed a row of shops for Major Gillum's Boys' Home and the boys there made furniture, to Webb's designs, which were given to Burne-Jones as a wedding present. In Ford Madox Brown's 'Work', one of the posters in fact advertises this same Boys Home, at 41 Euston Road. Webb's own designs for the Firm pioneered the taste for simple, uncluttered lines, and established a vernacular tradition both in furniture and architectural design that became a feature of the Arts and Crafts Movement.

Val Prinsep

14 February 1838 born in Calcutta, son of an Anglo Indian administrator and Sarah Monckton (nee Pattle), sister of the photographer, Julia Margaret Cameron. *1843* family returned to England; Prinsep educated at Haileybury with a view to his joining the Indian Civil Service. He rejected the notion in favour of becoming an artist, encouraged by his intimacy with G.F. Watts, who lived in the Prinsep's genial home, Little Holland House, for twenty-five years. Little Holland House was also one of the principal salons of artistic London: Tennyson, Thackeray, Gladstone and Disraeli were all habitues, as were artists such as Rossetti, Hunt and Dicky Doyle. *1856-7* visited Halicarnassus with Watts to watch Sir Charles Newton's excavations. *1857* participated in painting of Oxford Union Murals at Rossetti's invitation. *1859* student in Gleyre's studio in Paris, together with Du Maurier (Prinsep was the model for Taffy in *Trilby*), Whistler and Poynter. *1859* visited Sienna with Burne-Jones, and met Browning. *1861* painted his first Academy picture, 'How Bianca Capello sought to poison the Cardinal de Medici' (exhibited 1862); he was an annual exhibitor thereafter. His chief Academy works include: 'A Venetian Lover' (1868), 'Bacchus and Ariadne' (1869) and 'The Linen Gatherers' (1876). *1876* commissioned by the Rajahs of India to paint the Durbar at which Victoria had been pronounced Empress of India; completed in 1882 as 'At the Golden Gate'. *1878* elected associate of the Royal Academy. *1879* published *Imperial India: an Artist's Journals*. *1884* married Florence, daughter of the Liverpool shipowner and Pre-Raphaelite patron, Frederick Leyland. *1890* published his first novel, *Virginie*. *1893* published *Abibal the Tsourian*. *1894* became full Academician. *1901* appointed Professor of Painting. *11 November 1904* died at his home in Holland Park. Buried in Brompton cemetery.

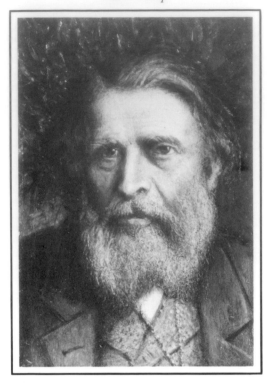

John Ruskin

Watercolour on ivory, 150 × 100 mm
Ashmolean Museum, Oxford

Valentine Cameron Prinsep made his first real contact with Ruskin in 1857 when Rossetti invited him to take part in the decoration of the Oxford Union Murals. Prinsep, who was only nineteen at the time, was aghast at the invitation: he could neither paint nor draw he protested, although he was in fact the pupil of the painter G. F. Watts, who lived in the home of the Prinsep family, Little Holland House in what is now Melbury Road, Kensington. This genial home was one of the chief artistic and intellectual salons of London, frequented by intimates of the Pre-Raphaelite circle as well as by men such as Thackery, Gladstone and Disraeli, and presided over by Val's mother (she was one of seven beautiful and talented Pattle sisters, another of whom was the photographer Julia Margaret Cameron). Val Prinsep was encouraged to join Rossetti in Oxford by Watts, who explained that:

> 'I . . . have plunged him into the Pre-Raphaelite Styx, . . . I found him loitering on the banks and gave him a good shove, and now his gods are Rossetti, Hunt and Millais — to whose elbows more power.'

Behind the whole venture of painting the Oxford Union Murals lies the inspiration of Ruskin. In 1853 the Arundel Society had started to publish wood engravings after Giotti's frescoes in the Arena Chapel in Padua, with descriptive notes written by Ruskin. Ruskin's interest not only in early Italian art but in the nature of architecture was brought before the public the same year, when he delivered a series of lectures on Architecture and Painting before the Edinburgh Institute. Ruskin's architectural principles, expounded both in *The Seven Lamps of Architecture* and *The Stones of Venice,* had had a profound impact on Benjamin Woodward, a partner in the Dublin firm of Deane, Woodward and Deane and who first met Ruskin in 1854. Woodward's designs for both the University Museum and the Debating Hall of the Oxford Union were fundamentally Gothic in inspiration, and Ruskin was particularly anxious that they should be adorned with appropriate embellishment and according to the principles he had advocated in his books and lectures. In 1855 he had encouraged Lizzie Siddal to make designs for the sculptural details of another of Woodward's buildings, Trinity College, Dublin, and he now wanted Millais and Rossetti in particular to provide the interior decoration for the Museum and the Debating Hall, so that his ideal of rich, organic, symbol-laden motifs could be made manifest. Millais and Rossetti, he hoped, would provide 'flower and beast borders — crocodiles and various vermin', for the Museum and there was also talk of Rossetti designing sculpture for the vestibule. Millais did not in fact participate but Rossetti managed to persuade six friends of his, Val Prinsep, Roddam Spencer Stanhope, Burne-Jones, Morris, Hughes and Hungerford Pollen to assist him in painting the murals to decorate the Union Debating Hall.

Prinsep's composition of 'Sir Pelleas and the Lady Ettarde' was not particularly distinguished, although, considering his inexperience, it was surprisingly well conceived. The delicate foreground foliage of this work attests to his thorough digestion of Ruskin's strictures about painting nature with an unswerving objectivity, but perhaps more important than the actual mural was Prinsep's written account of the painting of the Union Murals, *A Chapter from a Painter's Reminiscence,* published in 1904.

Dante Gabriel Rossetti

12 May 1828 born in Charlotte St London, son of an expatriate Italian Carbonaro. *1836-41* attended King's College School. *1841* entered Sass's Drawing Academy. *1845* became a Probationer then a full student at the Royal Academy schools. *1848* introduced himself to Ford Madox Brown and became his pupil for a short time; became friendly with Holman Hunt and Millais and founded the Pre-Raphaelite Brotherhood with them. *1848-9* worked in Hunt's studio and on his first Pre-Raphaelite canvas, 'The Girlhood of Mary Virgin'; on the proceeds of its sale (eighty guineas to the Marchioness of Bath) he visited Northern France and Belgium with Hunt. Initiated plans for *The Germ,* the literary magazine of the Brotherhood, to which he contributed important early poems, *The Blessed Damozel* and *My Sister's Sleep.* Met Elizabeth Siddal. *1852* took rooms at Chatham Place, Blackfriars Bridge. Early public criticism of his pictures deterred him from exhibiting in public and he started to concentrate on watercolours. He always considered himself primarily a poet and most of his work of the fifties was taken from Dante or *Morte d'Arthur. 1857* undertook the painting of the Oxford Union Debating Hall, selecting the artists and organising the scheme. Close collaboration with Burne-Jones and Morris. Met Jane Burden in Oxford. *1859* started work on the commissioned altarpiece for Llandaff Cathedral. Became familiar with Fanny Cornforth. *23 May 1860* married Elizabeth Siddal in St Clement's Church, Hastings, *1861* birth of a still-born child. Published *The Early Italian Poets together with Dante's Vita Nuova.* Founding of Morris' decorative arts firm, in which Rossetti took a financial and executive interest. *1862* death of Elizabeth Siddal through overdose; Rossetti moved to Tudor House, Cheyne Walk. Started to paint in oils again and took on studio assistants, first W.J. Knewstub, then Henry Treffry Dunn. Friendship with Swinburne, Meredith, Howell and Whistler. *1867* renewed intimacy with Mrs Morris. *1869* exhumation of his manuscript poems, thrown into Elizabeth Siddal's grave in Highgate Cemetery on her burial. *1870* publication of *Poems. 1871* appearance of Robert Buchanan's review of *Poems,* attacking Rossetti as leader of 'the Fleshly School of Poetry'. Took on joint-tenancy of Kelmscott Manor with Morris and spent increasing lengths of time there. *1872* mental collapse; recuperation in Scotland, followed by return to Kelmscott Manor. Met Watts-Dunton. *1877* increasing ill health and chloral addiction. *9 April 1882* died at Birchington-on-sea, Kent, and buried in Birchington churchyard.

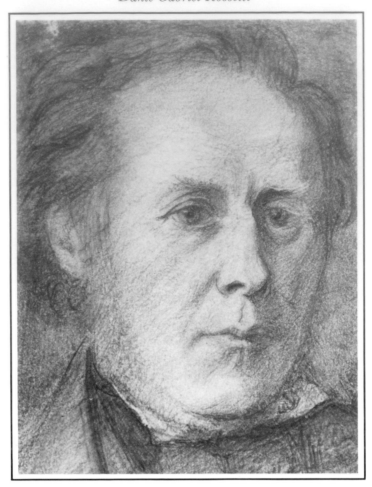

Major Calder Campbell

Pencil on paper, 111 × 86 mm
City Museum and Art Gallery, Birmingham

Rossetti's catholic and independent interests in literature began at an early age when he established a pattern for developing friendships with authors whose work interested him. Major Calder was one such friend. A retired officer of the India Army, he was a bachelor of over fifty when Rossetti met him in 1847. Campbell, a lively though minor writer, had written a great number of tales, verses and sketches; he was charmed by Rossetti and interested in helping his literary future. William Michael describes the characteristic way in which such friendships were fostered:

> 'For a couple of years or so my brother and I used to pass an evening weekly at his lodgings in University Street, Tottenham Court Road. Tea, literature and a spice of bantering scandal were the ingredients for a light-hearted and not unimproving colloquy. Mostly no one else was present. On one occasion — to please Dante Rossetti, who took a great deal of interest in a rather eccentric but certainly able volume of poems entitled *Studies of Sensation and Event* — Major Campbell secured the attendance of its author, Ebenezer Jones. . . . As late as February 1870 he [Rossetti] made some emphatic observations upon this poet in *Notes and Queries;* and his remarks led ultimately to a republication of the *Studies,*

and to a great deal of printed matter about Jones in the *Athenaeum.'*

Campbell had experience of the publishing world which the young Rossetti lacked; he tried to help him by showing his poetry to various editors, though with little success. This lack of interest in his work by commercial publishers helped Rossetti to formulate the idea of publishing his own magazine, and by 1848 the seeds of *The Germ,* the literary organ of the Pre-Raphaelite Brotherhood, were sown. Rossetti invited Campbell to contribute to the magazine when it was first published in 1849; the Colonel accepted with the following *Sonnet* for the February issue of the magazine in 1850:

When midst the summer roses the warm bees
Are swarming in the sun, and thou — so full
Of innocent glee — dost with thy white hands pull
Pink scented apples from the garden trees
To fling at me, I catch them, on my knees
Like those who gather'd manna; and I cull
Some hasty buds to pelt thee — white as wool,
Lilies, or yellow jonquils, or heartsease:—
Then I can speak of my love, ev'n tho' thy smiles
Gush out among thy blushes, like a flock
Of bright birds from rose bowers; but when thou'rt gone
I have no speech, — no magic that beguiles,
The stream of utterance from the harden'd rock:—
The dial cannot speak without the sun.

Elizabeth Siddal

Overleaf:
Black and brown ink with brown wash on paper, 129 × 112 mm
Signed in monogram and dated: *Feb 6/1855*
Ashmolean Museum, Oxford

In 1849 Rossetti wrote a short tale, *Hand and Soul,* about an imaginary painter living in thirteenth-century Tuscany. Religion, fame and morals all fail to comfort the painter or to breathe meaning into his life. He falls into despair until one day he is confronted by the vision of a radiant woman. She is the image of his soul and in recognizing her the contours of his own existence are defined:

> 'It seemed that the first thoughts he had ever known were given to him as at first from her eyes, and he knew her hair to be the golden veil through which he beheld his dreams.'

Rossetti's meeting with Elizabeth Siddal a year later curiously echoed this fictional pattern and provided Rossetti with a similar matrix into which to pour his heated, but as yet unshaped, imagination. Elizabeth Siddal gave substance to Rossetti's paintings and poetry for the next ten years. She was the inspiration for his sonnets of romantic love, and the model for the series of drawings he made of her, not sensuous, but delicate and fine, tracing through the lines in which he enfolds her the exact measure of her restraint.

The daughter of a Sheffield cutler, Lizzie or 'Guggums' as Rossetti affectionately called her, was a reserved and enigmatic figure, adored by Rossetti during the early years of the 1850s, but brittle, morbidly withdrawn and frequently ill. In all his many drawings of her she appears listless, her gestures closed, her eyes averted, her body shrinking, as it were, from the touch of the pencil. She was

Overleaf:
Pencil on paper
234 × 180 mm
Fitzwilliam Museum, Cambridge

not introduced to Rossetti's mother until five years after her relationship with Rossetti had commenced and she developed no close relations with any members of the Rossetti family apart from Gabriel. William Michael remembered that 'her talk was of a "chaffy" kind — its tone sarcastic, its substance lightsome', but both Swinburne and Ruskin thought highly of her, not simply as a beautiful creature, but as a talented and original woman. It is no irony that neither Ruskin nor Swinburne was ever able to sustain a relationship of equality and intimacy with a woman; their admiration for Lizzie never needed to develop deeper than that of the dream-ideal. Her ambiguous relationship with Rossetti lasted ten years, until, with Lizzie almost a confirmed invalid, the couple were married on 23 May 1860. Georgiana Burne-Jones recalled her impressions of Lizzie, shortly after returning from her own honeymoon in France:

> 'Lizzie's slender, elegant figure — tall for those days, but I never knew her actual height, comes back to me, in a graceful and simple dress, the incarnate opposite of the "tailor-made" young lady. We went home with them to their rooms in Hampstead and I know that I received an impression, which never wore away, of romance and tragedy between her and her husband. I see her in the little upstairs bedroom, with its lattice window, to which she carried me when we arrived, and the mass of her beautiful deep-red hair as she took off her bonnet: she wore her hair very loosely fastened up, so that it fell in soft heavy wings. Her complexion looked as if a rose tint lay beneath the dark skin, producing a most soft and delicate pink for the darkest flesh tones. Her eyes were of a kind of golden brown — agate colour is the only word I can find to describe them — and wonderfully luminous: in all Gabriel's drawings of her and in the type she created in his mind this is to be seen. Her eyelids were deep, but without any languour or drowsiness, and had the peculiarity of seeming scarcely to veil the light in her eyes when looking down.' (*Memorials,* Vol. I)

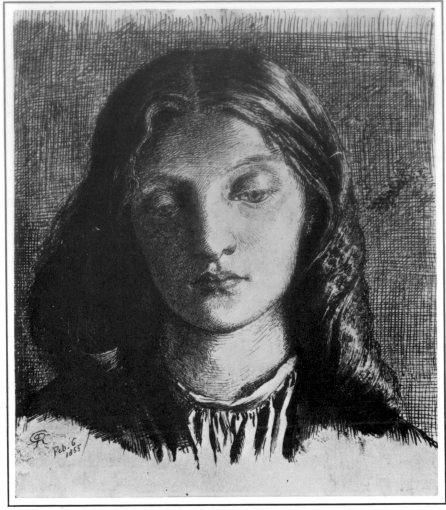

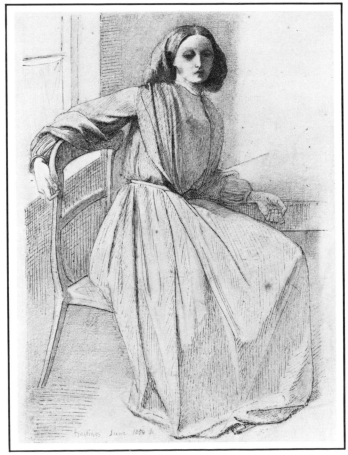

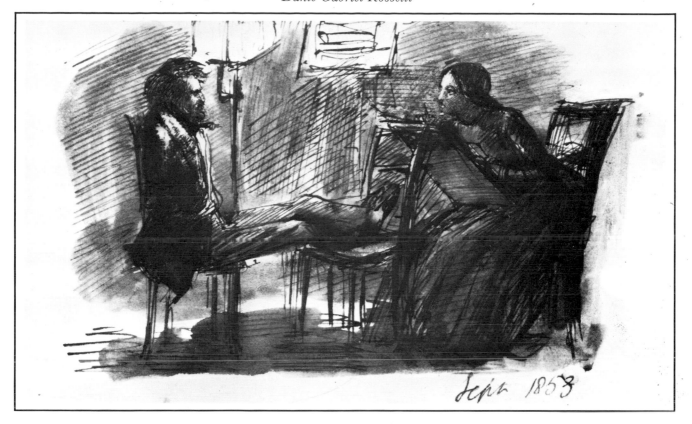

The Artist sitting to Elizabeth Siddal

Pen and brown ink, shaded with the finger, on writing paper,
106 × 162 mm
Dated: *Sept 1853/DGR*
City Museum and Art Gallery, Birmingham

In 1853 Rossetti was living at 14 Chatham Place, Black-
friars Bridge, in rooms overlooking the Thames, which, he
wrote to Woolner:

'. . . . are regularly built out into the river, and with
windows on all sides — also a large balcony over the
water, large enough to sit there with a model and paint.'

Such is presumably the setting for this drawing, in which
Rossetti's model, Elizabeth Siddal, draws the painter.
Although not formally engaged to Rossetti, Lizzie was a
frequent visitor to his rooms, and under his tutelage began
to draw and paint herself, as well as write poetry — work
mostly of a derivative nature, echoing in weaker rhythms
the main strains of Rossetti's own compositions. Lizzie's
talents were encouraged not only by Rossetti but also by
Ruskin, who furnished her with a regular income to
support her search for good health, and who wrote
optimistically of her artistic efforts:

'I have given her the means of going to Nice for the
winter, she being sanguine of being able to paint there
and send me home beautiful drawings of blue sea and
orange groves.'

Ruskin in fact settled £150 a year on Lizzie, or Ida, as he
preferred to call her, in return for all the work she produced
in a year, and he demonstrated an exceptional, if somewhat
patronising, concern for her health and welfare. In an
avuncular fashion he sent her packets of 'ivory dust' (to
make jellies) and offered her such advice as to take a holiday
'if possible near a cattle shed', which refers to a piece of
Victorian wisdom about the proximity to cows being
beneficial to weak lungs.

In 1855 Ruskin took it upon himself to write to Rossetti
about his ambiguous relationship with Lizzie Siddal:

'I should be very grateful if you thought it right to take
me entirely into your confidence, and to tell me whether
you have any plans or wishes, respecting Miss Siddal,
which you are prevented from carrying out by want of a
certain income, and if so what certain income would
enable you to carry them out.'

Rossetti confided no particular desire to Ruskin to marry
Lizzie and relations between the artist and critic gradually
waned. Lizzie's artistic output was not large and has rarely
been exhibited; the general consensus was that it was weak,
'feminine likenesses of Rossetti's' as Arthur Hughes
disparagingly termed her drawings. There is sufficient
evidence in her one self-portrait, however, painted in oils
between 1853 – 4, that she could paint with ability, and
perhaps even more remarkable in a self-portrait, without
vanity or sentimentality. Georgiana Burne-Jones accu-
rately surmised that Lizzie's inspiration was entirely
dependent upon that of her husband. Lizzie was not,
Georgie wrote:

'. . . without original power, but with her . . . art was a
plant that grew in the garden of love. . . . One sees in her
black and white designs and beautiful little water-
colours, Gabriel always looking over her shoulder and
sometimes taking pencil and brush from her hand to
complete the thing she had begun.'

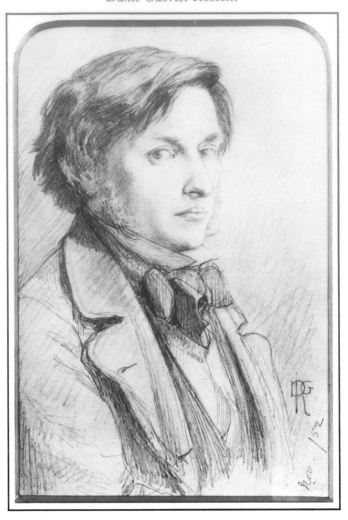

Ford Madox Brown

Pencil on paper, 165 × 114 mm
Signed in monogram and dated: *Nov/52*
National Portrait Gallery, London

'By far the best man I know — the really good man — is Brown.'

Such was Rossetti's unswerving opinion of Ford Madox Brown. Characteristic of the way in which many of Rossetti's friendships began, Rossetti wrote to Brown in 1848 in fulsome praise of the cartoons he had submitted to the exhibition of competitive designs for the new Palaces of Westminster in 1844. Suspecting that the letter was a hoax, Brown none the less called on Rossetti, and ended up agreeing to take him as a pupil. Brown's tutelage proved too exacting and methodical for Rossetti's impatient mind, and the relationship of master to pupil was short-lived, but from this time on the two men remained close friends.

Brown did not become a member of the Pre-Raphaelite Brotherhood, wary as he was of select coteries and what to him, a man six years Rossetti's senior, must have seemed the somewhat childish nature of the Brotherhood. He none the less advocated many of its principles in his own work and exerted a powerful influence on the work of the group. His contribution to the February issue of *The Germ*, an article entitled *On the Mechanism of a Historical Picture*, illustrates his belief that sincerity in a picture could only be achieved through direct naturalism. In the same context he makes a pertinent comment on the principles of Pre-Raphaelite portraiture:

'The first care of the painter, after having selected his subject, should be to make himself thoroughly acquainted with the character of the times, and the habit of the people, which he is to represent . . . it is impossible to conceive a design with any truth, not being acquainted with the character, habits, and appearance of the people represented. . . . Having settled these points in his mind . . . the student will take pencil and paper and sketch roughly each separate figure in his composition, studying his own acting, (in a looking-glass or else that of any friend he may have of an artistic or poetic temperament), but not employing for the purpose the ordinary paid models. It will be always found that they are stiff and feelingless, and, as such, tend to curb the vivacity of a first conception, so much so that the artist may believe an action impossible, through the want of comprehension of the model, which to himself or a friend might prove easy.'

Few professional models were employed by the Pre-Raphaelites for their pictures, in accordance with these principles of an exacting naturalism.

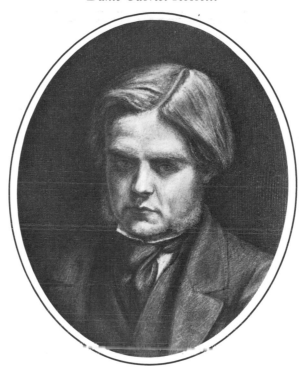

William Holman Hunt

Pencil on paper, oval, 219 × 175 mm
Inscribed beneath the mount (not in Rossetti's hand): *12th April 1853. D. G. Rossetti to Thomas Woolner, Edward Batemen, Bernard Smith*
City Museum and Art Gallery, Birmingham

This was one of the portraits made in Millais' Gower Street studio on the eve of Friday 12 April, 1853, which the Pre-Raphaelite Brothers made of one another to send to their Brother Woolner in Australia. Bateman and Smith, to whom the drawing is also inscribed, were two sculptors who accompanied Woolner. Hunt sketched Rossetti and Rossetti drew Hunt.

Hunt and Rossetti first became properly acquainted in 1848, when Rossetti openly admired Hunt's picture of the 'Eve of St Agnes' at the Royal Academy exhibition. Despite the difference in their temperaments — Rossetti irreverent, impatient and lyrical, Hunt, methodical and serious but just as impassioned as Rossetti — they quickly became friends, and Hunt took Rossetti into his confidence about the new sort of painting he was then attempting:

'I showed him my new picture of "Rienzi" in the painting of which at the outset I was putting into practice the principle of rejection of conventional dogma, and pursuing that of direct application to Nature for each feature, however humble a part of the foreground or background this might be . . . I justified the doing of this thoroughly as the only sure means of eradicating the stereotyped tricks of decadent schools, and of any conventions not recommended by an experienced personal judgement.'

It was a call-to-arms against the tyranny exercised by the teachings of the Royal Academy, with which Rossetti immediately identified. In later years Hunt resented deeply the fact that Rossetti was commonly considered the instigator and leading light behind the formation of the Brotherhood and took pains in his book on the history of the movement (published in 1905) to correct this impression. He stated that it was he who had taught Rossetti to paint, rather than Ford Madox Brown and he was aggrieved that Ruskin had championed Rossetti rather than himself. He wrote:

'Every time I visited Oxford, I heard more of the sensation Rossetti was making there. . . . Although what Rossetti had painted at Oxford had not pleased the person most immediately concerned, his reputation grew there with those reputed to be connoisseurs in taste. . . . His five or six years of seniority over his disciples gave him a voice of authority, and Ruskin's ever increasing praise perhaps did more than all in spreading the idea of what his brother calls his "leadership".'

Much of Hunt's rancour stemmed from personal prejudice against Rossetti, fanned by the incident over Annie Miller in the 1850s and kept heated by the difference between their natures. Temperamentally, they were so different. What Hunt criticised in Rossetti as being merely sensual or meretricious was often the result of a symbolism which Hunt, whose mentality was basically protestant, could simply not comprehend. Both dogged and dogmatic, the hard-working Hunt failed to see the basic sacramentalism of Rossetti's vision; that with Rossetti, as Walter Pater wrote of him, 'the spiritual attains the definite visibility of a crystal'.

Hunt's own strict interpretation of the Pre-Raphaelite belief in painting directly from nature remained unchanged throughout his life.

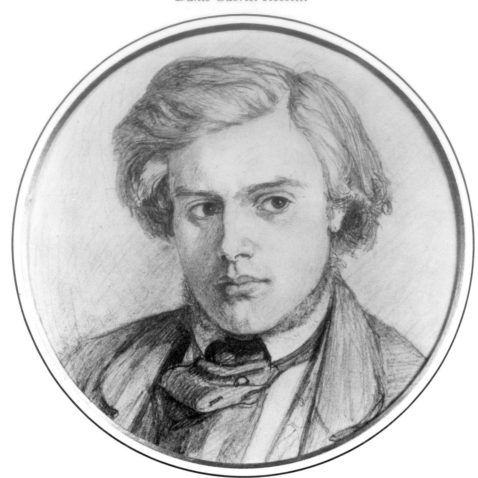

Thomas Woolner

Pencil on paper, diameter 127 mm
Dated: *July/52*
National Portrait Gallery, London

'A genial manly personage, full of gusto for many things in life; a vigorous believer in himself and his performances, and (it may be allowed) rather disinclined to admit the deservings of any rivals in his art.'

So recorded William Michael Rossetti of this only sculptor among the founding members of the Pre-Raphaelite Brotherhood. He was born in Suffolk and had shown such promise as a boy in drawing and modelling that he became a pupil of William Behnes when he was twelve. He had already exhibited several pieces before his introduction to Rossetti in 1847, and his subsequent friendship with Coventry Patmore, Carlyle and Tennyson, through the auspices of the Pre-Raphaelite Brotherhood led to his concentration on portrait medallions. He made a medallion of Wordsworth in 1850 and competed for the monument to the poet in 1852. His design however was rejected, and already embittered by the attitude of the Royal Academy towards sculpture and the general lack of encouragement for idealistic sculpture, he emigrated to **Australia in 1852**. The Rossettis, Madox Brown and Holman Hunt all went to see him off, and the event led to one of the finest products of the movement, Ford Madox Brown's 'Last of England', as well as to the series of portraits the Brotherhood made of one another to send out to the migrant Brother in the goldfields.

Unsuccessful as a prospector, Woolner was obliged to make portrait medallions of prominent Australians as a living; two years later he returned to England. On the journey home he read a pathetic tale of a fisherman which he subsequently told Tennyson. It became the basis for 'Enoch Arden'. He sculpted Tennyson's bust in 1857, a year which saw a turning-point in his career. His medallion portraits of Carlyle and Robert Browning of the same year were much admired and he started work on a sculptural group for the central saloon of Wallington Hall (completed in 1867). In 1864 he designed the vignette of the flute-player for the title page of Palgrave's *Golden Treasury*, having won the commission for the statue of Macauley two years earlier largely as a result of Palgrave's efforts on his behalf. Commercially and socially he was a success. In 1864 he married Alice Gertrude Waugh, sister of Fanny and Edith Waugh, and in 1871 became an Associate of the Royal Academy. Three years later he was made a full Academician and in 1877 was made Professor of Sculpture. There was little in his later work however that could be identified as 'Pre-Raphaelite', although the group of a mother teaching her child the Lord's Prayer, designed for Wallington, and his design for the Cawnpore Memorial of 1861 (never executed) showed that he could translate the linearity and the direct naturalism of Pre-Raphaelite painting into sculpture with great effect.

William Bell Scott

Overleaf:
Pencil on paper, 268 × 228 mm
Dated: *October/1852*
Sotheby's Belgravia

William Bell Scott, the son of an Edinburgh engraver, was a minor Pre-Raphaelite painter and a poet of slight stature. Rossetti had read his verse as a young man and wrote to Scott in 1847 in enthusiastic praise of his work. Scott subsequently called on Rossetti in London and an intimacy developed between the two men which lasted until Rossetti's death.

Scott was to scandalise the Pre-Raphaelite circle with the posthumous publication of his *Autobiographical Notes* in 1892, in which he revealed himself to be jealous, mean and uncharitable about the men with whom he had purportedly been friendly for many years, and in particular about Rossetti. 'The Poison of a Parasite' is the title of a letter Swinburne wrote on Scott's *Notes,* and it serves as an apt reminder of Scott's relation to the group.

During the early years of the Brotherhood Scott lived in Newcastle, where he was head of the Government School of Design, and though his northern isolation prevented any active participation in the activities of the Brotherhood, he did succeed in interesting future patrons such as the Leatharts in Newcastle and the Trevelyans at Wallington in Pre-Raphaelite work. Scott's connection with the Trevelyans was particularly fruitful, as it was through them that he met Ruskin and Swinburne and also received the commission in 1856 to decorate the central hall at Wallington with eight large canvases illustrating the history of Northumberland from Roman times. The whole project was designed to be the great Pre-Raphaelite showpiece of the north and Scott's achievement was impressive. One painting in particular, 'Iron and Coal', the last in the series, is one of the first contemporary depictions of heavy industry and is carried out in a remarkably objective and undidactic spirit. Scott's friendship with the Trevelyans also enabled him to introduce the Rossettis and other Pre-Raphaelite artists to Wallington, which became one of the most vital centres of artistic life in the North.

Scott's friendship with Alice Boyd was another important contact for the Pre-Raphelites outside London. Miss Boyd was the owner of Penkill Castle, Ayrshire, and she met Scott in 1859, when she was a little over thirty and he aged forty-eight, a 'Mephistophelian looking character', as Holman Hunt described him, with penetrating light blue eyes and thick brown hair. (He was reputed to have been extremely attractive to women, and after he lost all his hair in 1865, always sported a wig.) Although Scott was married, his friendship with Miss Boyd was deep and reciprocal, and from 1860 on they were inseparable. For half the year Scott and his wife were Miss Boyd's guests at Penkill Castle, the other half of the year she lived with them.

Rossetti visited Penkill Castle twice, the first time, in 1866, when he was suffering from severe depression. A cousin of Alice Boyd's, Miss Losh, was staying there at the time and took a great liking to Rossetti, offering him the loan of £1000. Though he was reticent at first about receiving such a kindness, Rossetti did eventually borrow £500 from Miss Losh, a sum which was outstanding on her sudden death in 1872. Although Miss Losh had never pressed for the return of the loan, and it was in all event probably meant more as a gift, Scott used this incident against Rossetti in his *Autobiographical Notes* as one in a long catalogue of complaints he compiled against his erstwhile friend. In truth Scott owed much of his recognition to his association with the Pre-Raphaelites, a fact which Swinburne stated in caustic terms:

> '. . . here . . . is a man whose name would never have been heard, whose verse would never have been read, whose daubs would never have been seen, outside some aesthetic Lilliput of the North, but for his casual and parasitical association with the Trevelyans, the Rossettis and Myself.'

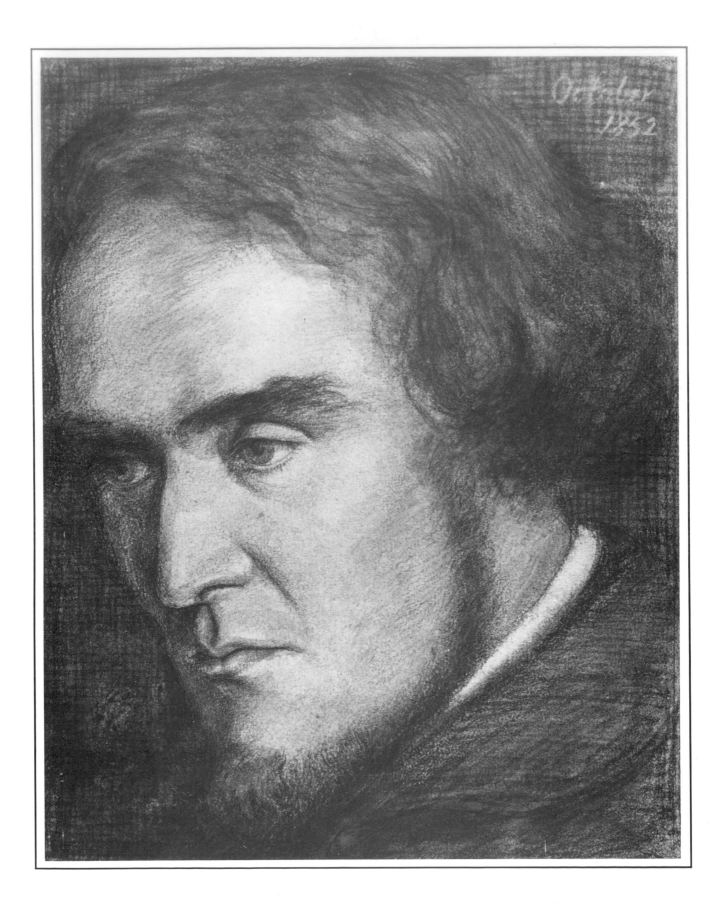

Tennyson reading Maud

Black and brown ink with grey wash on paper, 206 × 150 mm
Inscribed: *'Maud'/1855*
City Museum and Art Gallery, Birmingham

On the evening of Monday, 27 September 1855, Rossetti met Tennyson at the home of the Brownings where they were all entertained to a reading of Tennyson's favourite poem *Maud*. Elizabeth Barrett Browning sat at one end of the sofa, Tennyson at the other, and Rossetti furtively sketched the bard while he endlessly intoned its passages, now and then interjecting a critical note, such as ''There's a wonderful touch' and 'That's very tender' or 'How beautiful that is!'. As the poet read on through the lyrical and pathetic passages of his poem, surrendering himself without inhibition to his sentiments, tears flowed from his eyes. Rossetti, when he was not bored by Tennyson's egotism, was amused by his 'groanings and horrors over the reviews of *Maud*' and by the declamatory style of Tennyson's speech. He wrote a full account of the evening to William Allingham in a letter which was omitted from his published letters to Allingham because it was thought that the letter would 'be the death' of Tennyson's widow. Evidently, however, Tennyson's reading had similar effects on other listeners. Edward Lear wrote to Holman Hunt after he had attended a party at which Tennyson had read his poetry to the assembled audience:

> 'Alfred Tennyson has just read us his new poem. It is called *Maud* and *most astonishing*. One part, beginning ''O that 'twere possible'', is enough to make you stand on your head.'

As a young man Rossetti had greatly admired Tennyson's work: its lapidary, pictorial quality and its lush evocation of the medieval past not only directly inspired several Pre-Raphaelite paintings but also explains why several critics nominated Tennyson as the only true Pre-Raphaelite. Despite Rossetti's enthusiasm for Tennyson's work in general, he disliked *Maud*, declaring it 'very great of course but seems an odd De Balzackish sort of story for an English man at Tennyson's age. . . . Some very like rubbish'. Rossetti made a copy of the drawing he had sketched in the Browning's drawing-room to give to Lizzie Siddal; the original he gave to Browning.

It was altogether an evening of comedy and revealed Tennyson's self-conscious regard for his position as Poet Laureate. He and Rossetti left the Brownings' house together, passing Holborn Casino on their way home. Tennyson asked what the place was and, when Rossetti told him, suggested they both go in. But, as he had his foot on the threshold, Tennyson mournfully turned away, declaring to Rossetti that someone from the press might spot him and report his presence in a casino in one of the daily journals. He feared that both his reputation and his readership would be lost overnight. Rossetti, amused enough by the incident, was later to criticise Tennyson for taking a populist stance in his poetry, and accused him of lowering the poetic denominator to gain currency in a wider market. In his defence against the public resistance to his own poetry, Rossetti declared that 'the greater portion of my poetry is suited only to distinctly poetic readers'. It was not his 'vocation', he declared, to 'get within hail of general readers by rude aiming at the sort of popular view that Tennyson alone succeeds in taking'.

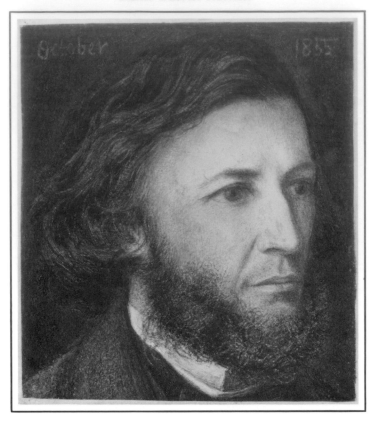

Robert Browning

Watercolour on paper, 120 × 104 mm
Dated: *October 1855*
Fitzwilliam Museum, Cambridge

In Rossetti's adolescence one of his greatest passions had been for the work of Robert Browning. Among his earliest completed works are two watercolours illustrating Browning's verse, 'The Laboratory', painted in 1849 to illustrate the lines 'In this devil's smithy/Where is the poison to poison her, prithee?' (from *The Laboratory: A Soliloquoy of the Spanish Cloister*), and 'Rosso Vestita', painted in 1850 to illustrate the following lines from *Pippa Passes*:

> 'Hist', said Kate the queen
> But 'Oh', cried the maiden, binding her tresses,
> 'Tis only a page that carols unseen
> Crumbling your hounds their messes! . . .
> Fitting your hawks their jesses'.

When he first read *Pauline,* which had been published anonymously in 1850, Rossetti had been so enthusiastic about it, and so confident that it had been written by Browning, that he wrote to the poet in Venice, asking whether or not he was the author. Browning confirmed it, and the following year was introduced to Rossetti by William Allingham in London. Rossetti observed:

> 'In person he is short but so well made that he scarcely looks so. His head is most stunning and even handsome in the common sense of the term.'

The two men continued to correspond and to see one another intermittently, and in 1855, thinking that it might be propitious for Lizzie's health to go to Italy, and if so that he might call on the Brownings in Florence while there, Rossetti first visited the Brownings during one of their stays in London. In fact he made several calls, and it was on one of these evenings that he was entertained by Tennyson's reading of *Maud.* Browning returned the call by visiting Rossetti in his studio, where Rossetti began this watercolour portrait of the poet. Work on the portrait was interrupted by Browning's departure for Paris, en route for Florence. There was cholera in Florence and the Brownings remained in Paris for several months. They were there when Rossetti arrived in the French capital with Alexander Munro to meet Lizzie Siddal, who had left England during the summer purportedly to travel south for her health. She had not got further than Paris where, fascinated by the shops, she had spent all her money and had sent an urgent request to Rossetti for funds. Rossetti brought the money himself. He called on the Brownings who were installed in the rue de Grenelle where they grudgingly received such visits as were made upon them. Elizabeth Barret Browning complained:

> 'We have been lying *perdus* in our hole and seeing nobody except such as we fell upon by chance and couldn't help speaking to — Sir Edward Lytton for instance — and Rossetti; the chief of the Pre-Raphaelites in England.'

Notwithstanding the indifferent welcome, Rossetti completed Browning's portrait during this period and brought it back to London with him on his return. It hung over his mantlepiece in Chatham Place until his removal to Cheyne Walk in 1862.

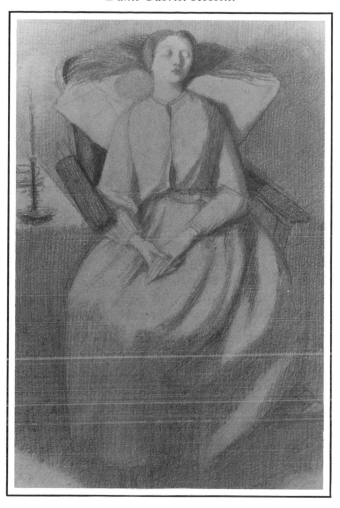

Elizabeth Siddal

Pencil on paper, 191 × 127 mm
Lord Clark of Saltwood

Ford Madox Brown noted in his diary in 1854 that he called on Rossetti and saw:

> 'Miss Siddal, looking thinner and more deathlike and more beautiful and more ragged than ever . . . Gabriel . . . drawing wonderful and lovely "Guggums" one after another, each one a fresh charm, each one stamped with immortality.'

Later, in August, 1855, he noted:

> 'Rossetti showed me a drawer full of "Guggums"; God knows how many . . . it is like a monomania with him, many of them are matchless in beauty . . . and one day will be worth large sums.'

Ill health dogged Lizzie throughout her relationship with Rossetti. In 1854 she went to Hastings for two months to recuperate, staying near the home of Barbara Leigh Smith, the feminist and amateur painter (later Mme Bodichon), and one of the founders of Girton College, Cambridge. Rossetti joined her there and sketched her with a rare tenderness and intimacy. Medically, opinion was divided about Lizzie's frailty. Dr Garth Wilkinson, whom she consulted shortly before going to Hastings, diagnosed 'curvature of the spine'; but Dr Acland, whom she saw in 1855 at the insistence of Ruskin, could find nothing organically wrong with her, and attributed her degenerating mental state to a nervous cause. Perhaps Lizzie herself gave the most clear indication in her wan and plaintive verse. Her poetry repeatedly echoes the theme of dead love and she seems aware that Rossetti's love, which had animated and elevated her beyond normal expectation in the early years of their relationship, had now expired and that the sympathy that he gave in its place was no substitute for the vitality of real love:

A Year and a Day

Slow days have passed that make a year,
 Slow hours that make a day,
Since I could take my first dear love,
 And kiss him the old way:
Yet the green leaves touch me on the cheek,
 Dear Christ, this month of May

 . . .

A silence falls upon my heart,
 And hushes all its pain,
I stretch my hands in the long grass,
 And fall to sleep again,
There to lie empty of all love,
 Like beaten corn of grain.

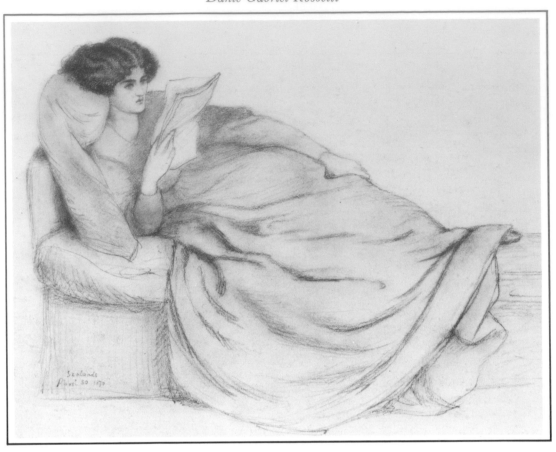

Jane Burden (Mrs Morris)

Pencil on paper,
Inscribed and dated: *Scalands/April 30 1870*
Ashmolean Museum, Oxford

'Oh, *ma chère,* such a wife! *Je n'en reviens pas* — she haunts me still. A figure cut out of a missal — out of one of Rossetti's or Hunt's pictures: to say this gives but a faint idea of her, because when such an image puts on flesh and blood, it is an apparition of fearful and wonderful intensity. It's hard to say whether she's a grand synthesis of all Pre-Raphaelite pictures ever made – or they a ''keen analysis'' of her – whether she's an original or a copy. In either case she is a wonder. Imagine a tall lean woman in a long dress of some dead purple stuff, guiltless of hoops (or of anything else, I should say), with a mass of crisp black hair heaped into great wavy projections on each side of her temples, a thin pale face, a pair of strange, sad, deep, dark Swinburnian temples, with great thick black oblique brows, joined in the middle and tucking themselves away under her hair . . . a long neck without any collar, and in lieu thereof some dozen strings of outlandish beads — in fine complete.'

Such was Henry James' description of Jane Burden, ten years after her marriage to William Morris in April 1859.

Opposite:
Pen and ink on paper, 440 × 330 mm
Signed in monogram and dated: *Oxford 1858*
National Gallery of Ireland, Dublin

The daughter of a local Oxford groom, 'Janey', as she was known, first came into the Pre-Raphaelite orbit in 1857, when Rossetti and Morris were in Oxford at work on the decorations for the Oxford Union murals. Her extraordinary looks ('Hers is one of the world's faces — unique' in Graham Robertson's words) were first appreciated by Rossetti who persuaded her to model for both him and Morris. Of the two murals on the theme of Launcelot and Guenevere that Rossetti was intending to paint for the Union, the first had been completed from the face of Lizzie Siddal as the model for Guenevere; her place in the second design was now taken by Jane Burden, although in fact the second design was never finally executed as a mural. It is probable that Rossetti fell in love with Jane Burden at this time, but loyalty and a sense of obligation to Elizabeth Siddal prevented him from marrying her. Perhaps the next best thing was to keep her within the Pre-Raphaelite circle, which her marriage to William Morris ensured. It was, moreover, a marriage which shaped the destiny of the Arts and Crafts movement in England through the building of the Red House, Bexley, as the Morris' marital home, and the subsequent establishment of the firm of Morris, Marshall, Faulkner and Co. Janey bore two daughters, Jenny, born in 1861 (who became a chronic invalid), and May, born in 1862. May became a skilled craftswoman and took over the direction of the Firm's embroidery department when she was twenty-three.

After her marriage to Morris, Jane's features do not appear in Rossetti's work again until 1867, when a renewed intimacy grew between them.

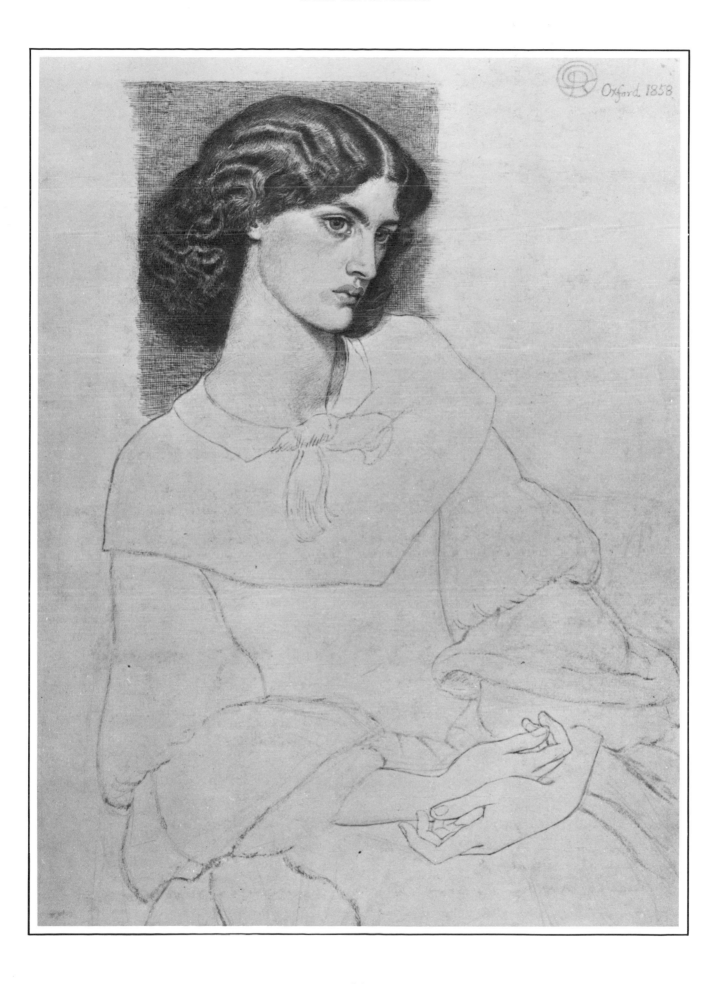

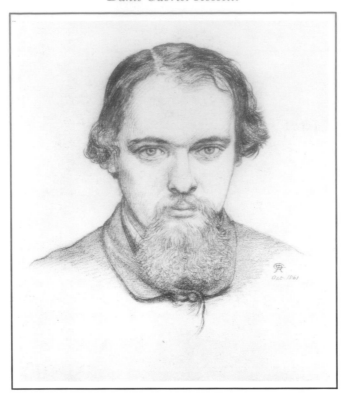

Dante Gabriel Rossetti (Self-Portrait)

Pencil on paper, 254 × 216 mm
Signed in monogram and dated: *Oct 1861*
City Museum and Art Gallery, Birmingham

In October 1861 Rossetti was thirty-three, a married man of a year's standing. Earlier the same year, in May, his wife had given birth to a still-born child and the promise of any vigour in their marriage dimmed correspondingly. That October, while Rossetti was away in Yorkshire on a commission, Lizzie went to stay with the Morrises at Red House, but her growing morbidity, resulting in her death four months later, was already obvious. She would appear 'without a word at dinner, rising — gliding away silent and unobserved as she had come — a ghost in the house of the living', as a guest in the house ominously discerned.

Concerned though he was for Lizzie's health, and aware that she was, by his own admission 'unhappily too confirmed an invalid to leave a hope now that she will ever be able to make the most of her genius', Rossetti none the less published that year his translations of the *Early Italian Poets and Dante's Vita Nuova* on which he had been working since 1845. Ruskin had advanced him £100 for the publication, which though well received by the critics, did not earn him sufficient capital to repay the debt until eight years later.

During this same year, 1861, the firm of Morris, Marshall, Faulkner and Co. was established and Rossetti was kept active producing designs for stained glass for the Firm. Despite his erratic working methods, Rossetti had, in the words of Burne-Jones' brother-in-law, 'business qualities of a high order and the eye of a trained financier for anything that had money in it', and he turned his attention to the affairs of the Firm with assiduousness.

Rossetti wrote to Ford Madox Brown complaining that he was 'getting awfully fat and torpid'. Henry Treffry Dunn, who became Rossetti's studio assistant and general factotum some years later, has left this description of the painter at the time, shortly before Rossetti suffered a mental breakdown:

'His face conveyed to me the existence of underlying currents of strong passions impregnated with melancholy. His eyes were dark grey, and deeply set; the eyebrows dark, thick, and well arched; the forehead large and well rounded, and the strongly formed brows produced a remarkable fullness at the ridge of the nose, such as I have often noticed in men possessed of great individuality. A thick but not heavy moustache partly concealed a well-formed and somewhat sensuous mouth, and at this time he wore a trimmed beard of a deep chestnut brown, with cheeks shaven; his hair was much darker in colour, curly and inclined to thinness. He was about 5 feet 7½ inches in height. . . . He possessed a voice which was peculiarly rich and musical in tone; and when, later, I had opportunities of hearing him read his poems, which he did from time to time to some of his intimate friends, it was very delightful to listen to him. His hands were small, and very white. Of jewellery he made no display; all that he wore was an old-fashioned gold chain attached to this watch. He was equally unassuming in dress. For studio use he generally wore a loose overcoat, with pockets into which he could easily thrust a good-sized memorandum book, which was indispensable to him, as it was his custom to jot down his thoughts either for poetry or painting as they arose in his mind.'

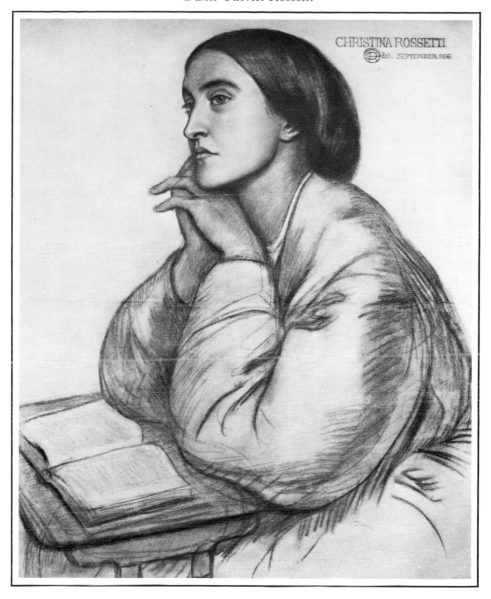

Christina Rossetti

Coloured chalks on blue-grey paper, 785 × 655 mm
Signed in monogram and dated: *del. September 1866*
Private collection

The Lowest Place

Give me the lowest place; not that I dare
Ask for that lowest place, but Thou has died
That I might live and share
Thy glory by Thy side.

Give me the lowest place; or if for me
That lowest place too high, make one more low
Where I may sit and see
My God and love Thee so.

This poem was first published in *The Prince's Progress and Other Poems* (Macmillan) in 1866, the date of this portrait of the poet by her brother. The second stanza was inscribed on her tombstone. Christina's place within the Pre-Raphaelite movement is something of an anomaly. Her family connections obviously brought her into contact with the people most closely associated with the movement, but her own poetry, apart from sharing an exotic vocabulary and a certain high colouring with the work of other Pre-Raphaelite poets, is more direct, less concerned with effect, than is usual in the Pre-Raphaelite canon. She published six principal volumes of verse during her lifetime: *Goblin Market and Other Poems* (1862), *The Prince's Progress and Other Poems* (1866), *Sing-Song* (1872), *Goblin Market, The Prince's Progress, and Other Poems* (1875), *A Pageant and Other Poems* (1881) and *Verses* (1893). She also published several tracts for the Society for Promoting Christian Knowledge and, after her death in 1894, William Michael Rossetti edited two volumes of her verse, with posthumous additions, *New Poems* (1896) and *Poetical Works* (1904).

The youngest of the four Rossetti children, Christina lived a life of few documented facts, though speculation exists about her possible passions. The only known facts about her emotional life consist of her engagement to James Collinson in 1849 and an involvement with Charles Bagot Cayley, the translator of Dante, twelve years later. She lived quietly with her mother in London, at 50 Charlotte Street and later at 30 Torrington Square.

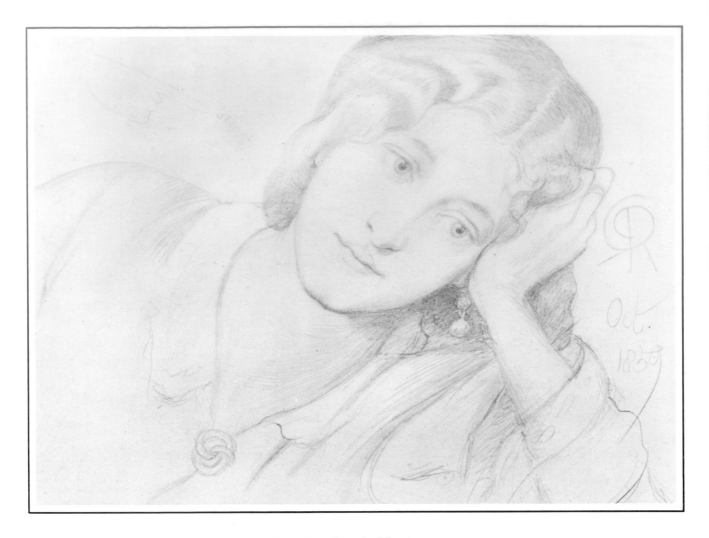

Louisa Ruth Herbert

Pencil on paper
Inscribed with monogram and dated: *Oct 1859*
Glasgow City Art Gallery

Mrs Herbert was an actress whom Rossetti spotted one evening at the theatre and whom he immediately begged to sit for him. Ellen Terry remarked drily:

> 'She was not a good actress but her appearance was made up to many for her want of skill . . . very tall, with pale gold hair and the spiritual, ethereal look which the aesthetic movement loved.'

Indeed Rossetti loved her luxuriant hair and drew her frequently between 1858 and 1859. He wrote excitedly to William Bell Scott about his new 'stunner' that:

> 'She has the most varied and highest expression I ever saw in a woman's face besides abundant beauty, golden hair etc. Did you ever see her? O my eye.'

Louisa Herbert, or Ruth as Rossetti commonly called her, was the daughter of a West Country brass-founder. In 1855 she married Edward Crabb, but was living apart from her husband when she met Rossetti. As an actress of melodrama, she first appeared at the Strand Theatre in 1855, and later played at the Olympic. She also appeared under her own management at the St James, where she was the heroine in *Lady Audley's Secret.*

Rossetti thought her the perfect model to sit for the figure of the Virgin in the commission he had received for an altarpiece for Llandaff Cathedral. (When he began work on the Triptych in the autumn of 1859 he in fact used the head of Jane Morris for the Virgin.) In this pencil portrait of Miss Herbert, done in October 1859, he has pencilled in the word *STUNNER* just beside her head. Her beautiful hair, pathetic expression and strong features provide a good example of the beauty to which Rossetti was susceptible, and Mrs Gaskell has left a nice description of how vulnerable those susceptibilities were. Writing to Charles Eliot Norton in October 1859 she declared of her London visit:

> 'I think we got to know Rossetti. I went three times to his studio, and met him at two evening parties — where I had a good talk with him, always excepting the times when ladies with beautiful hair came in, when he was like a cat turned into a lady, who jumped out of bed and ran after a mouse. It did not signify what we are talking about or how agreeable I was; if a particular kind of reddish brown, crepe wavy hair came in, he was away in a moment struggling for an introduction to the owner of said head of hair. He is not as mad as a March hare, but hair-mad.'

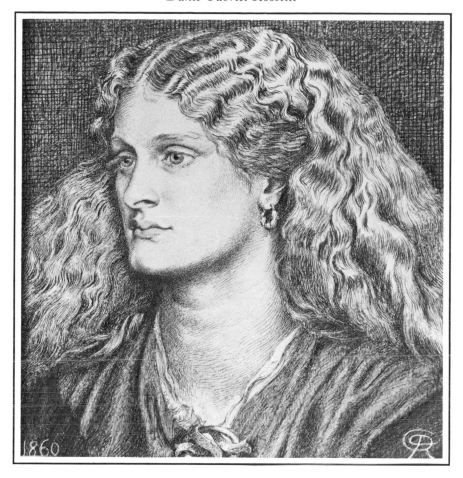

Annie Miller

Pen and ink on cream paper, 255 × 242 mm
Signed in monogram and dated: *1860;* Inscribed *Annie Miller in 1860/Aetat XXI*
Estate of the late Mr L. S. Lowry

Born in 1835, the daughter of a soldier, Annie Miller was brought up in the Chelsea slum of Cross Keys. Her 'siren-like' beauty, in the words of Ford Madox Brown, attracted Holman Hunt who noticed her in the street: she subsequently became both his model and lover. He felt he could 'improve' her sufficiently to make her a marriageable woman and significantly used her as his model for 'The Awakening Conscience' where a woman of easy virtue has sudden qualms of conscience. Hunt remained infatuated with her for many years, as indeed many members of the Pre-Raphaelite circle appear to have been at one time or another. When Hunt first visited the Middle East in 1854, he left Annie a restricted list of artists for whom she could sit but, possibly with the encouragement of Rossetti, she flouted his instructions. She not only sat to Rossetti and the watercolourist G. P. Boyce, but was taken out dancing by them to Cremorne Gardens, and to dinner at Bertolini's and even went boating with Rossetti's brother William Michael; 'they all seem mad about Annie', admitted Ford Madox Brown to his diary. On his return from the East, Hunt was similarly mad to learn that Annie had been seen walking in Regent Street with a 'swell whore', and in St James' with a celebrated roué, Lord Ranelagh. He reprimanded Annie for her lack of constancy and shrugged off the idea of marriage. He wrote to F. G. Stephens:

'If she cannot be preached to from the facts of her own bitter experience then she cannot be awakened at all. Do not omit to say that in rejecting my advice to avoid going to Rossetti and Boyce to sit she sacrificed my interest in her welfare to a very great extent.'

It was clear that, in the words of his brother, Rossetti 'was guilty of an offence' as far as Annie Miller was concerned and was in some measure responsible for Hunt's censure of her. However, Hunt's pompous attitude in the affair says more about his own moral stance than about that of either Rossetti or Annie.

Annie appears most notably as the model for Rossetti's 'Helen of Troy' (1863) and about which Swinburne wrote a panegyric in his *Essays and Studies:*

'Helen, with her Parian face and mouth of ardent blossom, framed in broad gold of widespread locks.'

Before his own marriage to Fanny Waugh in 1865 Holman Hunt was still worried about Annie Miller, afraid that she might attempt to ruin his name, and he instructed F. G. Stephens to go to Annie for the return of all his letters to her.

Many years later Hunt accidently met Annie at Richmond Hill, 'a buxom matron with a carriage full of children'. He learned that she was happily married and with timely humility confessed that he now condoned 'the offence' which he now considered 'worked me good rather than harm'.

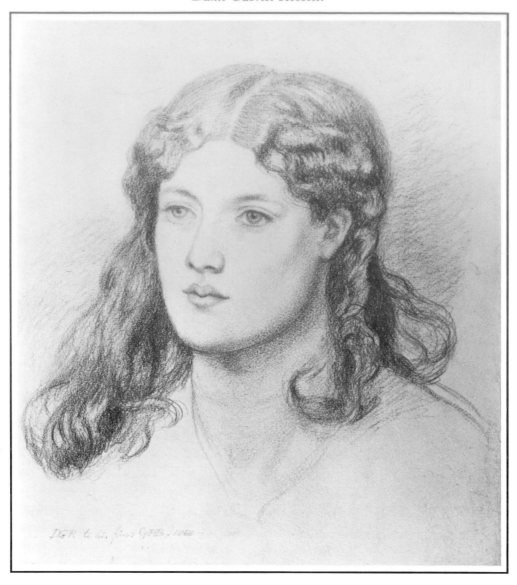

Ellen Smith

Pencil on paper, 237 × 212 mm
Inscribed and dated: *DGR to his friend GPB. 1863* Inscribed on the
back in the hand of G. P. Boyce: *Drawn from Ellen Smith by Dante G.
Rossetti and given by him to G. P. Boyce April 13th 1863*
City Museum and Art Gallery, Birmingham

In October 1862 Rossetti took on the tenancy of Tudor
House, in Cheyne Walk, Chelsea, where he began to collect
about him the curious creatures that gave him the reputa-
tion of a bogeyman in the district. In an anonymous
account of the life of a Chelsea family in the 1870s, *A Book
with Seven Seals,* Rossetti was identified as a familiar, if
forbidding, local sight by one of the children of the family:

> 'In Nurse's opinion he was only fit to be a bat and come
> out in the dusk, flitting up the Walk and in again to hide
> away from the sun in his great big house, where he
> painted pictures and kept a lot of poets and other wild
> beasts.'

On one of Rossetti's jaunts in the neighbourhood he
spotted a laundry-maid, Ellen Smith, whom he subse-
quently used in several of his pictures, including 'The
Loving Cup' and 'Washing Hands'. Rossetti's tastes for
ornament were becoming increasingly elaborate during
this period, and in one of his last portraits of Ellen Smith,
'Joli Coeur', painted in 1867, her hair is caught with a
complicated seed-pearl clasp and twisted to resemble the
device which Rossetti used as his monogram. It is almost as
if Rossetti so implanted his personality into the image of his
sitters that his most personal symbol is enmeshed in the very
fabric of his model's hair.

Rossetti's friends appear to have exchanged drawings
amongst themselves quite freely, as a note in Boyce's diary,
obviously referring to this sketch, indicates:

> 'May 15th, 1856. Rossetti sent for the study he gave me,
> a pencil head of Ellen Smith, said it was by inadvertence
> that he had parted with it as he particularly wished to
> dispose of it with other studies of the same picture ("The
> Song of Solomon") to the purchasers of the picture.'

Ellen Smith's sweet and gamine features are rather
exceptional in the repertory of sultry faces of Rossetti's later
models. Ellen suffered a cruel fate: she was brutally beaten
one day by a soldier who so disfigured her face that her
career as a model came to an abrupt end.

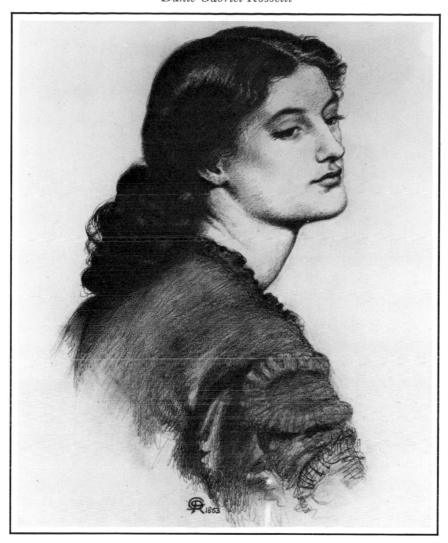

Ada Vernon

Pencil on paper, 403 × 295 mm
Signed in monogram and dated. *1863*
City Museum and Art Gallery, Birmingham

After Rossetti's move into Cheyne Walk in 1862, his predilections for a brooding, monumental quality in women became more defined. Models such as Ada Vernon anticipate the sombre beauty he later adulated in the face of Jane Morris. Ada Vernon was one of a small coterie of models he used between 1863 – 5, and this study of her is possibly in preparation for the small watercolour, 'Monna Pomona' where a seated figure holds an apple, with roses in her lap and a basketful of roses behind her. The composition forms a type which was to become standard with Rossetti, and almost all the portrait work that he produced from the late 1860s until his death follows this pattern. A single female sitter, alone against a shallow backcloth with possibly some symbolic arrangement of flowers or fruit about her, is caught in a perpetual stillness, staring blankly at the spectator. The prototype for this work had been Rossetti's portrait of Fanny Cornforth as 'Bocca Baciata' of 1859 and Holman Hunt's outraged feelings about the painting's vulgarity were echoed by many later critics of Rossetti's female portraiture of this genre:

'Most people admire it very much and speak to me of it as a triumph of our school. I have strong prejudices and may be influenced by them . . . I will not scruple to say that it impresses me as very remarkable in power of execution — but still more remarkable for gross sensuality of a revolting kind . . . I would not speak so unreservedly of it were it not that I see Rossetti is advocating as a principle mere gratification of the eye and, if any passion at all, the animal passion to be the aim of art.'

William Michael Rossetti spoke of such work in less impassioned terms, but with unnerving accuracy as 'female heads with floral adjuncts'. Certainly after the period of Elizabeth Siddal's death, Rossetti began to search for specific forms of female beauty, frankly sensual, perhaps overtly superficial and sensational. During the early years of widowerhood, he looked to the faces of models such as Fanny Cornforth, Ada Vernon and Alexa Wilding for relief and forgetfulness from the aridness of his emotional life. He chose women who shared similar physical characteristics: a columnar neck, well-formed lips, luxuriant hair, a certain richness of figure. But they all clearly satisfied his sensations only and could neither revive idealism in him, nor touch his deeper reserves of feeling.

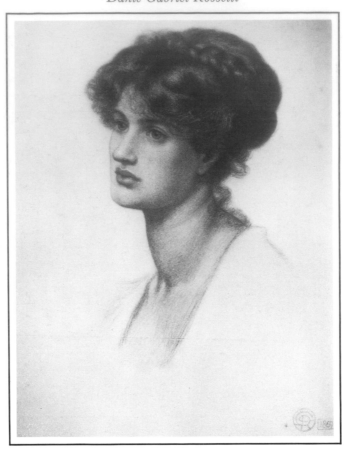

Marie Stillman

Red chalk on green paper, 622 × 470 mm
Signed in monogram and dated: *1869*
Private collection

'I always recommended would-be but wavering worshippers to start with Mrs Stillman who was, so to speak, Mrs Morris for Beginners. The two marvels had many points in common: the same lofty stature, the same long sweep of limb, the "neck like a tower" the night-dark tresses and the eyes of mystery, yet Mrs Stillman's loveliness conformed to the standard of ancient Greece and could at once be appreciated, while study of her trained the eye to understand the more esoteric beauty of Mrs Morris and "trace in Venus' eyes the gaze of Proserpine".'

Graham Robertson's assessment of Marie Stillman, published in his reminiscences, *Time Was,* was shared by many nineteenth-century writers of memoirs across whose pages her name is frequently mentioned. She was born Marie Spartali in 1844, daughter of Michael Spartali, the Greek Consul-General in London and a member of the warm, artistic and wealthy Greek colony in London, which included the Cassavetti and Ionides families.

Marie was tall and imposing, one of a group of three women that included Maria Zambaco and Aglaia Coronio, generally known as the Three Graces. Marie's sister, Christine, was Whistler's model for 'La Princess du Pays du Porcelaine', and Marie started to sit for Rossetti in 1869. She is the model in 'A Vision of Fiametta' of 1878.

Rossetti, however, though he admired her looks did not use her often as a model, for he found her hard to draw:

'I find her head about the most difficult I ever drew. It depends not nearly so much on real form as on subtle charm of life which one cannot re-create. I think it would be hardly possible to make a completely successful picture of her, and I feel a great deal humbler now when I look at other people's attempts.'

Marie was an accomplished painter herself, a one-time pupil of Ford Madox Brown, and she exhibited several works at the Royal Academy from 1870 – 77. But in the eyes of her friends her most remarkable achievement was her marriage to the American writer and artist, William James Stillman, 'an entirely unobtrusive man' as Rossetti described him to Swinburne. Stillman had in fact been editor of *The Crayon* between 1855 – 61, one of the few American journals to spread the news of Pre-Raphaelitism to the New World. He later served as the American consul in Crete during the Cretan insurrection of 1866, witnessing his wife's suicide on the island, commited as a result of the horrors of the rising. Marie Spartali married him in 1872, and lived happily with him, while her London friends remained faithful to the memory of her youthful beauty. Writing twenty years later to Aglaia Coronio, Burne-Jones maintained that she had been the most beautiful of the Three Graces. He opined to Aglaia Coronio:

'. . . and so constant of heart am I that I think so still — she is a Greek and is married to a husband — women often are — I never know why'.

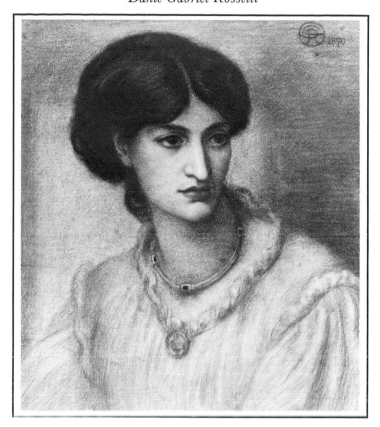

Aglaia Coronio

Coloured chalks on paper, 546 × 457 mm
Signed in monogram and dated: *1870*
Victoria and Albert Museum, London

Aglaia was another member of London's Greek community, which greatly enhanced the city's artistic life during the latter decades of the nineteenth century, both through their wealth, which they used handsomely in patronising the arts, and through their own artistic talents. The central family of this community was Ionides, a Phanariot family whose property had been confiscated by the Turks in Constantinople in 1815 and who had sought refuge in England. Here they prospered as importers of cotton and by the 1860s were wealthy and influential. Constantine, the head of the family, known as 'Zeus' or 'the Thunderer', lived at 8 Holland Villas and was a patron Rossetti. One of his brothers, Aleco, lived in a house in Holland Park decorated by Morris and Co. Luke Ionides was another brother, a friend of Whistler in Paris. Another Ionides sister, Nellie, married Whistler's younger brother, William.

Aglaia was one of Constantine's two sisters, and together with Maria Cassavetti and Marie Spartali (both relatives of the Ionides' family), was considered a noted beauty. Rossetti and various Pre-Raphaelite friends had met the Ionides in 1864 through Luke, who was unsuccessful as a businessman but in his element among artists. Aglaia, a sympathetic and intelligent woman, became friendly with both Morris and Rossetti and she maintained a confidential correspondence with both of them. Morris in particular bared his feelings in letters to

Aglaia in a manner more intimate than in his letters to his wife. In 1872 he wrote to Aglaia about Rossetti's increasing attachment to his wife Janey, and about his own despondency:

'When I said there was no cause for my feeling low, I meant that my friends had not changed at all towards me in any way and that there had been no quarrelling: and indeed I am afraid it comes from some cowardice and unmanliness in me . . . often in my better moods I wonder what it is in me that throws me into such rage and despair at other times. I suspect, do you know, that some such moods would have come upon me at times even without this failure of mine . . . then you have been away so that I have had nobody to talk to about things that bothered me. Another quite selfish business is that Rossetti has set himself down at Kelmscott as if he never meant to go away; and not only does that keep me from that harbour of refuge (because it really is a farce our meeting when we can help it) but also he has all sorts of ways so unsympathetic with the sweet simple old place, that I feel his presence there as a kind of slur on it. . . .'

Despite Morris' animosity towards Rossetti and his confidence in Aglaia, Rossetti himself remained friendly with Aglaia, and valued her judgement. She purchased several of Whistler's paintings and retained a lively interest in Rossetti's progress. When she suggested to him that he make alterations to his painting 'The Day Dream' he was quick to take her advice and noted with satisfaction that the work was much improved as a result. He frequently consulted her during the 1870s about his writing and his painting.

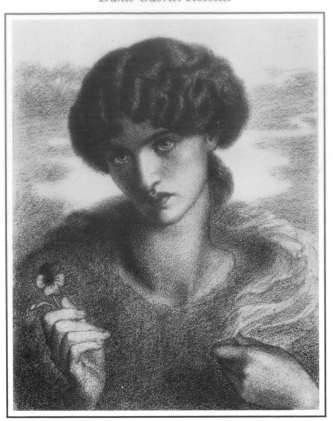

Jane Morris

Coloured chalks on green paper, 321 × 256 mm
Signed in monogram and dated: *1871*
City Museum and Art Gallery, Birmingham

This portrait of Jane Morris is a version of the oil painting, 'The Water Willow' (Delaware), which Rossetti painted in the same year. In the oil Mrs Morris holds branches of willow, and Kelmscott Manor, the house which Rossetti took on a joint tenancy with Morris in 1871, is seen in the background. Rossetti is clearly alluding to the atmosphere of emotional unease and unhappiness existing between himself and the Morrises at this time, exacerbated by his own deepening feelings for Janey. He can hardly have needed to remind himself to think of her, as the pansy ('pensez-a-moi') which Jane is holding in this chalk version instructs him to do. For from 1867 Jane Morris and Rossetti entered a period of intimacy. He wrote to her frequently during these years and in a manner which leaves no doubt about his feelings.

'. . . dear Janey, there are too few things that seem worth expressing as life goes on, for one friend to deny another the poor expression of what is most at his heart . . . I can never tell you how much I am with you at all times. Absence from your sight is what I have long been used to; and no absence can ever make me so far from you again as your presence did for years.' (30 July 1869)

Or again as he wrote to her on 4 February 1870:

'No one else seems alive at all to me now, and places that are empty of you are empty of all life. . . . You are the noblest and dearest thing that the world has had to show me; and if no lesser loss than the loss you could have brought me so much bitterness, I would still rather have had this to endure than have missed the fulness of wonder and worship which nothing else could have made known to me.'

Their friendship was common knowledge, for during 1870 – 71 Rossetti and Janey were often seen together. Edmund Gosse reported that he had seen Janey at Ford Madox Brown's house, where:

'. . . in her ripest beauty, and dressed in a long, unfashionable gown of ivory velvet, (she) occupied the painting-throne, and Dante Gabriel Rossetti, who, though still almost young, was yet too stout for elegance, squatted for some part of the evening at least on a hassock at her feet.'

William de Morgan recorded seeing:

'Rossetti at a party given by Mrs Virtue Tebbs, seated in a corner feeding Mrs William Morris with strawberries. He was carefully scraping off the cream, which was bad for her, and then solemnly presenting her with the strawberries in a spoon.'

Jane's face continued to dominate Rossetti's painting until his death in 1882. For William Morris, who seems publicly to have accepted the position with stoicism, the estrangement from his wife threw him into ever greater social activity; but the poetry he wrote during the years 1867 – 79, unpublished during his lifetime, confirms the sense of failure he felt in his own marriage and his disappointment in being unable to make the transition with Janey from youthful romance and idealism to a relationship based on mutual respect, confidence and intimacy.

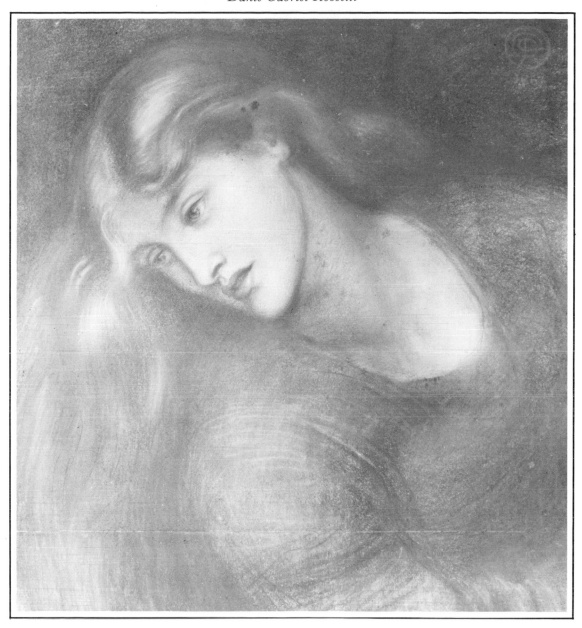

Alexa Wilding

Coloured chalks on paper, 657 × 595 mm
Signed in monogram and dated: *1867*
Private Collection

'Miss Wilding's was a lovely face, beautifully moulded in every feature, full of quiescent, soft, mystical repose that suited some of his [Rossetti's] conceptions admirably, but without any variety of expression. She sat like the Sphynx waiting to be questioned and with always a vague reply in return; about the last girl one would think to have the makings of an actress in her; and yet to be that was her ambition. . . . It was quite by chance that he met with such a face in harmony with the subjects he wanted to realise on canvas and by a lucky accident she came across his path. It was one summer evening that he was in the Strand on his way to the Arundel Club of which he was then a member. Walking quietly along amidst the hurrying folk that thronged the pavement he became aware of a young girl by his side. He turned his head to look at her and was struck by her beautiful face and golden auburn hair. She passed him and got mixed up in the crowd in front. Rossetti followed her for a considerable distance before he could well get up with her . . . with some amount of nervousness . . . he spoke to her and explained that he was an artist and was painting a picture and her face was the very one he required for the subject he was at work on, getting her to come to his studio and give him a sitting for the same, assuring her that she would be amply remunerated.'

So wrote Treffry Dunn, Rossetti's studio assistant, about his master's first encounter with Alexa Wilding. She sat regularly for Rossetti from July 1865, and was paid a retaining fee by Rossetti so that she would not sit for anyone else. She is the model in 'La Ghirlandata', 'Sea Spell', 'Monna Vanna' and 'Sybilla Palmifera' among many others and it is not hard to see the physical resemblance between her and Jane Morris.

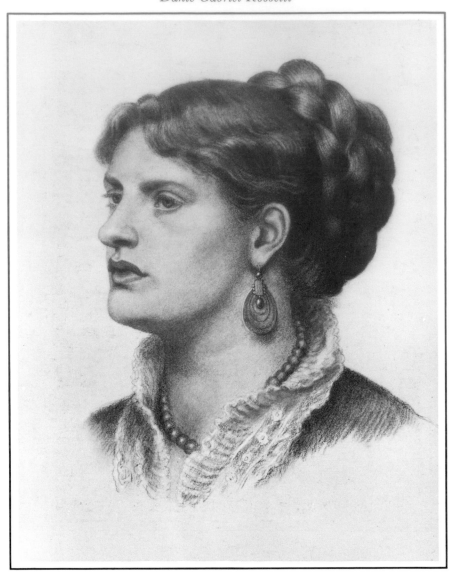

Fanny Cornforth

Coloured chalks on paper, 559 × 406 mm
Signed in monogram and dated: *1874*
City Museum and Art Gallery, Birmingham

Fanny first appears in Rossetti's works as the model for the country-girl turned prostitute in his studies for 'Found'. Her origins may well have had some parallel with this painting for she was illiterate, vulgar and had 'no charm of breeding, education or intellect', in the words of Rossetti's brother. What she did have, however, was abundant blonde hair, an uncomplicated nature and easy virtue; she met Rossetti most probably in 1858, when his relations with Lizzie Siddal were becoming increasingly trying. Fanny was born Sarah Cox, probably around 1826, and married a mechanical engineer, Timothy Hughes, shortly after meeting Rossetti. She appears to have separated from Hughes early in her married life and in 1859 was living in Tennyson Street, Battersea, not far from Cheyne Walk, to where Rossetti moved in 1862. She was Rossetti's mistress, probably before Lizzie's death, and certainly for some years afterwards, until Rossetti renewed intimacy with Jane Morris in 1867.

Although Rossetti was always affectionate towards her, calling her 'Dear Elephant' in his correspondence, she was not well liked by the majority of friends who called at Tudor House; Swinburne, Madox Brown, Hall Caine and Frederick Shields were all suspicious of her and felt that she would happily help herself to the property in the house given the opportunity. Rossetti, however, felt his responsibilities towards her keenly. In 1868, when he was troubled by failing eyesight and depression, he proposed making a deed gift of all his property to his brother William. Anticipating that he would realise £2,000, he stipulated that half this sum should go to Fanny. In 1872 Fanny became more independent of Rossetti when she took on the lease of The Rose and Crown in Jermyn Street, and even more so in 1879, when she married John Schott.

Fanny's ample, blowzy figure appears frequently in Rossetti's canvases from the early 1860s, in marked contrast to the angular, drawn features of Lizzie Siddal. Her appearance heralds Rossetti's departure from the finely wrought, intense work of his youth to the iconic, sensual work of his later life.

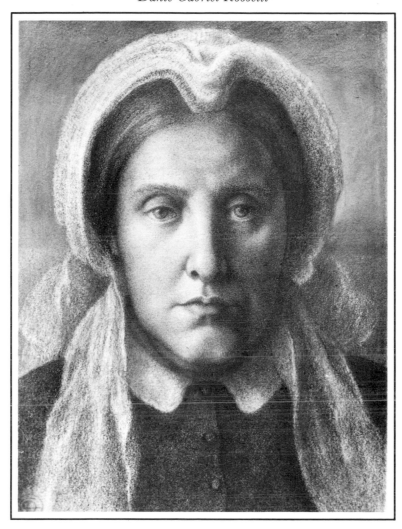

The Artist's Mother

Coloured chalks on paper, 381 × 325 mm
Signed in monogram
City Museum and Art Gallery, Birmingham

Rossetti drew this last portrait of his mother in 1877 at
Hunter's Forestall, near Herne Bay, where he had been
ordered by his doctor in an attempt to cure him of
depression and the excessive use of chloral into which he
had sunk by this date. His mother nursed him then as she
was to do at his death in 1882 — a cool and implacable
woman who was to survive her son by four years.

Born Frances Mary Lavinia Polidori in 1800, Rossetti's
mother was an Anglican, the daughter of an Italian teacher
in London, Gaetano Polidori, and an English governess.
Before her marriage to Gabriele Rossetti in 1826 she had
worked as a governess herself, and throughout her
marriage she maintained a calm and stabilising influence
on her volatile son. Philip Bourke Marston, the blind poet
and friend of Rossetti, disliked what he considered to be a
detachment and a certain lack of sympathy in her, but none
the less he rightly discerned the attachment which all her
children felt for her:

'She never seemed to me a very lovable old lady, but I
suppose she was, since she won the hearts of her
children.'

Mrs Rossetti's toughness enabled her to support the
emotional vicissitudes of her son, and to see the value of
practicality and balance. At the age of seventy three she
declared:

'I always had a passion for intellect and my wish was that
my husband should be distinguished for intellect, and
my children too. I have had my wish and I now wish that
there were a little less intellect in the family, so as to allow
for a little more common sense.'

On 8 April 1826 Frances Polidori married Gabriele
Rossetti, seventeen years her senior, a Catholic and a
political exile from the kingdom of Naples. He had arrived
in England in 1825, an ex-Carbanaro with a rather
glamorous history of rebellion behind him and became a
teacher of Italian at King's College, London. He was
appointed Professor of Italian there in 1833, and was
absorbed in the study of Dante until the end of his life in
1854.

Frances Rossetti brought up her children in very modest
circumstances in a small house in Charlotte Street (now
Hallam Street), but by the accounts of all four of them, their
childhood was happy and affectionate.

William Michael Rossetti

25 September 1829 born at 38 Charlotte Street, third child of Gabriele Rossetti. Educated at King's College School, London and entered the Excise Office (which later became the Inland Revenue Board) in *1845*. He remained there until his retirement in *1894*, having attained the position of Senior Assistant Secretary in *1869*. A critic and man of letters, William Michael edited *The Germ* (1850) and wrote art criticism for *The Spectator* and other journals during the 1850s. These he republished in *1867* under the title *Fine Art, chiefly Contemporary*. In *1866* he published a defence of *Swinburne's Poems and Ballads,* and together with Swinburne wrote the Royal Academy Notes for 1868. Swinburne dedicated his essay on William Blake to him. A republican in sympathy, he produced a volume of *Democratic Sonnets* in *1881*, but was prevented from publishing them by his brother, who feared their revolutionary sentiments would cause trouble in the Civil Service. They were published in *1907*. *1870-73* edited Moxon's series of popular poets; *1870* issued an edition of Shelley; *1874* an edition of Blake; *1887* wrote a Life of Keats for the 'Great Writers' series. The deaths of Dante Gabriel and Christina gave rise to his best editorial skills. Editions by him of his brother's collected works appeared in *1886, 1891, 1904* and *1911,* as well as the *Memoir, with Family Letters,* published in *1895*. For Christina, he edited *New Poems* (1896), *Collected Poems, with a memoir* (1904), and a collection of her family letters (1908). He also published a blank verse translation of his father's Italian 'versified auto-biography' (1901). Among his other literary work were translations of Dante's *Inferno* (1865), work on the *Oxford English Dictionary* and editorial tasks undertaken for the Early English Text Society. *1874* married Lucy Madox Brown, with whom he had two sons and three daughters. *5 February, 1919* died at his home at 3 St Edmund's Terrace, Primrose Hill.

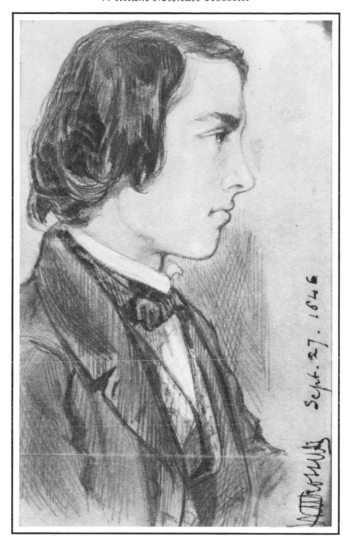

William Michael Rossetti (Self-portrait)

Pencil on paper
Signed and dated: *W M Rossetti Sept. 27 1846*
Private collection

As children Dante Gabriel and William Michael Rossetti received an identical education. Until the ages of nine and eight respectively they were taught at home by their mother, then sent to King's College School. As their father was a professor at King's College, education at the school was free for one son and at a reduced rate for a second. Dante Gabriel left the school in 1842 to attend Sass's Academy of Art; William Michael remained at King's College School until February 1845, when he went to work as a clerk in the Excise Office in Old Broad Street. He never received any formal art education but occasionally accompanied his brother to meetings of the Cyclographic Club as well as drawing informally at home. This self-portrait at the age of seventeen shows his capabilities: charming if lightweight. He was never in doubt that he was not intended as an artist and soon found his metier with the foundation of the Pre-Raphaelite Brotherhood, when he was appointed its secretary. Among his duties were the keeping of a diary of the proceedings of the Brotherhood and a record of the artwork produced by its members. He fulfilled these tasks assiduously, keeping a daily diary of the activities of the Brotherhood until 8 April 1850, and then regularly, though not daily, until 29 January 1853.

William Michael's abilities in poetry were much the same as those of his drawing: charming but lightweight. A typical example is this poem entitled *Winter*, written in 1850:

Clouds, seen through leafless trees, are blown
 Along the sky distinct and fast;
In changeless drench of rain, the ground
 Grows to a pulp: — the Autumn's past.

Loose flakes of snow, which, wavering, reach
 The ground, and change to wet at last,
Whose numbing penetrates the flesh:—
 A quarter of the winter's past.

A dim bleak sky; interstices
 Of black white-veined water, glassed
In the hard earth; a stiffened wind
 Which stiffens:— half the Winter's past.

Retreating mists; a bright pale sun
 In yellow glow; short pipings cast
At random through still leafless trees;
 A sense of love:— the Winter's past.

John Ruskin

8 February 1819 born in London, only son of a wealthy sherry merchant. *1823* moved with his parents to Herne Hill, where his education was undertaken largely by his mother. *1837* entered Christchurch, Oxford, as a Gentleman Commoner. *1839* won the Newdigate Prize. *1840* met J.M.W. Turner for the first time, having admired his illustrations to Rogers' *Italy* as a child. Became a Fellow of the Royal Geological Society. *1842 – 4* began to study Turner and reached maturity as a draughtsman. The family moved to Denmark Hill. Wrote first volume of *Modern Painters*. *1845* first tour of France and Italy without his parents; saw and admired medieval architecture in Florence and Lucca. Wrote second volume of *Modern Painters*. *1847* became engaged to Effie Gray. *1848* marriage to Effie. Wrote *Seven Lamps of Architecture*. *1849* worked on vols three and four of *Modern Painters*. Tour of Venice with Effie where he began work on *Stones of Venice*. *1851* defended Pre-Raphaelites in the press. *1853* holiday with Millais at Glenfinlas; gave first lectures in Edinburgh on art and architecture; initiated plans for the Oxford Museum. *1854* marriage with Effie annulled. Friendship with Rossetti began and he started teaching at the Working Men's College. *1855* began writing Academy Notes. *1856* met Burne-Jones and Morris. *1858* met Rose La Touche, then aged ten. *1859* wrote vol. five of *Modern Painters* and turned away from organized religion. *1860* wrote *Unto this Last*. *1861* spent autumn in Switzerland suffering from depression and religious uncertainty; wanted to found a community in Switzerland. *1862-3* bought land in Chamonix. *1866* proposed to Rose La Touche. *1864* bought property at Paradise Place for the social worker Octavia Hill; gave his *Sesame and Lilies* lectures. *1867* began laying plan for the Guild of St George. *1869* appointed first Slade Professor at Oxford. *1871* first issue of *Fors Clavigera* published; bought Brantwood at Coniston and suffered first serious mental illness. *1872* moved into Brantwood. *1878* mental breakdown; Whistler *v.* Ruskin trial held after Ruskin's attack on Whistler's painting in *Fors Clavigera*. *1879* resigned Slade Professorship as a result of verdict (Whistler awarded one farthing damages). *1881-9* repeated bouts of mental illness. *1883* reinstated Slade Professor but resigned again in *1885,* ostensibly as a protest against the approval of vivisection at Oxford. Wrote his autobiography, *Praeterita*. *20 January 1900* died at Brantwood. Joan Severn, who was looking after him at the time of his death, refused the offer of a grave in Westminster Abbey for him, and he was buried at Coniston.

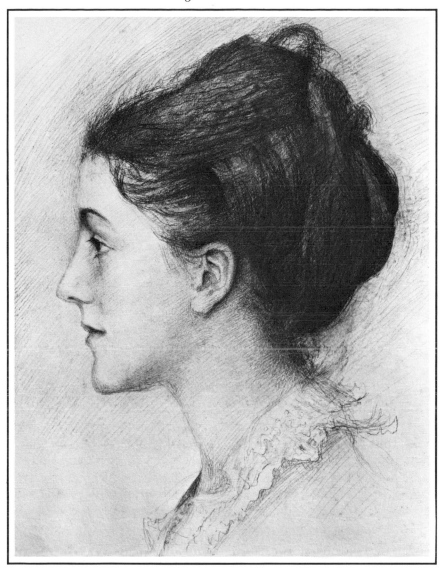

Constance Hilliard

Pencil on paper, 395 × 305 mm
Private collection

The Hilliards were related to the Trevelyans of Wallington: Pauline's sister Mary ('Moussy') was married to a Puseyite minister, the Reverend John Crosier Hilliard. Their daughter Constance, born in 1851, became a fond friend of John Ruskin and the relationship of the great critic with this small girl was not unlike that of Lewis Carroll's with Alice Liddell. He first met Constance at Wallington (the home of Pauline Trevelyan) in 1863, when William Bell Scott was also there, apprehensively awaiting Ruskin's reaction to his newly painted canvases of Northumbrian history installed around Wallington's central saloon. In fact, Ruskin found in the paintings 'some wonderfully dextrous things', but he also found on the same visit that Constance was 'one of the few perfectly delightful children I ever met'. The eminent man of letters was seen dancing on the lawn and playing croquet to amuse Constance; Scott confided to his friend Alice Boyd: 'I suppose one ought to be delighted with him; yet he is a little nauseous.'

Ruskin's mental equilibrium had become increasingly shaken by his infatuation with Rose La Touche, whom he met in 1859. By 1863 she was already an obsession, a 'mouse-pet', as he called her, 'who nibbles me to the very sick-bed with weariness to see her'. At the beginning of 1866, when Rose was just eighteen, Ruskin proposed to her, but he was rejected and asked to wait until she became of age, another three years off. At almost the same time Constance Hilliard, then fourteen, moved into the Ruskin family home at Denmark Hill, while her mother moved to Wallington to nurse her dying sister Pauline. Constance's company rallied Ruskin, who suggested a trip to Venice for the convalescent Pauline: in 1866 the Trevelyans, Ruskin and Constance Hilliard did set out for Italy, but they got no further than Neuchâtel, Switzerland, where Pauline Trevelyan died (13 April 1866). This drawing of Constance was made in 1870, when she was eighteen.

Ruskin had a poor appreciation of his attractions. He couldn't understand anyone liking him: 'they might as well have got fond of a camera lucida, or an ivory foot-rule,' he confided in *Praeterita*. Constance however was an exception. 'She took to me,' Ruskin felt bound to say 'like an aunt'.

115

Frederick Sandys

1 May 1829 born in Norwich, son of a textile worker and portrait painter. He was educated locally at St John Maddermarket and Norwich Grammar schools. His early talent for drawing was rewarded by the Royal Society of Arts in *1846* and *1847* with the Silver Isis medal for drawing. He studied under George Richmond and Samuel Lawrence at the Royal Academy schools, and exhibited his first work at the Royal Academy in *1851*, a portrait of 'Lord Loftus'. *1853* married Georgina Creed, daughter of a Norwich artist; commissioned to illustrate *Extracts from my Journal* (an account of the author's ascent of Mont Blanc) by James Redfoord Bulwer, a lawyer and Tory politician. *1855* changed the spelling of his name from Sands to Sandys. *1857* introduced himself to Rossetti to get his likeness for the satirical print he was working on, a mockery of Millais' Royal Academy picture of that year. The print, 'A Nightmare', brought his name into prominence, and gave him an entree into Pre-Raphaelite circles. *1860* received the first of a number of commissions to illustrate for *The Cornhill Magazine,* from its editor, Thackeray. *1862* visited the Low Countries with the solicitor and Pre-Raphaelite patron, James Anderson Rose; began to frequent Rossetti's house in Cheyne Walk. *1864* stayed with Meredith at Copseham Cottage, where he painted the landscape background of 'Gentle Spring', shown at the Royal Academy the following year. *1866* resident at Cheyne Walk with Rossetti until October; illustrated Christina Rossetti's poem 'If'. *1867* first appearance of Mary Jones, later to become his

common law wife, as a model in his work. *1868* painted 'Medea'. *1869* rift with Rossetti. *1873* stayed with Charles Augustus Howell and did a portrait of his wife. *1875* rift with Rossetti patched up; was to have started a portrait of Swinburne (according to Swinburne) though no such work has been traced. Birth of his daughter Winifred (she subsequently married Lionel, son of the painter Walter Crane). *1880* received commission from Alexander Macmillan for a series of chalk portraits of writers published by Macmillan and Company. These included: George Lillie Craik (a partner in Macmillan and husband of Dinah Nulock, the author of *John Halifax, Gentleman,*) Matthew Arnold (1881), Goldwin Smith (1881), John Morley (1881), James Russell Lowell (1882), Joseph Henry Shorthouse (1882), John Richard Green (1882), Alfred Tennyson (1884), Richard William Church (1884), Brooke Foss Westcott (1885), Lord Wolseley (unfinished) and Field Marshall Earl Roberts (unfinished). *1880* established in a house overlooking Brecon Beacon by Cyril Flower, to prevent his being lured by the distractions of London. *1887* birth of Gertrude, second youngest of his nine children by Mary Jones. (She married Lionel Crane in 1913. On her death in 1920 Winifred Crane became Lionel's second wife.) *1898* elected original member of the International Society of Sculptors, Painters and Gravers. *1904* retrospective exhibition at the Leicester Galleries. *25 June 1904* died at his home at 5 Hogarth Road. Buried in Brompton Cemetery (without a tombstone).

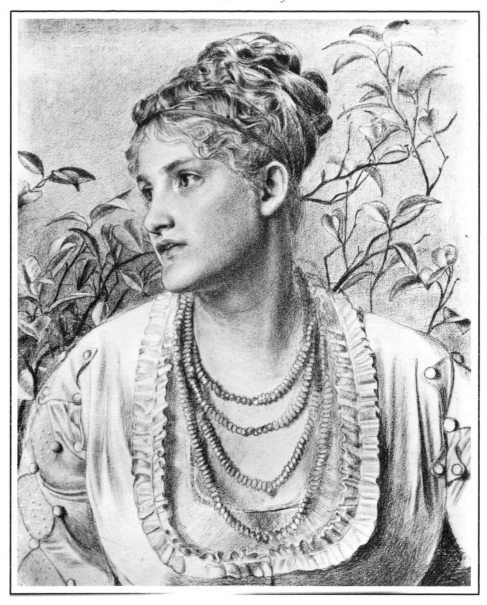

Mary Sandys

Coloured chalks on toned paper, 489 × 394 mm
City Museum and Art Gallery, Birmingham

Mary Sandys' first appearance as a model in Sandys' work is in 1867, the likely date of their first meeting. The daughter of Justice Jones of Hull, she trained as a Shakespearian actress and was probably appearing in private performances when she met Sandys. Then aged seventeen, she ran away to live with Sandys, who had previously been married in 1853 to the daughter of a Norwich artist; he does not appear to have ever legally separated from his first wife. Whatever the legal state of their union, Mary was universally accepted as Sandys' wife, bearing the first of their three children in the home of Sandys' father at St Giles Hill, Norwich. In 1873, probably the date of this portrait, Mary made her first public appearance as an actress, playing Constance in *King John* at the Queen's Theatre, after a considerable amount of advance publicity had been given to her new discovery. She

was, it appears, received with great applause, but she immediately became ill with rheumatic fever, and made no further stage performances. She bore Sandys nine children: seven daughters and two sons. The oldest daughter, Winifred, born in 1875, was an artist of considerable talent, and two other daughters, Mildred and Ruth were successful illustrators; Ruth originated the design of an early Victorian couple still used today to promote the sale of Lilley and Skinner shoes. The youngest daughter, Gertrude, married the son of the painter Walter Crane in 1913, despite opposition from both families. After Gertrude's death in 1920 her sister Winifred married the widowed Lionel Crane. Mary herself died in 1920, the subject of an obituary poem by Gordon Bottomley in which her quintessentially Pre-Raphaelite beauty, in particular the entrancing quality of her hair, is expressed:

> Now she is deathless by her lover's hand
> To move our hearts and those of men not born,
> With famous ladies by her living hair —
> Helen and Rosamund and Mary Sandys.

117

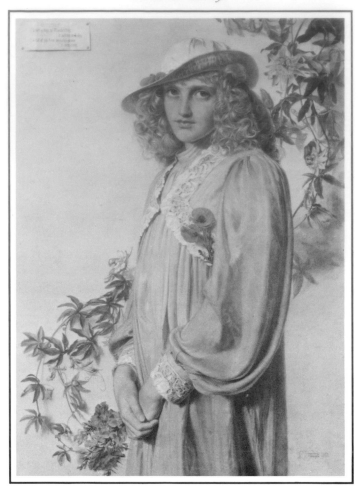

Gertrude Sandys

Coloured chalks with watercolour on paper, 750 × 560 mm
Signed and dated: *F. Sandys 1900*
Private collection

This portrait of the artist's youngest daughter, Gertrude, or 'Girlie' as she was known, is full of references to an adolescent girl's devoutness. The passion flowers which wind around her in the background denote Christian Faith in the Victorian language of flowers and the portrait is inscribed with a semi-devotional verse, entitled *Wondertime:*

> To her a day is Wondertime
> It seems so loud:
> So full of joy from morning, prime
> To even-song

Gertrude was thirteen when this portrait of her was made; she was one of her father's principal models, sitting for 'The Red Cap' (1903) and 'St Dorothy' (1904).

Much of Sandys' portrait work has a superficial hardness verging on nastiness, and something of this is visible in this portrait. Early in the friendship between Sandys and Rossetti, Rossetti had detected that while Sandys copied some of his stylistic features, his technique was not 'outwardly very conformable' to Rossetti's own ideas about painting. It was this opinion that caused the eventual rift between the two of them in 1869. It sheds an interesting light on Sandys' pettiness and Rossetti's generosity. Rossetti complained to Sandys that he stole his ideas, thus making it impossible to take up the themes himself. Sandys took exaggerated offence at this accusation and straightaway wrote to Rossetti to sever their relationship. He enclosed £50 in the envelope. Rossetti's reply would have softened the heart of any man less stiffened with pride than Sandys:

'Thanks for the £50. . . . You view this payment as the severance of a last tie between us; and any tie of this kind is so unimportant compared to those which you spontaneously broke through in your first letter that I had better proceed at once to reply to that. . . . I myself hold that friendship should only be resigned when one friend can prove malice or deception against another. Of the first of these I know I am innocent; of the second I should have been to a certain extent guilty if I had held my tongue as soon as I felt myself strongly impelled to speak. I believe myself firmly in the sincerity and single-mindedness of your friendship for me till this time, and even in all you say of your great pain at the termination to which you have chosen to bring it. You say that you believe this matters little to me; but why you say so I cannot conceive. It is however, some relief to know that the separation which you make between us comes at a moment when, to my joy, great success and many friends await you, and that I can on my side remain still — Affectionately Yours. . . .'

118

Charles Augustus Howell

Overleaf:
Coloured chalks on paper, 192 × 549 mm
Signed and dated: *F. Sandys 1882*
Ashmolean Museum, Oxford

A maverick figure in the English art world between the 1860s and 1880s, Howell (1840? – 90) was an entrepreneur and dealer of tremendous glamour but unscrupulous habits. Said to be the son of an English drawing master living in Lisbon and a Portuguese mother, his early life is vague; stories of his card-sharping in Oporto and diving off the Portuguese coast for booty in the wreck of the Spanish galleons certainly helped fabricate an air of swashbuckling romance. 'a Gil Blas = Robinson Crusoe hero out of his proper time', Whistler called him, 'the creature of top-boots and plumes, splendidly flamboyant'.

Howell first became known to the Rossettis in 1856 and after Rossetti's move to Tudor House in 1862 was a regular caller there. What he did exactly was open to conjecture, but he was an entrepreneur of wizard talent, dealing in works by Rossetti and other Pre-Raphaelite painters and acting at various times as adviser and agent to Ruskin, Whistler, Watts, Swinburne and Burne-Jones. Ruskin, for whom he acted as secretary from 1865 – 70, was so confident of his taste that when he was Slade Professor of Art at Oxford he commissioned Howell to furnish him a house so that he could display works of art there. The curious trio of Rossetti, Swinburne and Howell became a common sight during the mid 1860s, haunting the 'acrid putrescence' of London's low life, enjoying the pleasures of Cremorne Gardens, Astley's Theatre and the junk shops where Rossetti's appetite for collecting was indulged. With the introduction of Howell into the Pre-Raphaelite orbit, 'the Baron Munchausen of the Circle' as Ford Madox Brown described him, the wild stories of a bohemian existence within the group begin to take definite shape.

Howell's quixotic temperament was accompanied by an astute business sense. Encouraged by Rossetti in an interest in oriental 'blue and white' china, he built his collection of orientalia — Japanese prints, furniture and porcelain — into a profitable venture, at the same time helping to spread the taste for Japanese decorative arts. The appreciation of oriental aesthetics in the mid-nineteenth century had begun in France, primarily with the Goncourt brothers and Whistler. The latter, who had moved from France to England in 1859 had first infected Rossetti with his own interest in things oriental. Howell was friendly with both men and kept this common interest between the two artists alive.

Perhaps Howell's greatest service to Rossetti was in the exhumation of his poetry from Lizzie Siddal's grave. Rossetti had thrown the manuscript book containing all his poems into the coffin to be buried with his wife, but in 1869 he instructed Howell secretly to recover the book:

> '[it] is bound in rough grey calf and has, I am almost sure, red edges to the leaves. This will distinguish it from the bible, also there as I told you.'

Howell was unable to keep the transaction a secret; and it was this that eventually weakened his relations with the Pre-Raphaelite circle. He was 'one who came amongst us in friend's clothing', Georgiana Burne-Jones later wrote rather righteously, 'but inwardly was a stranger to all our life meant'. Rossetti's limerick is perhaps more to the point:

> There's a Portuguese person named Howell
> Who lays on his lies with a trowel
> When I goggle my eyes
> And start with surprise
> It's at monstrous big lies told by Howell.

There is a story that Howell died in mysterious circumstances in 1890, when he was found with his throat slit lying in the gutter outside a public house in Chelsea, a ten-shilling piece clenched between his teeth. Characteristically, he had once before this occasion staged his own death, having arranged a sale to follow it. So when his death was finally announced Ellen Terry wrote knowingly to Graham Robertson: 'Howell is *really* dead *this* time — do go to Christie's and see what turns up'.

119

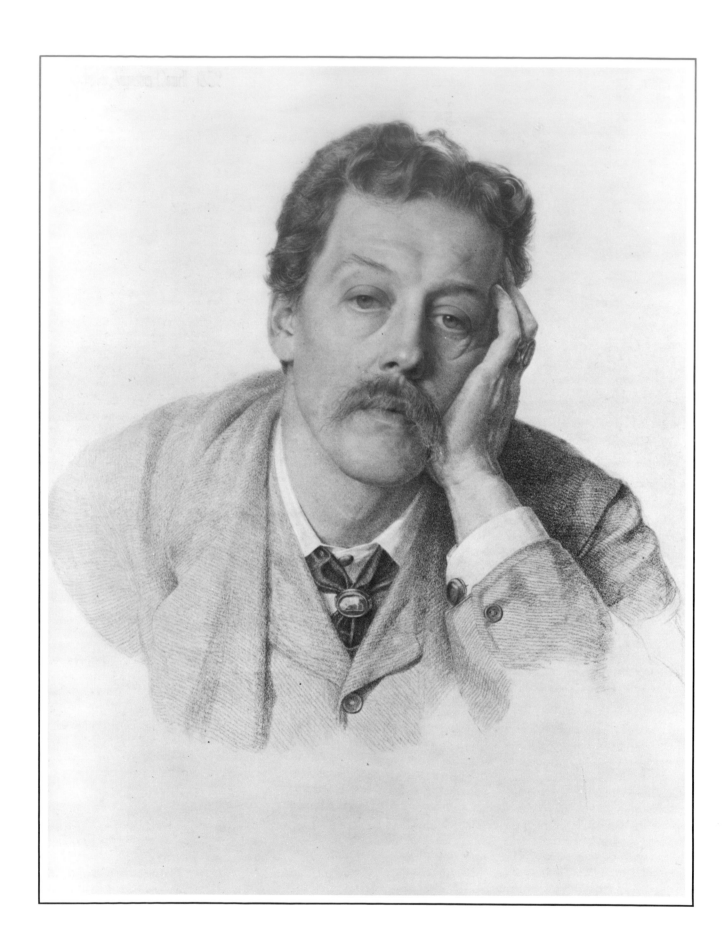

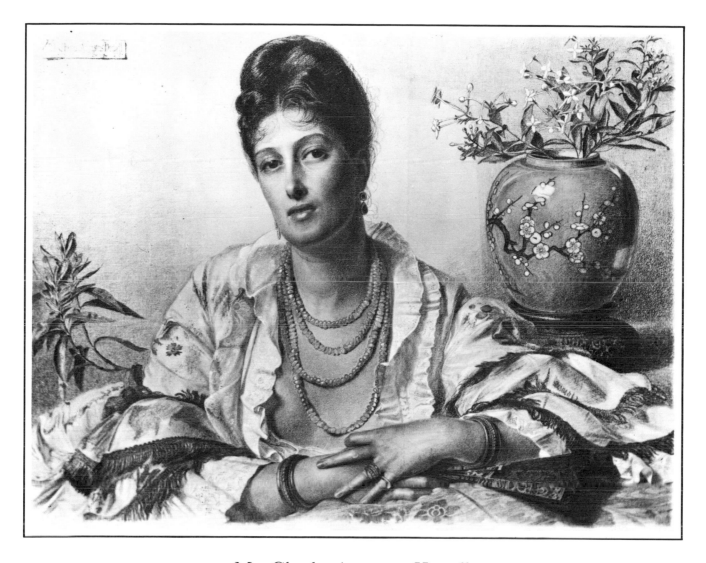

Mrs Charles Augustus Howell

Coloured chalks on toned paper, 697 × 657 mm
Signed and dated: *Fredk. Sandys 1873*
City Museum and Art Gallery, Birmingham

Frances Catherine (Kitty) Howell was the cousin of Charles Augustus Howell. She married him in Brixton in 1867 in a service attended by the Morris and Burne-Jones families, William and Christina Rossetti and Ford Madox Brown, whose daughers were bridesmaids. It was a period of comparative affluence for many of the Pre-Raphaelites, with Ford Madox Brown and Burne-Jones newly moved into rather grand houses, and giving animated parties at which the Howells were among their regular guests. The Morrises too were affluent, particularly since the firm of Morris and Co. had managed to swell its order book, and they were hosts to a party at their home in Queen Square which Allingham recorded in his diary for 27 May 1868 and which admirably describes the company the Howells kept:

'To dine with Morris, and find, just alighting Mrs Ned [Georgiana Burne-Jones], in a gorgeous yellow gown; 'tis a full dress party! and I in a velveteen jacket. Morris, Ned J. (thin), D. G. R. (looking well), Webb, Howell, Mr Winifred Heeley, Publisher Ellis, and W. A. (the men). Mrs Morris, Miss Burden, Mrs Ned (gay), Mrs Howell, Mrs Madox Brown (looks young with back to the window), Lucy Brown, Miss Faulkner (I between these), Mrs Ellis, Miss Heeley (the ladies) Banquet.'

The influence of Whistler is at its most potent in this portrait by Sandys, who knew Whistler well from their mutual visits to Cheyne Walk during the 1860s. The sensitive treatment of tone, the use of oriental props such as the blue and white vase and the jasmine, and the flat perspective of this portrait are all symptomatic of the new interest in oriental aesthetics for which Whistler was largely responsible. It was a salutary influence on Sandys' work, though short-lived.

121

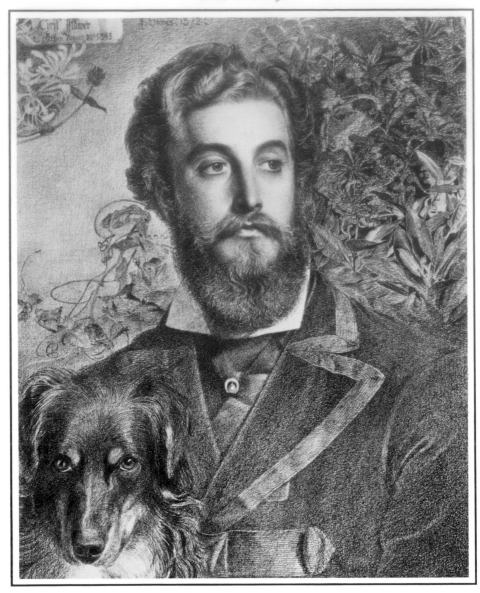

Cyril Flower

Coloured chalks on toned paper, 330 × 508 mm
Signed, dated and inscribed: *1872 F. Sandys Cyril Flower, born*
August 30th 1843
Private collection

Cyril Flower vied with the banker Sir Lindsay Coutts as the most handsome man in London. Known as 'the irresistible man', he was also said to be the original of *Eric (or Little by Little),* and he must surely have become even more attractive after his marriage to Constance, daughter of Sir Anthony Rothschild, in 1897.

Constance was the niece of Blanche Fitzroy who had married Sir Coutts Lindsay after meeting him at the home of the Prinseps, Little Holland House. The Lindsays' interest in art and their great wealth encouraged them to found a *contre-salon* to the Royal Academy in 1867, the Grosvenor Gallery, and it was from this gallery that the Flowers bought many of the Pre-Raphaelite works which formed part of their own large collection.

In the early years of the marriage, Constance had wanted to build a home in Battersea (where the Flowers owned substantial areas of land), that would in its beauty elevate the standards of taste of the working people living in the area. But Flower preferred to live in Surrey House, Marble Arch, and the beautiful home was never built. Nonetheless, the Flowers did build a collection of pictures and objets d'art of considerable interest, and among their paintings were works by Whistler, Sandys and Burne-Jones (one of Burne-Jones' most important canvases, 'The Golden Stairs', was bought by the Flowers after its exhibition at the Grosvenor Gallery in 1880).

In 1880, when Flower was Liberal MP for Brecon, he installed Frederick Sandys in a house in his constituency overlooking the Beacons in an attempt to get him to produce some of the work for which Flower had been paying him advances. Flower spent both time and money in his patronage of Sandys, but relations soured between the two men during the 1880s when the financial advances made of Flower were not repaid by Sandys.

Flower's political career flourished and he was elevated to the peerage by Gladstone in 1892.

Mrs Murray Marks

Overleaf:
Coloured chalks with watercolour on paper, 768 × 546 mm
Signed and dated: *F. Sandys 1873*
Victoria and Albert Museum, London

Murray Marks, a prominent London art dealer, commissioned this portrait of his wife, Louisa, from Sandys in 1873. Sandys had been introduced to Marks by Rossetti, a connection which Marks later came to rue. For though Marks was helpful to Sandys in finding him commissions and selling his work, Sandys was thoroughly unreliable in business matters. Portraits were started, the money for them drawn on account and then frequently left unfinished. An embarrassed Marks would be left to coax the artist into honouring his commitments.

After Sandys' death in 1904, Marks helped his widow by buying many of the artist's works for himself, and arranging for the sale of others. On his own death, however, in 1918, this portrait of his wife was the only work by Sandys left in his possession. The fillet of white jasmine in Mrs Marks' hair is a reference not only to her amiability, the quality it denotes in the Victorian language of flowers, but to her husband's business expertise in the field of oriental ceramics.

Marks was closely associated with the cult of Blue and White Nankin in the English art market of the late nineteenth century. In the 1850s, Marks' father had let a portion of his business premises at 395 Oxford Street to Frederick Hogg and Co., importers of modern Chinese goods. Murray Marks was fascinated by the stock and set about learning as much as possible on Chinese ceramics. By the early 1860s he had become a considerable expert. The only other firm at the time importing Blue and White

Nankin into England was Farmer and Rogers' Great Cloak and Shawl Emporium, under its manager Lazenby Liberty. In 1875 Liberty opened his own shop in Regent Street and Murray Marks, who had taken over the premises at 395 Oxford Street, commissioned the architect Norman Shaw to redesign the facade and elevation of his shop in the same year. The result of this collaboration with Shaw was the construction of the first commercial elevation in the Queen Anne style. In place of the usual Oxford Street frontages, with their large glass windows and obtrusive shop fronts, there rose a subtle, flat, cream-coloured facade, with small square window panels divided by carved wood surrounds and three elegant round-headed niches, set flush with the walls, to hold the choicest objects. This innovative design gave Marks the opportunity to display his goods in unique surroundings, stressing their aesthetic and decorative importance. Whistler and Rossetti came to him frequently for purchases for their Blue and White collections; in fact Rossetti, Whistler and Morris all collaborated on the design of Marks' trade card, which shows a ginger-jar of Chinese porcelain with prunus blossom decoration and a peacock feather tucked inside. Printed around this design are the names of Marks' other areas of interest: enamels, bronzes, armour, tapestry, leather, Sèvres and Dresden. These wider interests brought him into contact with many artists of the Pre-Raphaelite circle: with Ruskin, for whom Marks designed a cabinet to hold some of his minerals, with Philip Webb, Fairfax Murray, Burne-Jones, Simeon Solomon, Charles Augustus Howell, William Bell Scott, Swinburne and Millais. The boast that he was intimately concerned in the formation of every great collection in London and in Paris was certainly not far exaggerated.

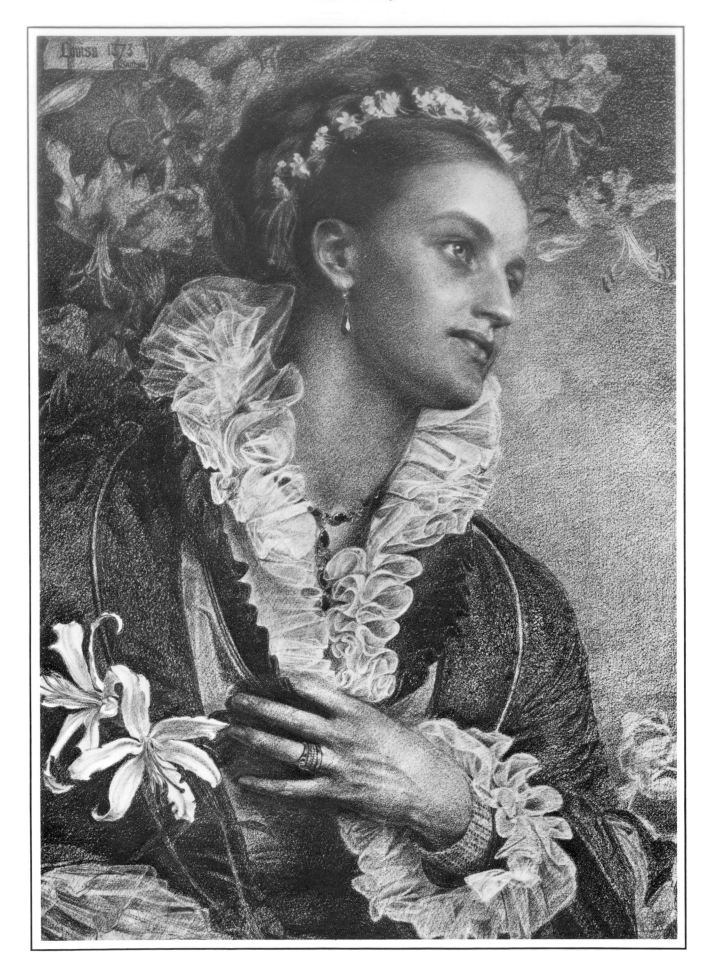

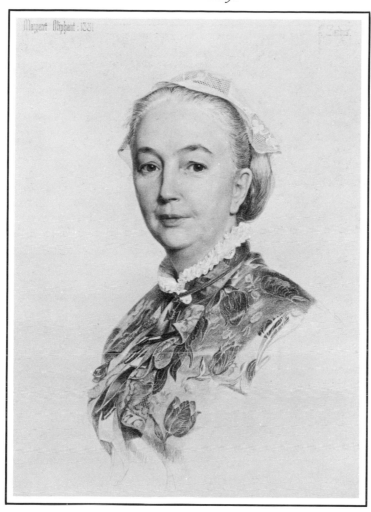

Margaret Oliphant

Coloured chalks on paper, 685 × 508 mm
Signed and dated: *F. Sandys 1881*
Private collection

Margaret Oliphant (1828 – 97) is an admirable, though unusual, example of an artist's wife. Her husband, Frank Oliphant, was a stained-glass designer of neither talent nor success. Early on in their marriage it became evident that Margaret, who had begun writing for *Blackwood's Magazine* in her early twenties, was to be the breadwinner. When her husband died of consumption in 1859, leaving her with three children and a debt of one thousand pounds, her need to earn a living became even more urgent. She continued to support her household by writing for the rest of her life, and sent her sons to Eton and Oxford, as well as maintaining within her household her widowed brother and his two children, and a further nephew, William.

Once the family had retired to bed she would begin to write — 'a night-spinning spider of long, loose, vivid yarns', as Henry James called her. She herself, in her old age, put it more straightforwardly: 'I don't think I have ever had two hours undisturbed for writing except when everyone else is in bed during my whole literary work'. Her literary success, though slight, began with the serialisation of *The Chronicles of Carlingford*, published by *Blackwood's*. Her output was catholic: books on biography and history,

books on travel in Florence, Venice and Jerusalem, tales of the supernatural such as *The Little Pilgrim in the Unseen*, and light satire such as *Miss Marjoribanks*. Her indefatigable energies however were not without their artistic toll. She was the first to recognise that her immense production caused her to forfeit the chance of producing any first-rate literary work. In the *Autobiography and Letters of Mrs Oliphant*, published in 1899, she drily recorded her predicament:

'I remember that I said to myself, having then perhaps a little stirring ambition, that I must make up my mind to think no more of that, and that to bring up the boys for the service of God was better than to write a fine novel, supposing even that it was in me to do so. . . . It seemed rather a fine thing to make that resolution, though in reality I had no choice; but now I think that if I had taken the other way, which seemed the less noble, it might have been better for all of us. I might have done better work . . . who can tell? I did with much labour what I thought the best, and there is only a *might have been* on the other side.'

On her death in 1897, *Blackwood's Magazine,* for whom Mrs Oliphant had written continously for forty-five years, published an obituary notice in which it was generously maintained that 'Mrs Oliphant has been to the England of letters what the Queen has been to our country as a whole'.

William Bell Scott

12 September 1811 born in Edinburgh, son of the engraver and illustrator, Robert Scott. He was educated at the Trustees' Academy and trained as a painter and illustrator by his father. *1835* began to publish poetry in *The Edinburgh Review. 1837* moved to London, supporting himself by working as a 'painter-etcher' and mixing in circles which included Frith, Richard Dadd, Leigh Hunt, John Leech and G. H. Lewes. *1842* competed for the Westminster Hall Decoration and entered his first works for the Royal Academy; they were rejected. *1843* offered one of the new appointments set up by the Board of Trade: the mastership of the Newcastle School of Art and Design. He found the challenge daunting. 'To touch the hide-bound and iron-bound heart of the community that had refused to consider the arts as anything but trifling amusement' was the task that he set himself, and he was reasonably successful. He made a point of encouraging and learning from artisans. He visited the extensive ecclesiastical glass painting establishment run by Francis Oliphant (the husband of the writer Mrs Oliphant) and became friendly with the couple. He visited the iron and brass foundries of the area; in Stephenson's railway engine factory he found the inspiration for his 'Iron and Coal', the most vivid of the murals he painted for Wallington Hall. *1846* published *The Year of the World: A Philosophical Poem: on "Redemption from the Fall"*; Rossetti admired it and wrote asking for an introduction on the strength of it. *1847* met Rossetti, Carlyle and Woolner. *1850* contributed two poems to *The Germ. 1853* published *Poems by a Painter* with three of his own illustrations. *1855* met the Trevelyans. *1856* commissioned to paint murals for Wallington Hall. *1857* met Swinburne. *1859* met Alice Boyd, owner of Penkill Castle, Ayrshire, for whom he experienced a lifelong devotion. *1864* left Newcastle to settle permanently in London. *1865* began series of wall decorations for Penkill, 'The King's Quair of King James I of Scotland,' completed in *1868* and etched by him for publication in *1885. 1870* moved to 92 Cheyne Walk, a close neighbour of Rossetti. *1875* publication of *Poems,* with dedication to Rossetti, Morris and Swinburne. *1882* published *A Poet's Harvest Home. 22 November 1890* died at Penkill Castle, from angina; he spent his last years being nursed by Miss Boyd. *1892* posthumous publication of *Autobiographical Notes . . . and Notices of His Artistic and Poetic Circle of Friends.*

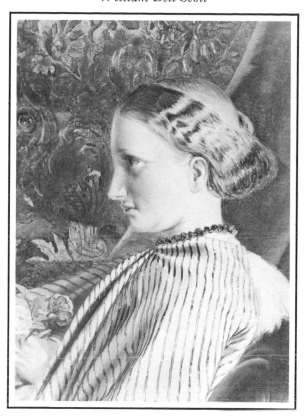

Pauline Trevelyan

Oil on canvas, 460 × 340 mm
The National Trust, Wallington

Friend and patron of the Pre-Raphaelites, Pauline Trevelyan (1816 – 66) was the daughter of George Jermyn, a parson and a naturalist of some note. In 1835 she married Sir Walter Calverley Trevelyan, a distinguished amateur natural scientist, twenty years her senior. Pauline was fond of painting and in the early years of her marriage familiarised herself with the English art scene. She admired Ruskin's writings and, having met the author in 1847, they became life-long friends. They shared an admiration for the Pre-Raphaelites from early in the 1850s, and Pauline was asked to review Ruskin's pamphlet *Pre-Raphaelitism*, published in 1851, for *The Scotsman*. In her review she gave an astute account of what the Pre-Raphaelites were attempting to do, and was strongly critical of a society which could produce such rebels in the first place:

> 'The system, not the men, was in fault . . . the training of academies, the shallow criticisms of many who profess to instruct the public — the un-enlightened patronage of a large portion of those who purchase pictures . . . to these causes may be added the artificial state of society in which we live. . . . Under these circumstances, how much firmness of character, originality of thought, and determined self-denial, must it cost to break through adverse influences, to resist all temptations, and resolutely adopt a course of severe study.'

Pauline met William Bell Scott in 1855. He was invited to the Trevelyan's Northumberland home, Wallington Hall, following the publication of his *Poems of a Painter*. By March 1856, Pauline was discussing with him the decorations for the redesigned central saloon of Wallington: eight large scenes of Northumbrian history were to be painted by Scott to fill in the spaces between the arches, which Pauline herself and John Ruskin were to paint with plants and foliage.

Several intimates of the Pre-Raphaelites were guests at Wallington: the two Millais brothers, Alexander Munro, Holman Hunt, Ford Madox Brown, Thomas Woolner, Christina and William Rossetti and Benjamin Woodward (the architect of the Oxford Union and the Oxford Debating Hall) among them. Pauline had been to see the Pre-Raphaelites at work on the murals in the Debating Hall and in 1858 commissioned a watercolour from Rossetti, 'Mary in the House of St John'. Her husband patronised Woodward's buildings in Oxford and later employed him to build a villa at Seaton.

Although the Trevelyans made Wallington their principal home, their other great estate was Nettlecombe Court in the Brendon Hills in Somerset. Scott, by this stage one of Pauline's closer friends, was invited to stay at Nettlecombe with the Trevelyans in 1864 and it was here that this portrait of Pauline was begun. She is holding camellias in her hand ('perfected loveliness' in the Victorian language of flowers) probably culled from plants that she and her husband, both keen botanists, had ordered for Nettlecombe when they visited Portugal in 1846. The vivacity and delicious sense of humour for which Pauline was renowned is much in evidence in this light, silvery portrait. She was in fact forty-eight when she sat to Scott, whom she nicknamed her 'Porcupine'.

Algernon Charles Swinburne

Opposite:
Oil on canvas, 464 × 318 mm
Balliol College, Oxford

Swinburne (1837 – 1909) was first introduced to the Pre-Raphaelites in 1855 at Wallington Hall, where he met William Bell Scott, a guest of the Trevelyans. Swinburne's family home, Capheaton, bordered on the estate of Wallington and the Swinburne and Trevelyan families were acquaintances of long standing. Swinburne, then only eighteen and about to go up to Balliol, took to Scott, twenty-six years his senior, and subsequently stayed with the Scotts in Northumberland on several occasions. His interest in the Pre-Raphaelites was further stimulated by Rossetti and Morris, whom he met as an undergraduate watching the progress of the mural decoration of the Oxford Union Debating Hall in 1857. When he went to stay with Scott in 1859 he could talk of nothing but Morris and Rossetti 'and only those books or things they admire'.

It was during Swinburne and Scott's stay together at Wallington in 1859 that they made the expedition to the Longstone lighthouse which inspired this portrait, begun in the first months of 1860. The sea journey to Longstone had made Scott sick, but Swinburne had loved the waves, which were as a 'nursing mother' to him, Scott wrote. His father, Charles Henry Swinburne, was an admiral, which might also account for Scott's unlikely portrayal of his friend standing, as it were, at the helm.

After Swinburne had been sent down from Oxford for his increasingly dissolute behaviour, he gravitated to Rossetti's rooms in Chatham Place, where he received literary encouragement from Gabriel and sympathetic understanding from Lizzie, who were only recently married. Swinburne was one of Rossetti's exceptional friends whom Lizzie not only liked but was confident with, and after her death Swinburne was her most vocal and vociferous champion: 'Except Lady Trevelyan,' he wrote in her defence, 'I never knew so brilliant and appreciative a woman.' When Rossetti moved into Tudor House in 1862, he took Swinburne on as a joint tenant, while his brother William Michael and the writer George Meredith slept in the house on various nights of the week as sub-tenants. Meredith lasted very little time and Swinburne made it well-nigh impossible for the remaining householders to live in peace with him: drink affected him badly and eventually his orgiastic excesses — sliding down the banisters naked and 'dancing all over the studio like a wild cat' — made it imperative for him too to leave. His relations with Rossetti, however, remained good until 1872, when, rather mysteriously, they were broken off. Swinburne did write a substantial portion of the work published in *Poems and Ballads* (1866) while staying either at Tudor House or under the benevolent eye of Rossetti. But he insisted somewhat hysterically that his work was not to be confused with that of the Pre-Raphaelites and that it bore no comparison with the work of Rossetti, as he pointed out in 1876:

'I do not see one point in common, as to choice of subject, turn of mind, tone of thought, trick of speech, aim or method, object or style, except that each, I hope I may say, is a good workman who chooses and uses his tools. . . . I really see no bond of community or even connexion between us beyond the private and casual tie of personal intimacy at one time of life.'

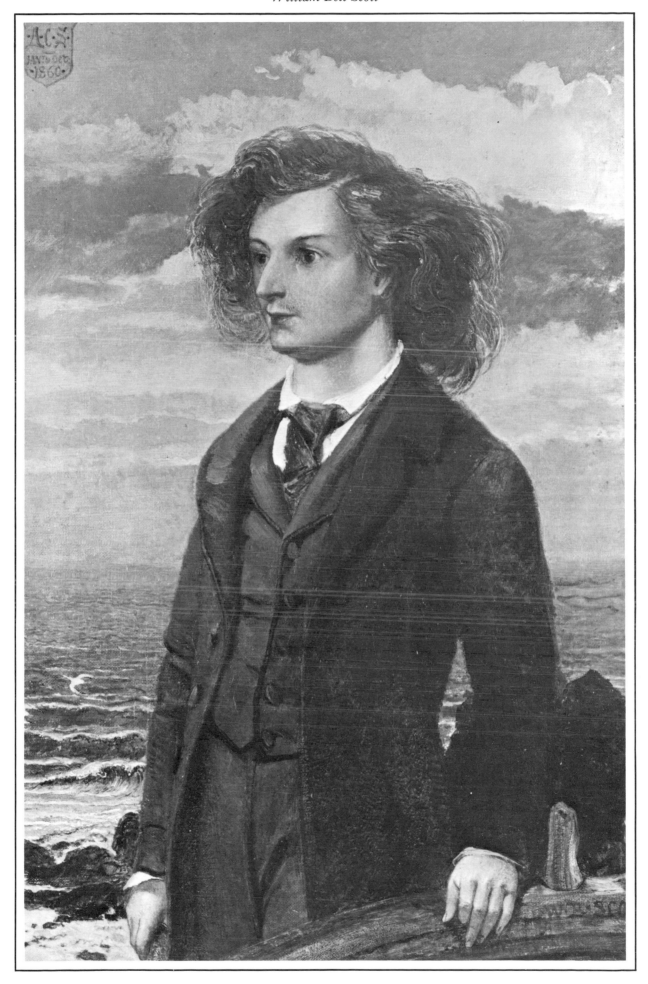

Elizabeth Siddal

25 July 1829 born in Holborn, one of seven (?) children born to Charles and Elizabeth Sidall. (The family name is spelled 'Siddal' on all the census returns, the Inquest papers and on Elizabeth's baptismal entry. For whatever recondite reason her name was spelled 'Siddal' in all Rossetti's correspondence, on her marriage certificate and in all mention made of her subsequent to her entry into Pre-Raphaelite circles.) Her father, originally from Sheffield, was a cutler and ironmonger by trade. At the time of Elizabeth's birth he was living in Hatton Garden, Holborn. By the time she was eleven the family was living in Upper Ground Street, Black-friars. In *1850* when she met Rossetti she was living with her parents at 8 Kent Place, Old Kent Road. Two of her sisters worked in dressmaking; Elizabeth worked as an assistant in a millinery shop in Cranbourne Alley, off Leicester Square. Appeared as a model first for Deverell, then for Hunt and Millais, finally for Rossetti. There are few certain dates within Elizabeth Siddal's shadowy career, but by *1852* she and Rossetti were considered engaged by the Brotherhood. *August 1852* first signs of illness, with recuperation in Hastings. *1854* friendship with the writer and journalist Mrs Howitt who supervised medical attention: 'curvature of the spine' diagnosed. Illness in Hastings, where her friendship with Barbara Leigh Smith and Bessie Parkes deepened. *1855* visited Dr. Acland in Oxford; *September* travelled to France with Mrs Kincaid (cousin of Rossetti); Christmas in Nice; returned to England spring 1856. Repeated illnesses, with 'water cures' in Matlock, Brighton and Hastings. *23 May 1860* marriage to Rossetti at St Clement's Church, Hastings. *2 May 1861* delivered a stillborn child. *11 February 1862* died at her home in Chatham Place. *12 February 1862* inquest held at Bridewell Hospital, where a verdict of accidental death caused by an overdose of laudanum was returned. Buried in the Rossetti family grave at Highgate cemetery.

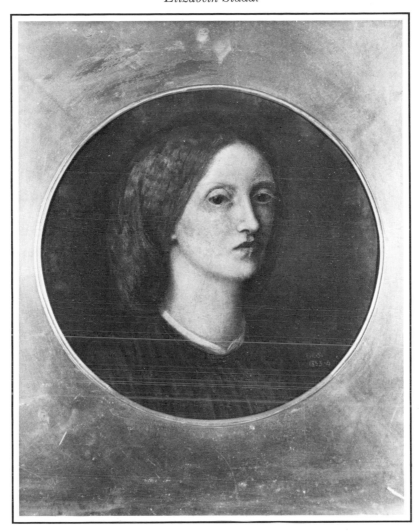

Self-portrait

Oil on canvas, 228mm diameter
Signed and dated: *E.E.S./1853.4*
Private collection

In an Artist's Studio (1856)

One face looks out from all his canvases,
One selfsame figure sits or walks or leans:
We found her hidden just behind those screens,
That mirror gave back all her loveliness.
A queen in opal or in ruby dress,
A nameless girl in freshest summer-greens,
A saint, an angel — every canvas means
That same one meaning, neither more nor less.
He feeds upon her face by day and night,
And she with true kind eyes looks back on him,
Fair as the moon and joyful as the light:
Not wan with waiting, not with sorrow dim,;
Not as she is, but was when hope shone bright;
Not as she is, but as she fills his dream.

Christina Rossetti's sonnet is one of the few contemporary references to Elizabeth Siddal's limiting influence on Rossetti. Ruskin thought her work excellent, even better than Rossetti's. Rossetti, with a lover's prejudice, concurred in Ruskin's judgement: 'Her fecundity of invention and facility are quite wonderful — much greater than mine.' Swinburne idolized her: '. . . so quick to see and so keen to enjoy that rare and delightful fusion of wit, humour, character painting, and dramatic poetry . . . which is only less wonderful and delightful than the very highest works of genius.' Even Ford Madox Brown, who was sceptical of Ruskin's claims for her genius, declared: 'She is a stunner and no mistake'.

Under Rossetti's tutelage Elizabeth Siddal began to draw and write verse; she started this self-portrait in 1853. Rossetti wrote breathlessly to Brown on 25 August that year to say that 'Lizzie has made a perfect wonder of her portrait, which is nearly done, and which I think we shall send to the Winter Exhibition'. The work was not in fact completed until the following year.

The self-portrait is unrepresentative of her work as a whole. For the most part her watercolours and drawings, on themes of romance and medieval legend, are brittle, drily drawn and often crudely coloured. Her verse was only published after her death, but it is less influenced by Rossetti than by his sister Christina. Neither literary nor lush in Rossetti's mode, her simple poems draw self-abnegation down to the level of self-pity. Death as an anodyne is frequently the solution and resolution of her poetry, and she made the poetic dream a reality when she took an overdose of laudanum in 1862.

James Smetham

9 September 1821 born at Pately Bridge, Yorkshire, the son of a Wesleyan minister. From an early age he wanted to be a painter, but was educated at Woodhouse Grove, Leeds, a school for the sons of Wesleyan ministers. Articled to the architect E.J. Willson, in Lincoln, where he spent most of his time painting in Lincoln Minster. Willson finally agreed to cancel his indentures. Earned a livelihood painting portraits in Shropshire. *1843* entered Royal Academy schools, where he did not distinguish himself. Ruskin however praised him, and he found a patron in J.S. Budgett; he made no headway though with the general public. Met Rossetti in Royal Academy schools. *1851* appointed Drawing Master at Wesleyan Normal College, Westminster. *1851-4* exhibited at Royal Academy and Liverpool Academy. Attempted book illustration, but after little success concentrated on drawing and etching his own poetic conceptions. *1854* married and settled first in Pimlico, then in Stoke Newington. *1869* braced himself to establish a position in art world by sending four works to Royal Academy: 'Hesper', 'The Women of the Crucifixion', 'The Dream of Pilate's Life', and 'Prospero and Miranda'. They were all rejected. Depression ensued. *1877* mental and physical health broke down completely and he was committed to an asylum. He never recovered sanity. *5 February 1889* died. Buried in Highgate cemetery.

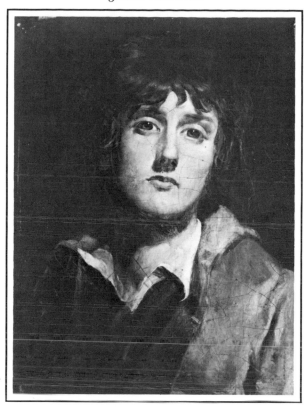

Self-portrait

Oil on panel, 203 × 150 mm
Ashmolean Museum, Oxford

'Two painters who were close friends, and who were sharply distinguished from most of our artistic acquaintances of the Cheyne Walk days by the fact that they were earnest believing and practising Christians of the Nonconformist class, were James Smetham and Frederick Shields.'

This is how William Michael wrote about his brother's friend James Smetham, the son of a Wesleyan minister and a devout Methodist all his life. He had been brought up in Shropshire and started to paint portraits as a livelihood from an early age. He probably first met Rossetti, thereafter an encouraging and sympathetic friend, in 1855, when he attended Rossetti's drawing class at the Working Men's College; he looked then 'a strongly-built man, with a fine face marked by observant and reflective gravity', noted William Michael. During the latter half of the 1850s he produced a number of fervid, sharply coloured works, such as 'Naboth's Vineyard' and 'Jacob at Bethel' which were clearly influenced by Rossetti. At the beginning of the 1860s Rossetti became especially close to Smetham, who, forever under financial stress and supporting a large family at Stoke Newington, came to work regularly every Wednesday in Rossetti's studio in Cheyne Walk. Intense, pious and assailed by doubts of his own self-worth, Smetham, as Rossetti astutely recognised, lacked the will and energy to rescue his work from the idyllic and contemplative backwater in which it was gently resting.

'. . . what you lack is simply ambition, i.e. the feeling of pure rage and self-hatred when any one else does better than you do. This in an ambitious mind leads not to envy in the least, but to self-scrutiny on all sides, and that to something if anything can. You comfort yourself with other things, whereas art must be its own comforter or else comfortless.'

However, Smetham was equally as perceptive a critic as Rossetti when it came to other people's work, and in 1868 published an essay on Blake which to this day remains one of the most eloquent appreciations of that artist's originality. He was also remarkably sensitive to the magical and curious qualities of Rossetti's imagination and described one of Rossetti's watercolours, 'The Wedding of St George' in a comment that evokes those qualities eloquently:

'One of the grandest things. Love credulous all gold, gold armour, a sense of secret enclosure in "palace chambers far apart", quaint chambers in quaint palaces, where angels creep in through sliding panel doors and stand behind rows of flowers, drumming on golden bells, with wings of crimson and green.'

It was no accident that Smetham believed that in this watercolour Rossetti had produced the only true image of a modern hero who approached the Christian ideal. During the last years of the 1860s Smetham's devoutness began to take on the signs of religious monomania and he became increasingly subject to fits of melancholia. In 1877, twelve years before his death, his mental and physical health broke down completely and he was committed to an asylum. He never recovered sanity.

This portrait is entitled 'Too deep for tears'. It was painted in 1844, from a reflection in a mirror.

Simeon Solomon

9 October 1840 born in Bishopsgate, London, the son of a Leghorn hat manufacturer and a prominent member of the London Jewish community (he was the first Jew to be given the freedom of the City of London). Simeon was the younger brother of the painters Abraham (1824-62) and Rebecca (1832-86) Solomon. He was schooled in Hebraic history and ritual and admitted to the Gower Street studio of his brother as a young boy; his talent for drawing showed rapidly and at fifteen he entered the Royal Academy schools. *1858* he showed his first picture at the Royal Academy, 'Isaac Offered'. He followed this with a series of works based on biblical themes: 'The Finding of Moses' (1860), 'The Child Jeremiah' (1862), 'Isaac and Rebecca' (1863). He also produced a suite of drawings of Jewish festival ceremonies, and in *1862* eight designs for *The Song of Solomon* and a further eight for *The Book of Ruth* for reproduction by Hollyer. His work was admired by Rossetti and Burne-Jones, and lavishly praised by Coventry Patmore and Swinburne. Thackeray too, then editor of *The Cornhill Magazine,* applauded his graphic work. He painted a portrait of Patmore and illustrated several poems by Swinburne. It was through Swinburne that he met Lord Houghton, whose influence led him from Hebraic to classical themes. *1865* showed his first classical subject at the Royal Academy, 'Habet'; followed by 'Damon and Aglae' (1866) and 'Bacchus' (1867). *1866* visited Florence; *1869* visited Rome where his classical tastes were reinforced. *1870* showed at the Dudley Gallery, and received much public notice, though he was irreparably damaged by the conviction of buggery brought against him in *1871,* and as a consequence of which his Pre-Raphaelite friends ostracised him completely. *1872* general mental deterioration; took to drink, refused further commissions, and suffered destitution and chronic alcoholism. He found brief consolation in visits to the Carmelite church in Kensington and continued to produce romantic pastel drawings, often concerned with Roman rite, but nearly always marred by sentimentality and mawkishness. Murray Marks, the dealer, bought a quantity of these 'venal' drawings specifically to destroy. Periodic fits of insanity marked the end of his life, interspersed with bursts as a pavement artist and as a regular at the St. Giles Workhouse. *May 1905* found insensible in Great Turnstile; taken to King's College Hospital and from there to the workhouse, where he died of heart failure on *14 August 1905.* Buried in the Jewish Cemetery, Willesden.

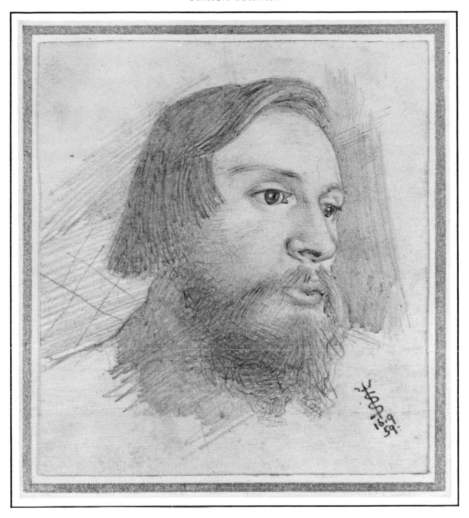

Edward Burne-Jones

Pencil on paper, 118 × 117 mm
Signed in monogram and dated: *16.9/59*
Ashmolean Museum, Oxford

After their marriage in 1859, Georgiana Macdonald and Burne-Jones moved into a house in Russell Place. This portrait by Solomon is one of very few portraits of the artist as a young man, apart from when he sat as Rossetti's model for Launcelot for the Oxford Union murals in 1857 (the only portrait of him without a beard) and as Christ in 'Mary Magdalene at the door of Simon the Pharisee' (1859). When Georgiana met him in 1852, she noted that he was:

'. . . rather tall and very thin, though not especially slender, straightly built with wide shoulders. Extremely pale he was, with the paleness that belongs to fair people, and he looked delicate but not ill. His hair was perfectly straight, and of a colourless kind. His eyes were light grey . . . and the space that their setting took up under his brow was extraordinary. . . . From the eyes themselves power simply radiated, and as he talked and listened, if anything moved him, not only his eyes but his whole face seemed lit up from within. I learned afterwards that he had an immovable conviction that he was hopelessly plain.'

Solomon was a frequent caller at Russell Place, and he introduced several of his fellow artists from the Royal Academy schools to Burne-Jones. Among these were Albert Moore and William de Morgan, and it was through this connection that all three artists were commissioned to design stained glass cartoons for Morris and Co. between 1861 and 1866. Burne-Jones is reputed to have called Solomon 'the greatest artist of us all', and several critics such as Thackeray, Pater and Swinburne acknowledged his early promise as an artist. Swinburne, however, proved a corrupting influence on the impressionable young man, encouraging him in a life of dissipation from which he was unable to retrieve himself. After his conviction for buggery in 1873, Solomon was destitute. Swinburne, who but for the support of Watts-Dunton would have suffered the same fate, was the most vicious of all Solomon's denouncers, referring to him as:

'. . . a thing unmentionable alike by men and women, as equally abhorrent to either — nay, to the very beasts.'

Early in the 1860s, however, Burne-Jones, Solomon and Swinburne kept close company. Two drawings by Solomon became the inspiration for two of Swinburne's poems, *Erotion* and *End of Month*. *Erotion* was subsequently published in Swinburne's *Poems and Ballads* of 1866, which bore the inscription: 'To my friend Edward Burne-Jones these poems are affectionately and admiringly dedicated.'

Thomas Woolner

17 December 1826 born in Hadleigh, Suffolk, son of a postmaster. After a preliminary education in Ipswich, he was sent to boarding school in Brixton, aged ten. *1838* studied under the painter Behnes, and on whose death soon after, with his brother, the noted sculptor William Behnes. *Dec 1842* entered Royal Academy schools. *1843* exhibited his first piece of sculpture at the Royal Academy, 'Eleanor sucking the poison from Prince Edward's wound'. *1847* met Rossetti and drawn into the circle of his intimates. *1848* founder member of the Pre-Raphaelite Brotherhood. *1848* visited Paris, his first trip to the continent; greatly impressed by Ingres, a lifelong hero. *1850* contributed several cantos to *The Germ,* though he later confessed, 'Poetry is not my proper work in this world; I must sculpture it, not write it.' *1848-51* made his livelihood from sculpting portrait medallions, among them portraits of Coventry Patmore and his wife ('The Angel' 1850). Introduced William Allingham to the Pre-Raphaelite group. Met Tennyson in *1848* and remained on particularly good terms with him and his wife throughout his life. *1852* emigrated to Australia after failure to win commission for the Wordsworth Memorial. *October 1854* returned to England; married Alice Gertrude Waugh (whose portrait was painted by Hughes in 1864) and established himself as a portrait sculptor with some success. *1855* introduced by William Bell Scott to the Trevelyans. *1856* modelled medallion of Tennyson which decorated the frontispiece of the Moxon edition of his poems in *1857,* and which was illustrated by members of the Pre-Raphaelite group. *1856* portrait of Browning; *1858* modelled figures of Moses, David, St. John and St. Paul for Llandaff Cathedral. *1861* portrait of F.D. Maurice. *1867* designed figures for Manchester Assize Court. His more distinguished sculpture includes the statue of John Stuart Mill (1878) on the Thames Embankment, Stamford Raffles (1887) for Singapore and busts of Darwin, Kingsley, Newman, Maurice, Keble, Adam Sedgwick and Archdeacon Hare. *1871* elected associate of the Royal Academy; *1873* became a full academician. *1877* appointed Professor of Sculpture but never lectured and resigned two years later. *7 October 1892* died of heart failure following an operation. Buried in St Mary's churchyard, Hendon.

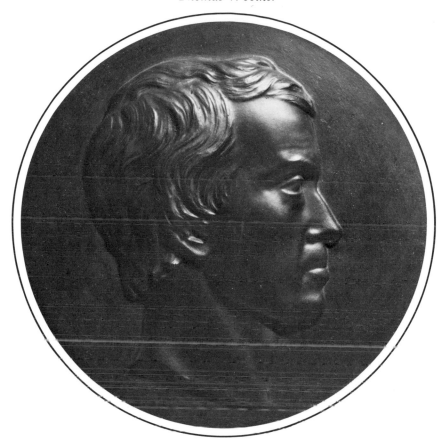

Thomas Carlyle

Plaster cast, painted black, 216 mm diameter
National Portrait Gallery, London

Lady Eastlake described Carlyle's physiognomy with admirable terseness 'He has', she noticed, 'the head of a thinker, the eye of a lover, and the mouth of a peasant'. James Anthony Froude, Carlyle's biographer, elaborated, describing Carlyle as he first met him in 1849, already the influential author of *Sartor Resartus* and *Past and Present*:

'He was then fifty-four years old; tall (about five feet eleven), thin, but at that time upright with no signs of the later stoop. His body was angular, his face beardless, such as it is represented in Woolner's medallion, which is by far the best likeness of him in the days of his strength. His head was extremely long, with the chin thrust forward; the neck was thin; the mouth firmly closed, the under lip slightly projecting, the hair grizzled and thick and bushy. His eyes, which grew lighter with age, were then of a deep violet, with fire burning at the bottom of them, which flashed out of the least excitement. The face was altogether more striking, most impressive every way. And I did not admire him the less because he treated me — I cannot say unkindly, but shortly and sternly. I saw then what I saw ever after — that no one need look for conventional politeness from Carlyle — he would hear the exact truth from him, and nothing else.'

A friend of Allingham, Patmore, Tennyson and Rossetti,

Carlyle approved of the Pre-Raphaelites, 'for copying the thing as it is'. However, unlike Ruskin, that other great prophet of the age, Carlyle had limited response to physical phenomena, and his powers of natural observation were small. But his powers as a preacher of righteousness were deployed through his vivid, fiery imagination, and his methods as an historian might well be described as 'Pre-Raphaelite'. In his historical studies he used the minute details of research — a dry business contract, a map, phrases from a letter — to build a sharply-drawn, strikingly immediate image, in contrast, say, to the wide, generalised views of history which Gibbon presented.

Carlyle's ideas had a profound influence on the intellectuals growing up in the 1840s. Looking around at the social disorder, the mechanicalism, the *laissez-faire* politics of the day, he lamented that 'this is not a religious age. Wonder is indeed on all hands dying.' There were plenty of churches, plenty of creeds, and plenty of dogma, but little living faith. Morality had become a book-keeping philosophy, drawn up on the calculations of profit and loss. The only remedy to Carlyle's mind was spiritual rebirth, though not seen as a conversion in the theological sense, but as a change of heart. It could only be achieved, he maintained, by the recognition of certain great truths, truths which he understood as coming from the fullest vision of nature which the human heart and mind could attain. This fundamentally moral principle was one of the wellsprings of the young Pre-Raphaelite Brotherhood, and much of their early work betrays their debt to Carlyle.

John Henry Newman

Opposite:
Plaster cast, painted black, height 695 mm
Incised on front of base: *JOHN HENRY NEWMAN* and on the
side *T. WOOLNER Sc/1866*
National Portrait Gallery, London

'Forty years ago, when I was an undergraduate at Oxford, voices were in the air there which haunt my memory still. Happy the man who in that susceptible season of youth hears such voices! They are a possession to him for ever. No such voices as those which we heard in our youth in Oxford are sounding there now. Oxford has more criticism now, more knowledge, more light; but such voices as those of our youth it has no longer. The name of Cardinal Newman is a great name to the imagination still; his genius and his style are still things of power. But he is over eighty years of age, he is in the Oratory at Birmingham; he has adopted, for the doubts and difficulties which beset men's minds today, a solution which, to speak frankly, is impossible. Forty years ago he was in the very prime of life; he was close at hand to us at Oxford; he was preaching in St Mary's pulpit every Sunday; he seemed about to renew what was for us the most national and natural institution in the world, the Church of England. Who could resist the charm of that spiritual apparition, gliding in the dim afternoon light through the aisles of St Mary's, rising in the pulpit, and then, in the most entrancing of voices, breaking the silence with words and thoughts which were a religious music — subtle, sweet, mournful?'

Matthew Arnold's elegiac portrait of Cardinal Newman (1801 – 90), given in his American discourse on Emerson in 1883, is a plaint for lost youth, for an ageing romanticism, for the dead causes ('the last enchantments of the Middle Age' as Arnold himself called them) that Newman and the Oxford Movement came to symbolise. During the 1830s, Newman had railed against Protestantism; not only was it found aesthetically meagre, but worldly and unspiritual. Newman sensed that there was in the air 'a spritual awakening of spiritual wants', as men of such different tenor as Carlyle, Ruskin, William Morris and Frederick Denison Maurice all came to feel in their time. For Newman, the solutions were to be sought in the spiritual arena, within the structure of the church itself. At first, he believed in the establishment of an English Catholic Church, apostolic, yet 'free from the practical abuses and excesses of Rome'. Gradually, however, he saw that the Rubicon had to be crossed, and in 1845 he embraced and endorsed Catholicism:

'What a scene', he declared, 'what a prospect, does the whole of Europe present at this day! . . . Lovers of their country and of their race, religious men, external to the Catholic Church, have attempted various expedients to arrest fierce wilful human nature in its forward course, and to bring it into subjection. The necessity of some form of religion for the interests of humanity, has been generally acknowledged: but where was the concrete representative of things invisible, which would have the force and the toughness to be a breakwater against the deluge?'

For the Pre-Raphaelites, Newman's ideas, his desires to show 'concrete representatives of things invisible', were still potent in 1848. Collins and Collinson were both closely affected by the Tractarianism with which Hunt and Millais, through their friendship with the Combes, came face to face in their early years as Pre-Raphaelite painters. Rossetti, who responded intuitively to the sacramental side of Catholicism, was early accused of 'imputations of popery'.

Although the Oxford Movement was mourned by Arnold fifty years on, it was nonetheless part of that deepening of seriousness, the will to wrestle with the conditions of contemporary life, that manifested itself variously throughout the century in Romanticism, in Evangelism, in Socialism and in part in Pre-Raphaelitism, long after Tractarianism itself had expired.

138

Select Bibliography

Angeli, Helen Rossetti *Dante Gabriel Rossetti: His Friends and Enemies,* 1949
Angeli, Helen Rossetti *Pre-Raphaelite Twilight: The Story of C.A. Howell,* 1954
Atlay, J.B. *Sir Henry Wentworth Acland, Bart. A Memoir*
Baldwin, A.W. *The Macdonald Sisters,* 1960
Benson, A.C. *Memories and Friends,* 1924
Burne-Jones, Georgiana *Memorials of Edward Burne-Jones,* 1904
Bryson and Troxell (ed.) *Dante Gabriel Rossetti and Jane Morris: Their Correspondence,* 1976
Callen, Anthea *Angel in the Studio,* 1979
Chapman, Ronald *The Laurel and the Thorn: A Study of G.F. Watts,* 1945
Chubbe, John (ed.) *Froude's Life of Carlyle,* 1979
Coghill, Mrs Harry (ed.) *Autobiography and Letters of Mrs Oliphant,* 1899
Collins, W. Wilkie *Memoirs of the Life of William Collins R.A.,* 1848 (reprinted 1978)
Davidson, Angus *Edward Lear, Landscape Painter and Nonsense Poet 1812 – 1888,* 1938
Douglas, James *Theodore Watts-Dunton,* 1904
Doughty, Oswald *A Victorian Romantic: Dante Gabriel Rossetti,* 1960
Douton, Maud Mary *A Book with Seven Seals,* 1928
Du Maurier, George *Trilby,* 1895
Dunn, Henry Treffry *Recollections of Dante Gabriel Rossetti and His Circle,* 1904
Fitzgerald, Penelope *Burne-Jones,* 1975
Gissing, A.C. *William Holman Hunt: A Biography,* 1936
Gosse, Edmund *Algernon Charles Swinburne,* 1917
Gosse, Edmund *Leaves and Fruit,* 1927
Grylls, Rosalie Glynn *Portrait of Rossetti,* 1964
Henderson, Philip *William Morris: His Life, Work and Friends,* 1967
Hiley, Michael *Victorian Working Women: Portraits from Life,* 1979
Horner, Francis *Time Remembered,* 1933
Holman-Hunt, Diana *My Grandmothers and I,* 1960
Hueffer, Ford Madox *Ford Madox Brown: A Record of his Life and Works,* 1896
Hunt, William Holman *Pre-Raphaelitism and the Pre-Raphaelite Brotherhood,* 1905
Ionides, Luke *Memories,* 1925
Kaye, Elaine *A History of Queen's College, London,* 1972
Litchfield, R.B. *The Beginnings of the Working Men's College*
Lutyens, Mary *Effie in Venice,* 1965
Maas, Jeremy *Gambart, Prince of the Victorian Art World,* 1975
Mastermann, Lucy (ed.) *Mary Gladstone: Her Diaries and Letters,* 1930
Millais, John Guille *The Life and Letters of Sir John Everett Millais,* 1899
Mills, Ernestine *Life and Letters of Frederick Shields,* 1891
Minto, W. (ed.) *William Bell Scott, Autobiographical Notes . . . and Notices of His Artistic and Poetic Circle of Friends, 1830-1882,* 1892
Moore, Katherine *Victorian Wives,* 1972
Patmore, Derek *Portrait of My Family,* 1935
Pedrick, Gale *Life with Rossetti,* 1964
Pinchbeck, Ivy *Women Workers and the Industrial Revolution, 1750 – 1850,* 1930
Piper, David *The English Face,* 1957
Postgate, Raymond *The Story of a Year, 1848,* 1955
Robertson, Graham *Time Was: Reminiscences,* 1931
Rossetti, William Michael *Some Reminiscences,* 1901
Seddon, John P. *Memoir and Letters of the Late Thomas Seddon, Artist. By his Brother,* 1858
Smetham and Davies (ed.) *Letters of James Smetham, with an Introductory Memoir,* 1891
Spanton, W.S. *An Art Student and his Teachers in the Sixties,* 1927
Stephens, F.G. *Dante Gabriel Rossetti,* 1908
Stillman, William James *Autobiography of a Journalist,* 1901
Thirkell, Angela *Three Houses,* 1931
Thompson, E.P. *William Morris: Romantic to Revolutionary,* 1958
Trevelyan, Raleigh *A Pre-Raphaelite Circle,* 1978
Watts-Dunton, Theodore *Aylwin,* 1901
Watts-Dunton, Theodore *Old Familiar Faces,* 1916
Williamson, G.C. *Murray Marks and his Friends,* 1919

Index